Design it Yourself
Logos, Letterheads, & Business Cards

First published in the United States of America by:
Rockport Publishers, Inc.
33 Commercial Street
Gloucester, Massachusetts 01930-5089
Telephone: 978 282 9590
Facsimile: 978 283 2742
www.rockpub.com

ISBN 1-56496-768-9

10 9 8 7 6 5 4

Design: Chuck Green

Printed in Hong Kong

Design it Yourself
Logos, Letterheads, & Business Cards

The Non-Designer's Step-By-Step Guide
CHUCK GREEN

GLOUCESTER MASSACHUSETTS

ROCKPORT PUBLISHERS

ACKNOWLEDGMENTS

Thank you to all of the talented people who had the passion to create, and the tenacity to get published, the clip art, photographs, and typefaces I used to illustrate these ideas and layouts.

Thanks, too, to the folks at Rockport Publishers for allowing me the creative freedom to take their vision for the Design-it-Yourself Series and make it my own. I am especially grateful to Publisher Winnie Prentis, Managing Editor Jay Donahue, Acquisitions Editor Kristin Ellison, Designer Susan Raymond, and Acquisitions Director Shawna Mullen.

Finally, thanks to my wife Leslie and sons Jeffrey and Robert for supplying the support and energy that has allowedme to weave another small thread into the ever-growing fabric of ideas.

DEDICATION

Early in my life, two outstanding artists offered me the encouragement I needed to choose the road I travel. In so doing, they offered a profound gift—simple, selfless concern. This book is dedicatedto their memory.

For illustrator Dill Cole
and designer George P. Riddick Jr.

Contents

PART 1

Learn the steps necessary to research, design, and produce a logo and to incorporate it into a letterhead, business card, and envelope. Part 1 includes everything from defining your goals to checking the final printed pieces.

PART 2

Create a design using any of twenty-five Design Recipes, each including in-depth, detailed information about designing a logo, letterhead, business card, and envelope using different styles, typefaces, and color schemes.

INTRODUCTION

This is not a design *theory* book— it is a design *instruction* book.

A design theory book examines abstract concepts such as contrast, symmetry, and white space, under the assumption that if you learn to think the thoughts of a designer, you will be a designer.

I'm not sure it's that easy. In my opinion, the capacity to visualize and compose is influenced by more than theory. Some mix of natural talent and experience seems to play a significant enough role that I doubt many of us could get the desired result by simply understanding a premise.

I propose an entirely different approach—to demonstrate how one designer does it.

You and I will tackle a real project from the initial idea to the final printed piece—and I'm going to tell you how I handle each detail every step of the way.

Think of it as a cookbook. Instead of discussing the history of the stove and the intricacies of milling flour, I'm going to show you how to bake a cake. And if I've done my job, following one of my design recipes will result in a logo, letterhead, and business card that looks and sells as if it were designed by a pro.

Who this book is for

The Design-it-Yourself series is written primarily for "non-designers," in layman's language, and endeavors to include all the information necessary to produce real-world, professional-quality results. Everyone, of course, is a designer in the sense that they make artistic judgments about everything from the clothes they wear to the way they decorate the rooms they live in. By "non-designer," I simply mean those who don't make their living at it.

But even chefs use cookbooks. I hope even an experienced designer will profit from seeing how another designer navigates familiar territory. I'm a much better designer for having studied my colleagues' work—their justification for making subtle choices, the tips and tricks they use in everyday production, and the resources they tap for the details they don't handle in-house.

How to use it

The book is divided into two parts. Part 1: Step-By-Step Design, beginning on page 11, covers the steps necessary to research, design, and produce a logo and incorporate it into a letterhead, business card, and envelope. We discuss how to create a name, write a benefits-oriented tag line, and how to choose the right tools and most effective resources. It includes eight ways to design a logo and shows you how to add important functionality to your business cards and letterheads. I'll even help you find a commercial printer and choose the right paper to print your letterhead on.

I suggest you read through Part 1 start to finish before beginning your project, then use the checklists included with each step as a guide. The checklists summarize the key points and are coded to the text so you can easily review the details as necessary.

Part 2, beginning on page 55, features twenty-five Design Recipes, each including in-depth, detailed information about designing a logo, letterhead, business card, and envelope using different styles, typefaces, and color schemes. Each recipe includes page layouts and dimensions, typeface names and sizes, specific color suggestions, even the sources of graphics and photography. And, because they are created specifically for the Design-it-Yourself series, you are free to copy any recipe in whole or in part to create your own materials.

What you need

This book is not about a particular software program and does not require a specific computer system. Most of the projects are easiest to produce using a desktop publishing program such as QuarkXPress, Adobe InDesign, Adobe PageMaker, or Microsoft Publisher. The other software you will need depends on the recipe you choose to follow. Some of the logos require a drawing program such as Adobe Illustrator, Macromedia Free-Hand, or CorelDRAW; or an image editing program such as Adobe Photoshop or Jasc Software's Paint Shop Pro. Program suggestions are listed throughout.

Continue the discussion at www.designiy.com

Want to share your side of the experience? I've established a place for you and other readers to share your insights and experiences about Design-It-Yourself: Logos, Letterheads, and Business Cards—www.designiy.com. In addition to posting selected comments from readers, I'll keep you current on the latest resources and upcoming titles in the Design-it-Yourself series.

This, of course, is just the beginning of what is possible. As more and more of us learn to master today's powerful design-oriented software programs, the appreciation of good design, based on honest marketing principles, will increase dramatically. I hope, in some small way, what you find here furthers that outcome.

Chuck Green
chuckgreen@designiy.com

Design it Yourself

PART 1
Step-By-Step Design

STEP 1

Establish Your Mission

Your logo is your organization's strategic center of gravity—the foundation on which your letterhead, business card, and envelope are built. It deserves an investment of significant thought and effort. Design it well, and in the months and years to come, it will help arouse the curiosity of your prospects, build your image in the minds of customers, and provide a symbolic rallying point for your organization.

For the purposes of this book, *a logo is defined as the combination of a name, a symbol, and a short tag line.* The sum of the parts identifies at a glance the nature of your product or service, transmits the benefit of using it, and defines your attitude about it. It is the first step of building a brand.

The brand, as advertising pioneer David Ogilvy put it, is a "product's personality ... its name, its packaging, its price, the style of its advertising, and above all, the nature of the product itself." Your logo is an important part of that brand. Your customers and prospects will see it over and over again on everything you produce. As advertising and marketing themes ebb and flow, your logo is the visual anchor that holds the ship steady.

Do some big-picture thinking

The first step toward designing a logo is to establish a mission—to define what you hope to accomplish and determine how you will go about it. This takes some big-picture thinking.

1.1 Start by *identifying the target*—are you selling a product, a service, or a cause? Though many an organization uses its reputation and attitude to do its selling, it is important to remember that customers buy benefits, not companies. From the outset, you need to determine if you should invest your resources in creating a logo for a specific product, service, or cause; for the organization that sells it; or both.

A consumer products company such as Frito-Lay, for example, sells many different products—Doritos, Ruffles, Lay's, and others—all of which have their own identity. It's obvious that, on the consumer front, they spend far more on the identities of individual products than they do on the Frito-Lay name. A legal firm or a custom-home builder typically does just the opposite—it focuses on establishing a favorable image of its company name.

1.2 Next, *pinpoint your audience.* Obviously, to sell something to someone, you have to know who they are and how to reach them. At one extreme, you might have a single, easy-to-reach audience; at the other, different audiences for each product or service that are reached in a variety of ways.

1.3 Though the name of this book is *Design-it-Yourself,* that doesn't mean you have to wear all the hats. It is a good idea, early on, to clearly *define your role* in the process. Maybe you are confident about your ability to create a symbol but have a terrible time deciding on a palette of colors. If that's the case, by all means, enlist some help. You may even go so far as to take the preliminary research and planning steps and hire someone else to complete the project using this book as your guide.

1.4 Now, too, is the time to *determine how and where your logo will be used.*

Size—If your logo will be used at a very small size, you'll need to keep it simple. If it will be used in a retail environment, it may need to be readable from four or five feet away.

Number of colors—Your logo should work well in color and in black and white; you don't want to be forced to print your invoices or Yellow Pages ad in multiple colors.

Where it is used—Logos are imprinted on machinery, painted on the sides of trucks, and branded on the backsides of cattle. Though you can't anticipate all the places it will be used, it pays to make a list of the probable uses and determine how they affect the design. Here are a few:

Yellow Pages	Packaging
Newspapers	Signage
Magazines	Marketing giveaways
TV	CDs
Webs	Clothing

1.5 The design process requires subjective judgments about matters of taste. Trying to gain the consensus of a group often leads to a homogeneous design that lacks the passion that makes a logo memorable. To expedite the process and avoid conflict, *appoint the decision-makers* before you begin. Choose people who best understand the organization and its style—people who are comfortable making aesthetic decisions and whose design and marketing sense you most trust.

1.6 *Establish a budget*—not every nickel and dime, but a realistic, general figure. Include the cost of time, software, and outside services such as printing.

1.7 Finally, *set a schedule.* At a minimum, allow:

4	hours for research
8	hours to create a name
4	hours to write a defining phrase
8	hours to design a logo
4	hours to layout a letterhead
2	hours to layout a business card
1	hour to layout an envelope
10	working days for printing

Step 1: MISSION CHECKLIST

1.1 Identify the target

1.2 Pinpoint your audience

1.3 Define your role

1.4 Determine how and where your logo will be used

1.5 Appoint the decision-makers

1.6 Establish a budget

1.7 Set a schedule

How to use this book

Each stage is summarized in a checklist. Once you've read through the text start to finish, refer back to the checklist or the corresponding text to revisit the details.

Throughout Part 1 of this book, all the stages of each step are discussed in the text.

STEP 2

Do Some Research

Once you know where you're headed, you need to figure out how to get there. That takes research—about your competition, your customers, and what you need to do to stand out from the crowd. While some of this may seem excessive, I assure you that developing a good map up front will save you miles of backtracking later on.

I learned this lesson the hard way: I decided to skip the research step in a rush to design an ad for a client on a tight deadline. They liked my solution and pointed out that their primary competitor must have liked it, too—it had run a nearly identical ad several months earlier.

SOURCE Illustrations: Magnifying glass from *Just Tools* by CMCD, 800-661-9410, 403-294-3195, www.eyewire.com. © CMCD, all rights reserved; map collage by the author.

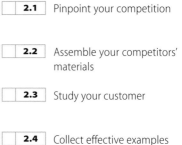

2.1	Pinpoint your competition
2.2	Assemble your competitors' materials
2.3	Study your customer
2.4	Collect effective examples (concepts, designs, colors)

This is not an unusual problem. Designers and writers often come up with similar ideas and layouts because, as a result of their research, they come to similar conclusions.

To compete effectively, you need to know as much as possible about the other players and the field of play. **2.1** Start your research by *pinpointing your competition*. Find out as much as you can about them and their history. History is important because you may be able to avoid some of the mistakes they made early on. And don't limit yourself to local competitors. Even if you only operate in one region of the country, check out what others are doing elsewhere. Stiffer completion in another region may offer more advanced examples of how to top your rivals.

2.2 Next, *assemble your competitors' materials*. This once-daunting task is easier now that so many organizations have sites on the World Wide Web. There is a huge amount of extraordinarily valuable competitive information available—you have only to seek it out. Read everything you can get your hands on, and see how competitors answer the same questions you are asking yourself about mission, style, customer relations, and so on.

2.3 Now *study your customer*. Remember that business is not a "we" thing—it's a "they" thing. The most important principle for any organization to establish is the benefit of its products or services to its prospects and customers.

Everything you do, from the design of your logo to the layout of your invoices, should be focused on one thing— customer benefits. Step into your customer's shoes now, and stay there until you retire.

Don't hesitate to ask customers directly. What first attracted them to your products and services? What brought them back a second time? Surveying customers is the highest form of flattery. It means you value their opinion and appreciate that they have a perspective of your organization that you do not.

2.4 With these basics under your belt, you can go about *collecting effective examples* of concepts, designs, and color schemes of the logos, letterheads, and business cards of other organizations. Not just in your field, but any material that catches your eye. Collect enough of them and you will begin to see a trend—the typefaces you find most attractive, the page layouts that look most professional, the colors that attract you, and so on.

Immerse yourself in the details—the more you know, the more confident you will be about the solutions you uncover.

**Who?
What?
Where?
When?
Why?**

STEP 3

Create a Name

Naming is simple. Naming is complex.

It is said that truly great abstract painters must learn to paint realistically before they can paint a valid abstraction. In naming, you must understand the complexity of your subject before you can simplify it.

Organizations that specialize in naming make it look easy. Take, for example, Solutia,® the name of a chemical business dreamed up by Addison and Metaphor Name Consultants, or Hewlett-Packard's printer family DeskJet,® named by Lexicon Branding, Inc.—two powerful names that make the benefits of complex services and products simple to understand.

The name of your organization is critical in itself and fundamental to its logo. The problem is, few small businesses can afford the tens of thousands of dollars it costs to pay naming experts to develop it. The alternative? Design-it-Yourself.

3.1 Review the research you created in Step 2 and *collect the naming tools* necessary for the brainstorming session below. You'll need a good dictionary and thesaurus—something more complete than the standard tools included with your word processor. Another helpful resource, *The Random House Word Menu*, offers comprehensive lists of words organized in very specific subject classes.

3.2 There are many ways to combine words and ideas into names. You can derive them from historical ideas and from foreign language words, or even invent new words altogether. But, generally speaking, it is to your advantage to start with a name that says what it means—Airbus, for example, makes aircraft, and Frigidaire, refrigerators. If the name is hazy, you will forever be explaining the meaning via your advertising and marketing efforts.

The most straightforward way to go about naming is to combine two or three ideas into a one- or two-word name. You can simply add whole words together as in QuickBooks, or abbreviate words and add them together as in FedEx.

To create your unique name, start by *compiling a brainstorming list*. Make one column for each of the benefits you have identified. For example, a delivery company that promises fast delivery to a nationwide audience might start with columns for words associated with delivery, nationwide, and speed. Find as many positive words as possible and list them, then begin to experiment with combinations of words from each column. There are hundreds, if not thousands, of possibilities.

NATIONWIDE	SPEEDY	DELIVERY
central	express	dispatch
federal	fast	launch
focal	quick	send
national	rapid	ship
network	rush	transfer

This is just one of many ways to name your organization. For more naming ideas and guidelines, visit www.designiy.com

3.3 *Wait twenty-four hours, and then filter your list.* Put your list aside and return after a day or two with a fresh perspective. Judge the names against a specific list of merits, which might include:

ı Is not neutral or negative

ı Is not difficult to spell or pronounce

ı Does not have to be seen or heard to be understood

ı Does not play off another organization's identity

ı Is not too cute or too funny

ı Is not an acronym

ı Does not use the names of people or places

ı Does not use slang or offensive language

ı Does not limit future growth

3.4 Next, *choose the two or three strongest ideas and create a rationale for them.* The rationale is a paragraph of text that summarizes your perspective on the name. Ask others to read it after they have seen the name to help you gauge if they got a similar impression.

3.5 The naming world is replete with stories of names that work well in one language but are nonsensical or offensive in another. If any of your prospects communicate in another language, you should work with a language expert to *check for language conflicts.*

3.6 At this stage, before you invest any more time and money, you should *do a preliminary trademark check* to determine if the name you are pursuing can be protected. Without a trademark, you could spend a huge amount of energy building a brand that belongs to someone else. At a minimum, do a search for the word or phrase on an Internet search engine and search the Trademark Electronic Search System (TESS) at www.uspto.gov/web/menu/search.html

3.7 Once you have had a chance to sleep on it, *choose a name and test the market.* Testing could be as casual as gathering the reactions of a few colleagues and customers, or as formal as organizing a focus group of neutral prospects. The more extensive the survey and complete the opinions, the better.

3.8 Finally, once you have a firm decision, you should *legally secure the name* by applying for a trademark. The United States Patent and Trademark Office defines a trademark as "a word, phrase, symbol or design, or combination of words, phrases, symbols or designs, which identifies and distinguishes the source of the goods or services of one party from those of others. A service mark is the same as a trademark except that it identifies and distinguishes the source of a service rather than a product.... Normally, a mark for goods appears on the product or on its packaging, while a service mark appears in advertising for the services."

The Trademark Electronic Business Center is a one-stop source for all online trademark searching, filing, and follow-up (www.uspto.gov). If you need answers to specific trademark questions or want to know more about trademarks in general, consult an attorney or contact the Trademark Assistance Center at 800-786-9199. Another good perspective is offered in the pages of *Trademark: Legal Care for Your Business & Product Name*, (NOLO Press, 1999).

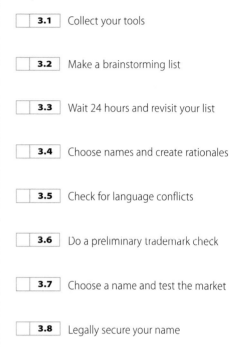

Step 3: NAMING CHECKLIST

3.1 Collect your tools

3.2 Make a brainstorming list

3.3 Wait 24 hours and revisit your list

3.4 Choose names and create rationales

3.5 Check for language conflicts

3.6 Do a preliminary trademark check

3.7 Choose a name and test the market

3.8 Legally secure your name

STEP 4

Write a Defining Phrase

The most important part of any design is the message it sends. Your logo, in addition to a visual image and the name of your organization, should include a five- to fifteen-word phrase that defines what you do and the benefit of your product or service to your customer.

For a small business, a defining phrase is better than a slogan or a tag line. Slogans and tag lines are so-called attention-getters that very often do not plainly declare what a company does.

A slogan such as "Just do it," for example, is successful for a company such as Nike because it spends millions of dollars repeating the message in its advertising. A small business such as a photo lab or a day care center doesn't get that kind of exposure and is better off getting right to the point.

4.1 There are two components to a successful defining phrase. The first *defines your market*. This is especially important if your organization's name does not spell out the business you're in. The name "Delta Corporation" doesn't tell you what the company does, but the names "Delta Faucet Company" and "Delta Air Lines" are abundantly clear.

4.2 The second component of your phrase should express the most important benefits of using your product or service. To do it, *translate features to benefits*—an extremely important distinction. Features describe your products or services from your organization's viewpoint; benefits describe them from your customer's perspective.

A "me"-oriented defining phrase is more effective when stated in terms of the customer. Visa could have used one like, "Our credit cards are accepted around the world," but instead they chose the more powerful, "Visa—It's everywhere you want to be." Apple could have claimed "the highest-quality computers" but opted instead to offer "The power to be your best." A "large selection" is a feature—"see all models in one place" is a benefit.

4.3 Next, *list the benefits in order of importance.* Our first inclination is to advertise as many benefits as possible in the hope that everyone will find something that compels them to take action. But too many messages muddy the water—especially in the confines of a fifteen-word phrase. Keep it as simple as and as focused as possible.

For example, the top benefits of a hypothetical copier retailer might be:

1. They offer a lowest-price guarantee

2. They have the area's largest selection

3. They support and service everything they sell twenty-four hours a day, seven days a week

4.4 The ideal defining phrase includes a "hook"—the combination of benefits that establishes the important difference between you and your competition. In advertising, it is sometimes called the unique selling proposition. To *identify the hook,* combine two or more of the top benefits. If that doesn't demonstrate the distinct difference, or if your benefits are much the same as your competitor's, study their marketing materials and focus on a benefit they do not promote.

4.5 Next, *condense your ideas into a five- to fifteen-word phrase.* In this case it might be: "Lexington's largest copier showroom and guaranteed lowest prices, backed by 24/7 support and service." Too boring? Clever is good if it doesn't get in the way. It is far better to have a less-exciting defining phrase than a line that twenty percent of your prospects don't understand.

4.6 Finally, *test your defining phrase with customers.* The true test of whether you have a good phrase is to ask someone who doesn't know anything about your business if, by reading it, they can name the type of business you are in and the benefits you have defined. One difficulty of writing and producing your own marketing materials is that you are very close to the action—at times, too close to see the message clearly. Run your defining phrase by a few customers to hear their reactions and suggestions.

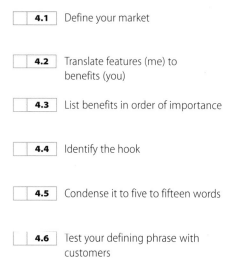

Step 4: PHRASE CHECKLIST

4.1 Define your market

4.2 Translate features (me) to benefits (you)

4.3 List benefits in order of importance

4.4 Identify the hook

4.5 Condense it to five to fifteen words

4.6 Test your defining phrase with customers

STEP 5

Choose a Style

A brash man in a Hawaiian shirt will be treated differently than a soft-spoken man in a tailored business suit. *How* they are treated depends on where they wear what and who is making the judgment.

It's the same with an organization. Dress your organization in the style of the audience it hopes to attract. Get a sense of what appeals to them and adopt a demeanor they relate to. Want to attract young, affluent, technology workers? As a whole, they respond to a different style than middle-aged factory workers.

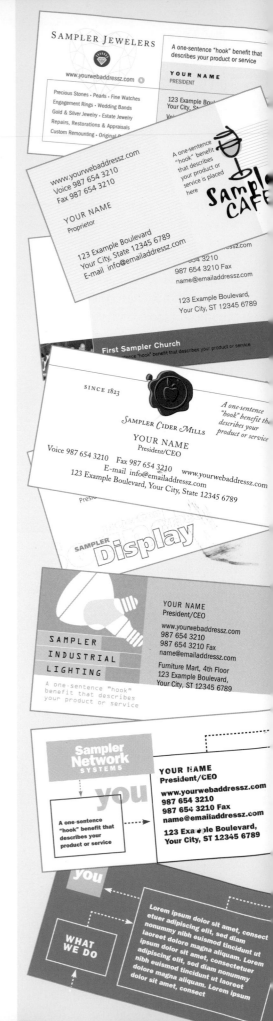

For the purposes of this book, *style is defined as the visual and emotional mood of your organization. It is the combination of the message, how it is presented, the images used to illustrate it, the stance of the layout, and the choices of typefaces and color.*

Why choose a style? From the first moment they meet your organization, prospective customers begin to form an opinion of it. You can take a passive role by allowing them to form their own opinions, or you can use your style to influence it.

5.1 Your choice of style, like all your other marketing decisions, should be made from the customer's point of view. *Study the research* you gathered about who your prospects are, the benefits they seek, and what turns them on or off.

5.2 Style is another way to draw distinctions between your organization and its competition. *Reexamine how your organization presents itself*—its message, illustrations, and layouts. What style would set your organization apart stylistically?

5.3 Too often, today's advertising experts use negative or controversial messages under the guise of attracting the attention of prospects.

One postcard, for example, showed a young bride seated in a limousine next to an elderly man. The thought balloon above her head showed a bare-chested young man and a headline that read: "Why not love *and* money?"

While the approach might appeal to some, it is guaranteed to offend others. Savvy communicators *build on a positive message.* Why risk repelling a single prospect if you can achieve the same goal without offending anyone?

5.4 Once you have a clear idea of where your competitors stand, you can *choose a style that fits.* That, of course, doesn't mean you should try to make your organization something it is not— sheep in wolves' clothing stand a good chance of being devoured.

The second part of this book, beginning on page 55, presents twenty-five different ways to handle the visual side of your style—combinations of layout, color, and type. The designs were created specifically for the Design-it-Yourself series. You are free to copy any recipe in whole or in part to produce your own materials. The only restriction is that you cannot trademark the copied design.

Step 5: STYLE CHECKLIST

5.1 Study the research

5.2 Reexamine how your organization presents itself

5.3 Build on a positive message

5.4 Choose a style that fits

STEP 6

Choose Your Tools

It wasn't long ago that the headline shown above cost $12 to set. That's right, as recently as the 1980s it was not unusual for a designer to pay $4 or more per word to have headline-sized words set on a machine called a Typositor. The words were cranked out, letter by letter, on strips of photographic paper, trimmed, lined up, cemented to a paste-up board, and burnished down. Designing something as simple as a letterhead was expensive and time-consuming, and it required significant mechanical skills.

Today, the financial and mechanical barriers are all but gone. With a personal computer and some specialized software, you wield creative potential that was not even dreamed of those few short years ago. The idea that designers are designers only if they devote their career to it is fast becoming as outmoded as the idea that you must drive full-time to be considered a driver.

6.1 *Choose a desktop publishing program.* Most of the Design-it-Yourself projects are easiest to produce using a desktop publishing (DTP) program such as Adobe InDesign, Adobe PageMaker, QuarkXPress, or Microsoft Publisher. They offer the ideal venue for combining the text you create in your word processor and the graphics you create with a draw or paint program into the files needed by a commercial printer.

The primary difference between a DTP program and a word processing program is the ease and precision with which text can be formatted, graphics can be imported and manipulated, color can be applied and edited, and output can be controlled. If you are going to produce your own print materials, a desktop publishing program is a wise investment.

6.2 *Choose a drawing program.* There are two basic categories of computer graphics—"draw," for creating line art, and "paint," for creating photograph-like images. Draw graphics, also referred to as "vector" or "object-oriented," are created using objects such as lines, ovals, rectangles, and curves. The primary advantage of a draw file is that it is smaller than a paint file and can be sized very large or very small at the maximum quality the printer is able to produce.

A few of the most popular programs for creating and editing draw graphics are Adobe Illustrator, Macromedia FreeHand, and CorelDRAW. The most common draw file formats are Encapsulated PostScript (EPS) files and Windows Metafiles (WMF).

6.3 *Choose a paint program.* Paint images, also referred to as "raster" or "bit-mapped," are divided into a grid of tens of thousands of tiny rectangles called pixels. Each pixel can be a different color or shade of gray. The primary advantage of a paint file is that it can represent a much more complex range of colors and shades than a draw file. The downside is

the larger you plan to print the image, the larger the file size.

Two of the most popular programs for creating and editing paint graphics are Adobe Photoshop and Jasc Software's Paint Shop Pro. The most common paint file formats are Joint Photographic Experts Group (JPEG or JPG) and Tagged-Image File Format (TIFF or TIF).

6.4 *Choose a standard.* The design world speaks primarily in PostScript, a language that allows your software to talk to output devices such as desktop printers. Almost all commercial printers require that the files you send them are PostScript compatible—meaning they include the information necessary to be translated to the printers' software and ultimately their presses. Many of the best fonts and clip art collections are only available in PostScript format.

If you plan to create your own print materials, buy programs that produce PostScript output and a PostScript-compatible printer or add PostScript hardware/software to the printer you already own (check with your printer's manufacturer for details).

6.5 *Choose a computer system.* It is said that you should choose software before you choose hardware. Nowhere is this more true than when you are working with graphics. Though Apple's Macintosh line has long been the platform of choice for the professional design community, PCs are gaining acceptance. All the programs mentioned are available in both Mac and Windows versions, and the program features and keystrokes are almost identical.

Perhaps the best gauge of the system you'll need is the software manufacturer's recommended hardware requirements. From the programs you plan to use, take the one that requires the most memory and CPU horsepower, and base your purchase on those recommendations.

Step 6: Tools Checklist

6.1 Choose a desktop publishing program

6.2 Choose a drawing program

6.3 Choose a paint program

6.4 Choose a standard

6.5 Choose a computer system

STEP 7

Design a Logo

Though it often looks as if the designer conceived and produced a logo just as you see it, that rarely happens. Design is an evolutionary process. One idea leads to another; one image sparks an idea for the next. Solutions are found in the mixing of image and typographic elements—sizing, shaping, adjusting the proximity of one object to another, and so on. If you come up with an initial idea that you like, push it to the next level. It is that exploration that makes an ordinary design exceptional.

Starting from scratch is just one way to design a logo. On pages 26 though 37 you'll see how to design a logo using clip art, typefaces, photographs, symbols, and other design elements. But there are some preliminary rules that apply to designing just about any type of logo.

7.1 The first stage of creating a logo is to *collect the visual puzzle pieces*. These are the images that best illustrate the benefits you define. If, for example, you are designing a logo for a home

inspection company, make a list of all the images that might apply to homes and those that are associated with inspection.

Stuck for ideas? See what others have done. Clip art collections and illustration web sites show how professional illustrators approach just about any subject you can think of. You can also visit the U. S. Patent and Trademark Office Trademark Electronic Search System (TESS) at www.uspto.gov to search for the trademarks of competitors to see how they handle the same subject.

7.2 The goal is to create a logo that visually defines the benefit of doing business with your organization. With that in mind, *merge the images from your list into unique visual ideas.* It is mingling the two that makes your logo one-of-a-kind.

Don't worry about creating fancy, finished drawings. Scribble as many different ideas as possible, visualizing your organization from as many different angles as possible. Take at least two or three hours to experiment, and don't settle for less than five strong ideas.

7.3 Now, *wait twenty-four hours, then do some weeding.* Don't peek—you need a day or two to regain a fresh perspective. An idea that seemed right at first may seem totally misplaced. And the idea that was an afterthought might be worth pursuing. Eliminate ideas that others are using, are dated, or are clichéd. You may also want to ask for the opinion of one or two others involved in the process.

7.4 If you need another brainstorming session, have at it. If you've got some strong possibilities, choose the two or three strongest ideas and *produce preliminary artwork using one of the techniques* described on pages 26 though 37. The objective is to produce artwork that is close to finished-looking, but it is not necessary to make it technically perfect.

7.5 Next, *add the organization's name.* Typefaces have personalities— some are quiet and reserved; others stand out in a crowd. Adding a typeface to a logo pulls it in the direction of that personality. When you're done, take another break and return after twenty-four hours with a clear perspective.

7.6 The next stage is to *test the effectiveness of the design.* Show your ideas to colleagues and at least two or three people who know little or nothing about your business. Get their reactions and gauge how effective your efforts have been. Don't make the mistake of showing weak ideas along with those you consider strong. It is not out of the realm of possibility for a decision-maker to choose a weak design that you will then have to talk them out of.

7.7 Now, *choose and finalize the design.* Weigh the pros and cons of each design, consider the feedback you've gathered, consult your decision-makers, and select the winning design. As with the name you chose, you'll have to determine if your idea can be trademarked. Produce the finished artwork.

7.8 Finally, *create usage guidelines,* a simple document that describes how and where the logo may be used. It is for use by your own organization and for anyone outside the organization that might have occasion to reproduce your logo. Large organizations go so far as to layout every conceivable way the logo might be used and to dictate every detail. Depending on how widely your logo will be used, and even if it is nothing more than a reminder for yourself, the guidelines might include:

Color values
Minimum sizes
Permission for use
Resolution restrictions
Legal notice
Typefaces used

Step 2: LOGO DESIGN CHECKLIST

☐	**7.1**	Collect the visual puzzle pieces
☐	**7.2**	Merge the images into unique visual ideas
☐	**7.3**	Wait twenty-four hours, then do some weeding
☐	**7.4**	Produce preliminary artwork using one of the techniques
☐	**7.5**	Add the organization's name
☐	**7.6**	Test the effectiveness of the design
☐	**7.7**	Choose and finalize the design
☐	**7.8**	Create usage guidelines

STEP 8

Choose a Technique
Custom Logos

There are many ways to design a logo. Since this book speaks in large part to non-designers, it focuses on techniques that begin with a preexisting image: clip art, type, photographs, or silhouettes. If, however, you have some basic drawing skills or the patience to learn, designing a logo from scratch does allow you the most creative freedom.

No matter which technique you decide to pursue, it's important to understand the value of draw and paint software programs (see *Choose Your Tools,* page 22). They are logo laboratories—the ideal places to conduct visual experiments. With them, you can apply effects that make even the simplest of images interesting. Shown here, in column one, are some of the many effects possible with most draw programs. In a paint program, you can apply photographic effects such as those in column two.

Draw—Stretch

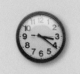
Paint—Shadow

Draw—Reflect

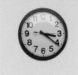
Paint—Colorize

Draw—Skew

Paint—Pastel Filter

Draw—Rotate

Paint—Tranparency

Draw—Distort

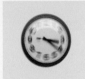
Paint—Radial Blur

Draw—Twirl Filter

Paint—Wave Distort

? What you need
Breaking apart draw artwork and editing the pieces requires a draw program such as Adobe Illustrator, CorelDRAW, or Macromedia FreeHand. Editing and adding effects to photographic images requires a paint or digital imaging program such as Adobe Photoshop or Jasc Software's Paint Shop Pro.

Once you've developed a sound, basic idea, open the appropriate software program and start experimenting. Be sure it is an idea worth pursuing—it can take hours to find the right combination of effects to make your design one-of-a-kind.

The illustration demonstrates just a few of the stages of one idea from the most basic idea (top left) to the finished design (bottom right). In reality, it is quite common to create many variations in order to find the one that works.

Start with a sound idea.

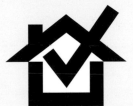

Refine the basic shapes.

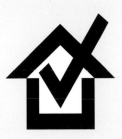

Create a bold variation.

The shapes are thinned down slightly.

Would a chimney make the image more recognizable?

The height of the logo is stretched slightly.

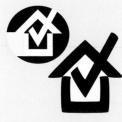

Other variations are tried.

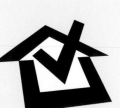

The image is distorted to give it perspective.

Text and color are added.

STEP 8

Choose a Technique
Clip Art Logos

Clip art has overcome its inferiority complex. It was once considered junk art—little decorations pasted on advertisements. Today, talented professionals produce reams of eye-catching, thought-provoking images that are every bit a powerful as those commissioned from illustrators by clients for ten times the cost.

If you can get beyond one significant barrier, a clip art illustration can make a great logo. That barrier is protection—it is doubtful whether even a drastically altered clip art image can be trademarked. Though that certainly prevents a large organization from creating a clip art logo, it does not necessarily preclude a small one from doing so. A local plumbing-and-heating contractor, a small accounting firm, and a citywide real-estate operation probably don't need a trademarked logo.

Use the illustration as is
Sometimes the illustration already says what you want it to say. In this case, creating a logo is a matter of cropping the bold border and integrating the name. A second square with a simple row of triangles is added and colors pulled from the illustration are applied.

Combine two or more illustrations
Another way to arrive at a unique solution is to combine two images that are drawn in a similar style. In this case, two literal images—binoculars to represent the search, and pyramids to represent the destination—are combined on a rectangular shape and a complement of type. The whole is greater than the sum of its parts.

Use a piece of an illustration
Still another way to use clip art is to pull a small piece from a larger illustration. Since simplicity is often the goal of a logo, isolating a piece of a complex image is a good solution. Though many logos rely on subtle meanings, there's nothing wrong with being literal. Here, using an ornate chair to represent an antiques seller is an obvious—but effective—solution.

What you need
Breaking apart draw artwork and editing the pieces requires a draw program such as Adobe Illustrator, CorelDRAW, or Macromedia FreeHand.

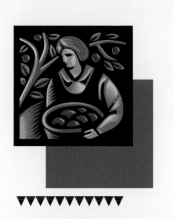 =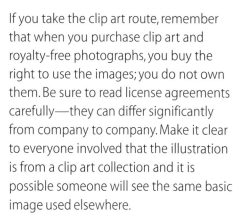

 =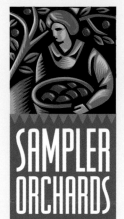

If you take the clip art route, remember that when you purchase clip art and royalty-free photographs, you buy the right to use the images; you do not own them. Be sure to read license agreements carefully—they can differ significantly from company to company. Make it clear to everyone involved that the illustration is from a clip art collection and it is possible someone will see the same basic image used elsewhere.

These logos were all created from off-the-shelf clip art collections. Creating your version is a process of experimentation—deciding on an idea, finding the right illustrations, and choosing a compatible type style.

STEP 8

Choose a Technique
All-Type Logos

A typeface is like a language—some have a slight accent in a familiar tongue; others coin a dialect all their own.

Type is the designer's secret weapon. Your organization's name set in one or two carefully chosen typefaces is a fast, easy solution to creating a professional-looking logo. It does not, of course, show what your organization does, but if you choose the typefaces carefully, the finished logo provides a distinct personality.

Use the typeface as is
Sometimes a typeface is so well designed that you are better using it as is, without any modifications. What makes it work as a logo is the addition of a second, complementary typeface—typically a complex or bold face for the main expression, "Sampler River," and a simpler face for the supportive expression, "INN."

Fit the words together
Another simple technique is to set all the words in one or two typefaces and size each word to reflect its importance. The words are then fitted together like puzzle pieces. Making one word capitals and lowercase and another all caps adds a second level of emphasis and visual interest.

Use contrast
You can also use the differences between faces to create an interesting, all-type logo. Try using the contrast between intricate and simple, bold and light, condensed and extended, serif and sans serif, and so on. (Serif letters have "feet," sans serif do not. See page 39 for examples.)

What you need
Draw programs such as Adobe Illustrator, CorelDRAW, and Macromedia FreeHand allow you to covert type to line art. They provide powerful tools for fine-tuning size, adjusting alignment, adding color, distorting shapes, and so on.

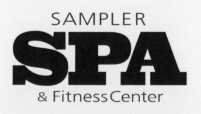

SOURCES Typefaces: "River" Bickham Script, "INN" Copperplate Gothic 33BC, "Forge" Franklin Gothic Heavy, "SAMPLER...Fitness" Frutiger Light, Adobe Systems, Inc., 800-682-3623, www.adobe.com/type; "SPA" Giza-SevenSeven, Font Bureau, 617-423-8770, www.fontbureau.com.

It is critically important to pay close attention to the spacing between words and individual letters. Though most computer fonts compensate for the spacing (kerning) between letters, some do not do it well. For example, at the top (left) is the word "alignment" as it was typed. Below it is a version that shows the same word after the spacing has been tightened. You can see where to add and subtract space by squinting at the letters and by equalizing the space between the shapes.

As with people, personality is in the eye of the beholder. To the right are a few faces and one opinion of the qualities they represent.

Airy typeface — Raleigh Gothic

Bookish typeface — Century Expanded

Brash typeface — Impact

Clean typeface — Myriad Multiple Master 830BL 700SE

Delicate typeface — Bodega Sans Light

Dynamic typefac — Frutiger 95 Ultra Black

Elegant typeface — Bickham Script

Funny typef — Postino

Graceful typeface — Racer

Historical typeface — Caslon

Technical typeface — Cachet Bold

Thunderous typ — Giza Seven-Seven

TRADITIONAL TYPEF — Charlemagne

Whimsical typeface — Galahad

SOURCES Typefaces: Raleigh Gothic, Bodega Sans Light, Cachet Bold, Charlemagne, Galahad, AGFA/Monotype, 888-988-2432, 978-658-0200, www.agfamonotype.com; Century Expanded, Impact, Myriad Multiple Master 830BL 700SE, Frutiger 95 Ultra Black, Bickham Script, Postino, Racer, Caslon, Adobe Systems, Inc., 800-682-3623, www.adobe.com/type; Giza-SevenSeven, Font Bureau, 617-423-8770, www.fontbureau.com.

31

STEP 8

Choose a Technique
Photo Logos

Photographs are convincing. We are so accustomed to seeing realistic images in the context of everyday life that when you combine a photo with your organization's name, it is sometimes more believable and compelling than stylized artwork.

Photographic logos have another thing going for them—they are uncommon. And when you do something unexpected, you attract interest and attention.

Use the photograph as is
Some photographs say what needs to be said without embellishment. It could be the photograph itself or a combination of the photograph and the text that makes the point.

Combine two or more images
Merging two or more photographs or a photograph and a drawing allows you to redirect the idea. Removing the arrow and adding a lightbulb changes this photograph of a road sign into a metaphor for a bright idea.

Use a custom photograph
A photograph of your specific product or service is, perhaps, the most effective way to create a photographic logo. Visualize the result of working with your organization and reduce it to a simple expression.

Color not required
A simple photographic logo can be just as effective in black and white.

? What you need
Breaking apart draw artwork and editing the pieces requires a draw program such as Adobe Illustrator, CorelDRAW, or Macromedia FreeHand. Editing and adding effects to photographic images requires a paint or digital imaging program such as Adobe Photoshop or Jasc Software's Paint Shop Pro.

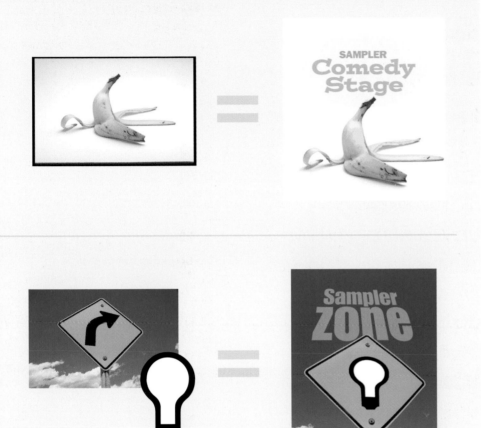

Using an off-the-shelf photograph presents the same problem as using clip art—it typically cannot be trademarked. That's because when you purchase royalty-free photographs or clip art, you buy the right to use the images; you do not own them. Be sure to read license agreements carefully—they can differ significantly from company to company.

Unlike clip art, though, there is a realistic alternative that allows you to protect your logo—you can shoot the photograph yourself or commission a professional photographer to shoot one for you.

In the end, you'll have to decide if a photographic logo is a good alternative. If, for example, you will regularly use your logo at very small sizes, a photographic logo might be impractical.

STEP 8

Choose a Technique
Symbol Logos

Symbols, signs, and icons—we've been using them for all of recorded history. Well-conceived visual images transmit information quickly and effectively.

To be accurate, the images shown here are icons—images that suggest their meaning. A symbol is defined as a visible image of something that is invisible—for example, an hourglass represents the idea of time. A sign is a shorthand device that stands for something else, such as the @ sign, which stands for "at."

SOURCE Illustrations: Deer, rider, from Petroglyph font by Judith Sutcliffe.

Add a symbol to the name
A symbol can be subtle. In this case, a leaf is added as if it were growing from a letter in the name, suggesting a connection with nature.

Combine two or more symbols
Mixing images results in new meanings. When a sun is combined with a snowflake, the result is hot and cold—in this case to represent heating and air-conditioning.

Use a picture font
There are many sources for symbols, signs, and icons, but one of the best is a picture font. You install a picture font like any other typeface, but when you type, instead of a character for each keystroke, you type pictures.

a b c d e

? What you need
Breaking apart draw artwork and editing the pieces requires a draw program such as Adobe Illustrator, CorelDRAW, or Macromedia FreeHand.

34

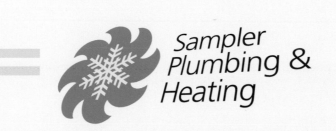

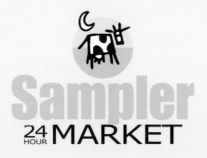

Where do you find simple, symbolic images? In addition to the obvious places—in clip art collections, picture fonts, and print resources—you will find many suitable images as part of larger illustrations.

When illustrators reduce an idea to clip art form, they often dramatically simplify small elements. Those pictures-within-pictures, blown up and refined, can often be used as is or as a catalyst for a new idea.

Can you trademark a symbol such as those shown here? Possibly. Be sure to read license agreements of the clip art and graphics you are using. Usage can differ significantly from company to company. In some cases, using a small portion of an image or drastically changing it may allow you to trademark your logo.

SOURCES Illustrations: Leaf, sun, snowflake from *Design Elements* by Ultimate Symbol, 800-611-4761, 914-942-0003, www.ultimatesymbol.com, © Ultimate Symbol, all rights reserved; cow from Good Dog Bones font by Fonthead Design, 302-479-7922, www.fonthead.com; Typefaces: "GROVE" Racer, "Plumbing" Myriad Regular, "Sampler" (bottom) Impact, Adobe Systems, Inc., 800-682-3623, www.adobe.com/type.

STEP 8

Choose a Technique
Silhouette Logos, Engraving Logos, and Beyond

The techniques described on the previous pages are a few of the most straightforward ways to design a logo. They are, by no means, the only possibilities. At the right are three more techniques: using a silhouette, an antique illustration, and the outline of an image.

By now, you see that design is not a process in which you begin with a clear idea of the end result in mind. It is, instead, a process of building on an idea and pursuing it until you find what you're looking for, or until you find another direction to go in. In some cases, one idea leads to the next, and you may find yourself abandoning one idea altogether and taking an entirely different course.

Use a silhouette

A silhouette illustration shows the shape of the subject minus the detail. That simplicity makes silhouettes particularly good for designing logos.

Use an antique illustration

Woodcuts and engravings culled from old books and magazines can be found in compilations published for the purpose of reusing them. Publishers such as Dover Publications offer compilations with varied constraints on use of the artwork.

Use shapes and outlines

Still another way to make something unique out of something common is to reduce it to simple shapes and outlines.

What you need

Editing drawings such as the skier and the microphone requires a draw program such as Adobe Illustrator, CorelDRAW, or Macromedia FreeHand. Editing and adding effects to photographic images requires a paint or digital imaging program such as Adobe Photoshop or Jasc Software's Paint Shop Pro.

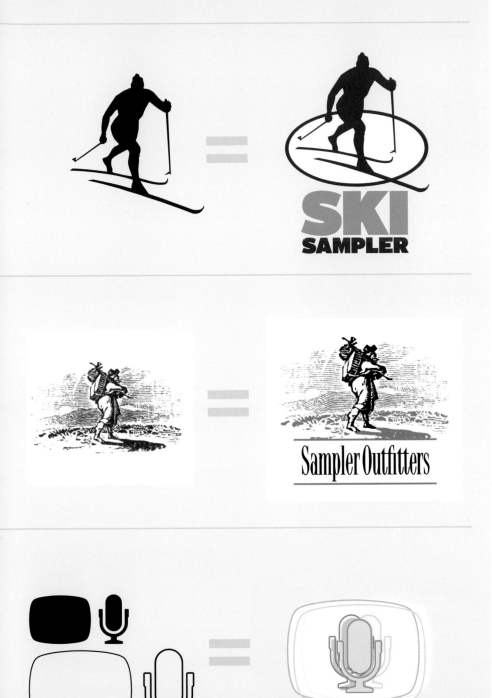

No matter what technique you choose, these five design fundamentals apply:

First, *get beyond the first idea*. It's oh-so-tempting to think you have the solution on the first or second try. Don't fool yourself. It typically takes lots of thinking to develop a unique idea, and lots of visualizing to discover a compelling logo. Once convinced you're finished, try another approach, change a typeface, choose a different color, or adjust the relative size of one element to another.

Second, *use a delicate hand*. New designers tend to make text and graphics too big and/or too bold.

Third, *take a real-world view of work in progress*. Print out ideas and see what they look like on paper. Physical size and the computer monitor can dramatically affect the look and feel of the final piece.

Fourth, *heed opinions*. When should you abandon what you think is a good solution? When twenty percent of the people you show the name, logo, and defining phrase dislike it. When anyone has a rational reason to dislike it intensely. Or when a respected judge thinks it is unprofessional.

When it comes to aesthetic judgments, it doesn't matter whether your audience is wrong or right. Their opinions represent the tastes of others, and it rarely makes sense to adopt a stance that precipitates a battle.

Fifth, once you have what you think is a final design, *remove yourself from the process for at least twenty four hours* to see the design from a new perspective. A fresh review often results in the refinements that yield the kind of logo that seems as if it were the obvious solution all along.

SOURCES Illustrations: Skier from *Simple Silhouettes*, microphone, video screen, from *Objects & Icons* by Image Club Clip Art, 800-661-9410, 403-294-3195, www.eyewire.com, © Image Club Graphics, all rights reserved; hiker from *1800 Woodcuts by Thomas Bewick and His School* from Dover Publications, Inc., www.doverpublications.com.

Typefaces: "SKI" Interstate UltraBlack, Font Bureau, 617-423-8770, www.fontbureau.com; "Outfitters" Latino Elongated, ITC 866-823-5828, www.itcfonts.com; "Media" Fruitiger 45 Light, Adobe Systems, Inc., 800-682-3623, www.adobe.com/type.

STEP 9

Lay Out a Letterhead

Your letterhead is ground zero. The layout, typefaces, and colors you establish here dictate the design of all the pieces that follow—from your business cards and envelopes to your Web site and brochure.

Why the letterhead? Because it is typically used to present the most important one-on-one personal communications—introductions, proposals, requests, personal messages, and such—the written greetings and meetings that require you to look your best.

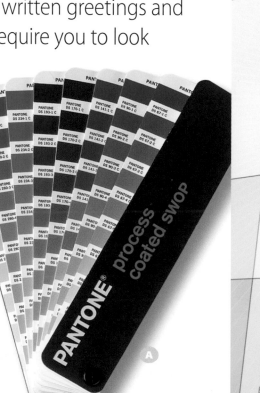

Designers and printers use PANTONE® formula guides to specify ink colors. This guide is for specifying process colors, there are others for specifying solid colors.

SOURCE
PANTONE formula guides, www.pantone.com;
© Pantone, Inc., all rights reserved.

The Sampler Group

A one-sentence "hook" benefit that describes your product or service

The Sampler Group
123 Example Boulevard, Suite 210
Your City, ST 12345 6789

987 654 3210
800 987 6543
987 654 3210 Fax
www.yourwebaddressz.com
E-mail info@youremailaddressz.com

Serif Typefaces **B**

Lorem ipsum dolor sit amet, consectetuer adipiscing elit, sed diam nonummy nibh euismod tincidunt ut laoreet dolore magna aliquam erat volutpat. Ut wisi enim ad minim veniam, quis nostrud exerci tation ullamcorper suscipit.
Caslon Regular

Lorem ipsum dolor sit amet, consectetuer adipiscing elit, sed diam nonummy nibh euismod tincidunt ut laoreet dolore magna aliquam erat volutpat. Ut wisi enim ad minim veniam, quis nostrud exerci tation.
Century Expanded

Lorem ipsum dolor sit amet, consectetuer adipiscing elit, sed diam nonummy nibh euismod tincidunt ut laoreet dolore magna aliquam erat volutpat. Ut wisi enim ad minim veniam, quis nostrud exerci tation ullamcorper suscipit lobortis nisl ut aliquip ex ea commodo consequat. Lorem
Garamond Light Condensed

Lorem Lorem ipsum dolor sit amet, consectetuer adipiscing elit, sed diam nonummy nibh euismod tincidunt ut laoreet dolore magna aliquam erat volutpat. Ut wisi enim ad minim veniam, quis nostrud exerci tation ullamcorper suscipit.
Minion Regular

Sans Serif Typefaces

Lorem ipsum dolor sit amet, consectetuer adipiscing elit, sed diam nonummy nibh euismod tincidunt ut laoreet dolore magna aliquam erat volutpat. Ut wisi enim ad minim veniam, quis nostrud exerci tation ullamcorper.
Formata Light

Lorem ipsum dolor sit amet, consectetuer adipiscing elit, sed diam nonummy nibh euismod tincidunt ut laoreet dolore magna aliquam erat volutpat. Ut wisi enim ad minim veniam, quis nostrud exerci tation ullamcorper suscipit lobortis nisl ut aliquip ex ea.
Franklin Gothic Book Condensed

Lorem ipsum dolor sit amet, consectetuer adipiscing elit, sed diam nonummy nibh euismod tincidunt ut laoreet dolore magna aliquam erat volutpat. Ut wisi enim ad minim veniam, quis nostrud exerci tation.
Helvetica Regular

Lorem ipsum dolor sit amet, consectetuer adipiscing elit, sed diam nonummy nibh euismod tincidunt ut laoreet dolore magna aliquam erat volutpat. Ut wisi enim ad minim veniam, quis nostrud exerci tation ullamcorper.
Myriad Regular

SOURCES Type families: Caslon Regular, Century Expanded, Garamond Light, Condensed, Minion Regular, Formata Light, Helvetica Regular, Myriad Regular, Adobe Systems, Inc., 800-682-3623, www.adobe.com/type; Franklin Gothic Book Condensed, ITC, 866-823-5828, www.itcfonts.com.

9.1 Before you layout your letterhead, you must first *define the elements* you plan to include on it. Beyond the name of the organization, the symbol, and the defining phrase, consider including:

- Department/division name
- Street address
- Floor/suite/mail stop
- Alternate P.O. box address
- Zip+4/postal code
- Country
- Voice phone/extension number
- Toll-free phone number
- Fax number
- E-mail address
- Web site address
- Office hours
- Time zone
- Pronunciation of unusual names

9.2 Next, *choose a typeface* for the letterhead text (fig. B), one that complements the typeface you chose for your logo. If you use a serif face for the name, it often works well to use a sans serif typeface for the text. (Serif letters have "feet," sans serif letters do not.) In either case, because it is meant to play a supporting role, choose a typeface that has a simple form and is easy to read.

9.3 With those basics defined, you're ready to *decide on the number of colors*. You first need to understand how commercial printers reproduce color. There are two ways to arrive at matching a specific color. You can choose a specific ink color that matches it, called a solid PANTONE® Color or you can combine four standard colors to match it as closely as possible, referred to as process colors.

There are over one thousand Solid PANTONE Colors. If, for example, you want bright orange, you would choose a color from a PANTONE formula guide (fig. A), a tool designed for just that purpose. You choose the exact color you want, provide the printer with the corresponding PANTONE Number, and they buy a

container of that ink and print your job using it.

The alternative method is to print the job using the four-color process. The process colors are cyan, magenta, yellow, and black (CMYK). This combination of colors can be screened to represent just about any color value across the spectrum. This method is best for printing color photographs and any other material that contains a range of colors that cannot be reproduced using two or three solid colors.

The limitation the four-color process is that it cannot reproduce some colors as vividly, and is typically more expensive than the solid color method.

The least expensive route is to print black or a single solid color on white or colored stock (in printer's language, black is a color). If you're willing to spend a little more, you can print with two colors, typically black and one solid color. The general rule is the more colors you print, the more complex the printing press needed to print them, and the more your job will cost. The four-color process, generally speaking, is the most expensive.

For a comprehensive look at the printing process, get a copy of the *Pocket Pal Graphic Arts Production Handbook* by International Paper from Signet Inc., 800-654-3889, 901-387-5560, www.pocketpalstore.com.

9.4 You should also *incorporate your preliminary paper choices in your design*. There is a complete discussion of paper beginning on page 48.

9.5 Now that you have all the puzzle pieces—the information and the typefaces, and you have determined your color strategy—you're ready to *experiment with the layout*.

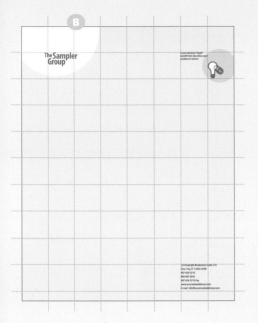

9.1	Define the elements
9.2	Choose a typeface
9.3	Decide on the number of colors
9.4	Incorporate paper in the design
9.5	Experiment with the layout
9.6	Build a grid
9.7	Test the design
9.8	Refine the proportions

Take the elements and begin to move them around on the page. It's not necessary to create finished designs. Just shuffle the pieces to see what the possibilities are.

Once you have some potential solutions, print the pages out to see how well the designs work on paper. Designing on a computer screen can be deceiving. Type that looks just right on the screen is often too big at actual size. Printing your design early on keeps you from wasting time refining a design that still needs work.

9.6 Once you know the basic layout, you should *build a grid* (fig. B) that will help you determine the final placement of the elements. A grid is a fundamental part of any layout that is often overlooked by non-designers. A grid is a series of invisible lines that keeps all the elements on the page lined up. The grid shown is nothing more than a series of columns. Desktop publishing, draw, and paint programs all have "guides" designed to be used for just this purpose.

9.7 Before you finalize it, be sure to *test the design*. Prove its practicality by inserting the contents of a sample letter (fig. C). What might appear to be an excellent design can turn up with real problems when you start using it in the real world. Then fold it in thirds to insure that critical graphics and text are not affected by the creases.

9.8 Finally, you should *refine the proportions* of all the elements on the page. Non-designers tend to make their designs too bold by making the images and the typefaces too large. Remember: It is the food on the plate that most interests the diner, not the plate itself. Likewise, your letterhead should enhance the experience of receiving the information—not overwhelm it.

STEP 10

Lay Out a Business Card

Don't be a formula thinker. Instead of doing things the way they have always been done, a smart designer challenges the premise of every project by asking three fundamental questions: What is its purpose? Why is it done the way it's done? And how can I do it more effectively?

10.1 The first stage of designing a business card is to *choose a format*. Adopting the conventional 3.5-by-2-inch size (fig. A) is important if you hope your prospects will save your card in a business card binder or rotary file. If you use the standard size, by all means use

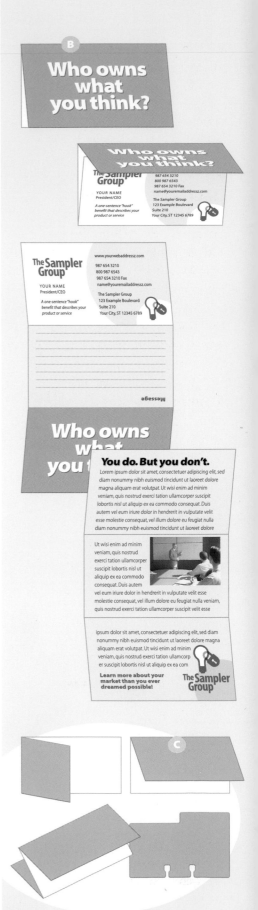

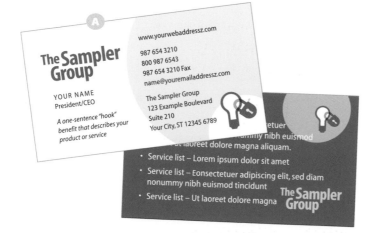

the back of the card. It is the ideal place for a more in-depth explanation of your services, a summary of your mission, or a space to jot down a message or product number.

But adopting the standard only means the finished size must be 3.5 by 2 inches. By adding panels and folds, you can create something more than a traditional calling card. The card in fig. B, for example, is a mini-brochure. In addition to a detachable business card, it includes a cover headline, a marketing message, and a photograph.

Fig. C shows some other possibilities. You might even consider something totally different such as printing your business card pre-cut to fit in a Rolodex.

10.2 Like the letterhead, the next stage of designing a business card consists of *defining the elements* you plan to include on it. Beyond the basics, consider including:

PEOPLE
Name of person
(Nickname) in parentheses
Title
Affiliations
Professional/academic designations

PLACE
Pronunciation of unusual names
Department/division name
Organization street address
Floor/suite/mail stop
Alternate P.O. box address
City/state/state abbreviation
Zip+4/postal code
Country
Home street address

COMMUNICATION
Voice phone/extension number
Toll-free phone number
Mobile phone number
Pager number
Fax phone number
Home phone number
E-mail address
Web site address

DETAILS
Office hours
Time zone
Appointment fill-in
Map/directions

ORIENTATION
Name of organization
Defining phrase
Product/service categories
Resource info
Special offer
Invitation
Illustration/photo
Logo
Organizational affiliations

10.3 The rest of the process is much like designing your letterhead. Use the same typefaces (see Step 9.2, *Choose a typeface*) with the possible addition of a typeface for headlines if the format you choose calls for them.

10.4 In most cases, you will also repeat the colors you chose for the letterhead (see Step 9.3, *Decide on the number of colors*). The exception here is when you choose a different color scheme for each piece, as shown in fig. D.

10.5 Next, repeat process of *experimenting with the layout* (Step 9.4). Move the elements around on the page, decide on a potential solution, and print the page out to see how well the design works on paper.

10.6 Even a layout as small as a business card or a business card brochure should be *built on a grid*. When all of the elements line up, the design has an ordered look that cannot be achieved any other way.

10.7 Before you finalize it, be sure to *test the design*. As you did with the letterhead, be sure critical text and graphics are not affected by folds and trimming.

10.8 Finally, you should *refine the proportions* of all the elements on the page. Be sure the type is readable. Type smaller than six points high will be unreadable by many.

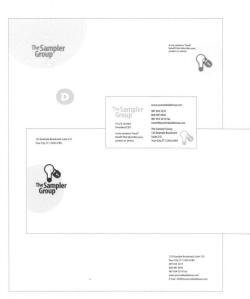

STEP 11

Lay Out an Envelope

Don't underestimate the importance of your envelope. When you send unsolicited mail, in the moments between its arrival and the time your prospect decides what to do with it, your envelope is the most important marketing weapon in your arsenal.

You could print your envelopes one by one, as you need them, from a laser or inkjet printer, but commercial printing produces a far superior product. It allows you to print on any type of paper and sends the message that you are in business to stay.

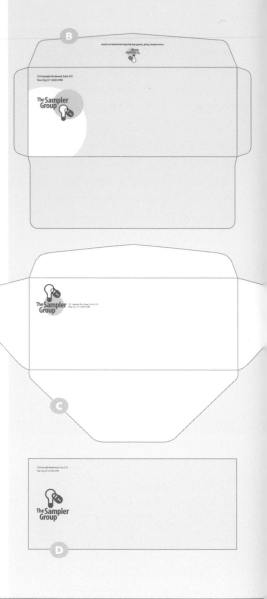

123 Example Boulevard, Suite 210
Your City, ST 12345 6789

The Sampler Group

More information
For a complete discussion of business mail regulations and downloadable resources, visit www.usps.com and select "Info," then "Business Mail 101."

11.1 When it comes to envelopes, to a great degree, postal regulations influence the *format you choose*. Though just about any envelope can be mailed, the size, shape, proportions, weight, speed of delivery, and other issues dictate how much postage is necessary. Adding an additional ten cents to the standard first-class postage of one envelope may not seem like much, but over a period of years, an unusual design can cost hundreds, possibly thousands, of dollars more than a design that meets certain guidelines.

As of this writing, the United States Post Office (USPS) says that to qualify for first-class postage, an envelope must be "at least 3 1/2 inches high by 5 inches long by 0.007 inch thick and no more than 6 1/8 inches high by 11 1/2 inches long by 1/4 inch thick." Disproportionate sizes—envelopes that are unusually short and wide or tall and narrow and more or less square pieces—may also cost more because they tend to jam postal equipment. Using a standard 4.125-by-9.5-inch (#10) commercial business envelope is the best way to insure you qualify for the best rate.

11.2 Printing envelopes is a bit more complicated than printing letterheads and business cards. In most cases, you print on envelopes that are already folded and glued in finished form (fig. A). If you design an envelope with an image that extends (bleeds) off the edge of the envelope (fig. B), the artwork must be printed on a flat sheet before it is assembled. This may make your design significantly more interesting, but it comes at a cost. Printing on a flat sheet could cost twice as much, or more, than using a finished envelope.

This side-seamed commercial envelope (fig. B) allows you to wrap your graphics around the back of the envelope more easily than does a standard version (fig. C).

If you use a finished envelope, keep the artwork a minimum of 0.25 inches from the edge.

11.3 The next stage, as with the previous pieces, is to *define the elements*. In most cases, they are limited to your logo and return address. In some cases, you might also include your defining phrase, but including more might make your everyday correspondence look like a direct mail piece, which might result in it being discarded.

11.4 For the rest of the process, you can follow the same steps used in developing your letterhead and business cards: Use the same typefaces used in Step 9.2, *Choose a typeface*.

11.5 In most cases, you will also repeat the colors you chose for the letterhead (see Step 9.3, *Decide on the number of colors*). If you have a limited budget, the alternative is to print one color on a colored envelope, as shown in fig. D.

11.6 Next, repeat the process of *experimenting with the layout* (Step 9.4). Move the elements around on the page, decide on a potential solution, and print the page to see how well the design works on paper.

11.7 Even your envelope should be *built on a grid*. Be sure each element is in line.

11.8 And, as always, be sure to *test the design*. Consider how the design will look with the addition of postage and an imprinted address or label.

11.9 Finally, *refine the proportions* of all the elements on the page. The USPS has specific recommendations on how to type the name and address of the recipient to help speed the mailing process. In part, you should use black, uppercase letters in a 10- or 12-point, sans serif typeface. Type the name and address flush left, with the city, state, and zip code on one line. Use standard, two-letter state abbreviations and omit punctuation.

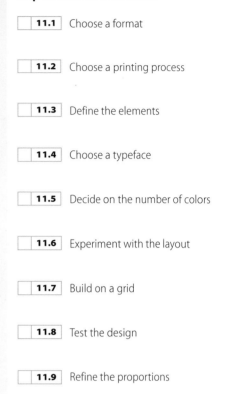

Step 11: ENVELOPE CHECKLIST

11.1 Choose a format

11.2 Choose a printing process

11.3 Define the elements

11.4 Choose a typeface

11.5 Decide on the number of colors

11.6 Experiment with the layout

11.7 Build on a grid

11.8 Test the design

11.9 Refine the proportions

STEP 12

Find a Printer

You're only as good as your printer. No matter how well you plan and execute a smart, good-looking design, you must rely on the skills of a commercial printer to translate your computer files into a finished product. Finding a printer that is well-suited to the type of job you are printing, committed to producing a quality product, and willing to produce it for a reasonable price is a critical piece of the design-it-yourself puzzle.

12.1 The first stage is to *find a printer with an offset lithographic press.* There are other methods of printing equal to the task, but offset lithography is, generally speaking, the best process for a one- to four-color job such as a letterhead, business card, or envelope. It can reproduce fine detail and big areas of color, and can print large-enough sheet sizes to allow you to extend (bleed) images and areas of color off the edges of the sheet.

SOURCE Illustration:
Photographs courtesy of
Printing Services, Inc.
Richmond, Virginia.

12.2 When you first speak to the printer's representative, *explain the scope of the job* to determine if it fits within the printer's capabilities. Some printers specialize in printing one- and two-color work and are ill-equipped to print four-color process, others aren't interested in anything but large runs of four-color, and so on. A rule of thumb is avoid being the smallest job in a big shop or vice versa.

Expect to order at least 1,000 sheets of letterhead, 500 envelopes, and 500 business cards for each name. It is possible to print less, but the difference between printing fifty and five hundred impressions is insignificant—little more than the cost of the paper.

Be aware that it is not unusual for printers without the equipment to produce your job to accept it and broker it to a third party. Ask early on if the printer will be printing your project in-house. If they are sending it out, you may get a better price by going direct.

12.3 *Verify that you and the printer are technically compatible.* Ask if the printer's prepress department supports the computer hardware and software you will use to produce the artwork, exactly how the files need to be set up, and how they charge for their services.

12.4 Assuming all of the preliminary answers are to your liking, *ask to see some samples* of similar jobs the printer has produced. Look for good printing, not good design. The creative part of printing is normally in the client's hands, so a printer is more concerned with science than art. Check for bright, clean colors; for smooth, dense solid areas; for text and images that are focused and clear; and for images that are printed on the page squarely and in the correct position.

It also helps to show the printer an example of the quality you expect and the effects you are hoping to achieve. Take advantage of the expertise of veteran salespeople and their coworkers in the press room. They can provide a wealth of information and guidance.

12.5 Find at least two printers that can handle your job and *request job estimates.* Estimates can vary widely from printer to printer. Some base them on strict estimating formulas; others adjust for how busy they are and, therefore, how eager they are to have your business. Most are willing to bargain.

The cost of printing is based on the amount of time the job ties up the press and the size of the press needed to print the job. The more complex the job, the more complex the press needed to print it. You normally get the best price on the smallest press that can handle your job.

To prepare an estimate, the printer will need some preliminary information: the form in which you will supply the artwork, the overall size of the piece, the finished/folded size, the number of colors on each surface, the preferred paper color and weight, the quantity, and how you want it finished, folded, bound, packaged and shipped.

12.6 Finally, *review the printer's contract.* Many printers include a detailed contract with their estimate. Printing is a complex combination of product and service that presents many opportunities for misunderstanding. Be certain you understand the intricacies of the legalese.

Step 12: PRINTER CHECKLIST

- [] **12.1** Find a printer with an offset lithographic press
- [] **12.2** Explain the scope of the job
- [] **12.3** Verify technical compatibility
- [] **12.4** Review samples
- [] **12.5** Get two or more job estimates
- [] **12.6** Review the printer's contract

STEP 13

Choose Paper

Paper is a fundamental element of design. In the printing world, it is referred to as "stock." The impact of a letter, in particular, can be greatly enhanced by the quality of the stock it is printed on and the look and feel of the envelope in which it is delivered.

13.1 Paper plays an important role in printing, but you should also incorporate the paper into the design process. To see what is possible, *request paper samples* from your printer or a local paper distributor. They can provide swatch books and printed samples of literally thousands of possible finishes, weights, and colors of paper available. A printer might narrow the selection to the brands that are most readily available—but insist on seeing at least five to ten different brands.

13.2 The first consideration when selecting paper is to *choose the proper grade*. Though there are many different grades available, there are only two to concern yourself with for this type of project—bond or writing papers for letterheads and envelopes, and cover papers for business cards.

13.3 The next consideration is to *choose the surface texture or finish of the paper*.

Generally speaking, letterhead, business cards, and envelopes are printed on uncoated stock, not the coated stock you typically see in magazines. Coated stock has a thin layer of clay-like substrate that creates a smooth, flat surface ideal for printing superfine detail such as photographs.

Uncoated stock ranges from rough to smooth with finishes such as "laid," a series of tiny ridges; pebbled; and smooth. Assuming the letterhead and envelopes will be printed on a laser or inkjet printer, any finish is acceptable as long as it is designated laser-compatible.

13.4 Next, *choose the weight*. Typically, letterhead is printed on 20- to 28-lb bond stock. Check the documentation of the desktop printer that will be used to print on the letterhead and envelopes to determine the minimum and maximum weights it can accommodate.

Your business card should be printed on a more substantial weight stock that can withstand a significant amount of handling—in most cases a minimum 80-lb cover stock. The bond paper you use for the letterhead and envelopes will often have a matching cover stock for just this purpose.

Be aware that paper has a grain, much like a wooden board. The printer can show you how rigidity is affected by printing with—versus against—the grain.

13.5 *The most obvious choice is color*. There is a seemingly endless rainbow of paper colors and a huge range of warm to cool whites. In some cases, the sheets are a consistent color; in other cases, a subtle, confetti-like mix of fibers provide various effects.

It is important to remember that ink color is affected by the color of paper. Yellow ink on white paper, for example, will look significantly different than yellow ink on a light shade of green.

Again, paper samples can help you envision the result of various combinations. Paper companies go to great expense creating samples that show how different inks and printing techniques affect their papers. Be sure to request samples from the printer and figure them into your preliminary design decisions.

13.6 Be sure to *consider opacity*. Opacity is the property of paper that determines the degree to which a printed image shows through from one side of a sheet to the other. If the letterhead is not opaque enough, you might see enough of the image from the opposite side for it to be distracting. Your printer representative can help you gauge the amount of show-through likely from the paper you specify.

13.7 Finally, *ask your printer for guidance*. They may discourage you from using a certain sheet for a particular job because of past experience, incompatibility with their equipment, availability, and so on. As long as they have given you a wide range of finishes, weights, and color to choose from, it is best to follow their recommendations.

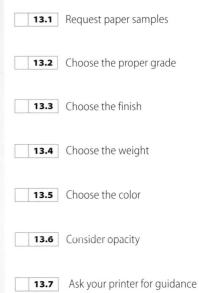

Step 13: PAPER CHECKLIST

☐ **13.1** Request paper samples

☐ **13.2** Choose the proper grade

☐ **13.3** Choose the finish

☐ **13.4** Choose the weight

☐ **13.5** Choose the color

☐ **13.6** Consider opacity

☐ **13.7** Ask your printer for guidance

Some popular paper brands

Fox River Paper Company: www.foxriverpaper.com
Fraser Papers: www.fraserpapers.com
French Paper Co.: www.mrfrench.com
Gilbert Paper: www.gilbertpaper.com
International Paper: www.internationalpaper.com
Mead Paper: www.meadpaper.com
Mohawk Paper: www.mohawkpaper.com

STEP 14

Prepare for the Press

One of the most critical parts of printing does not involve a press at all—the prepress process.

Prepress is a general term used to describe the steps taken to prepare your project for printing. The printer takes the files you created along with the fonts and any images you linked to them and translates them to a form the shop's hardware and software understands. Among other things, prepress processes determine how to position each piece on the sheet, incorporate a slight overlap, or "trap," between colors that touch, and separate the colors for making individual plates.

You play an important part in the prepress process.

14.1 First and foremost, you should *finalize and proofread the content*. Triple-check spelling and grammar, and determine that all the information necessary is included and correct. Then have someone else check it. You might be surprised how often a printer's clients leave issues unresolved in the rush to keep a job in progress. Changes once your job is in the printer's hands can be very costly.

14.2 Next, *preflight your files*. "Preflighting" is the process of gathering together and reviewing all the elements necessary for the printer to translate what you create on your computer to their computer system—in most cases, printers use something other than conventional, off-the-shelf software. Most printers can provide you with a preflight checklist such as the one shown in fig. A.

Some desktop publishing programs have a preflight feature that aids in the process. At minimum, the printer will require the names and descriptions of the document files and any other image files linked to them, the name and version number of the software program used to produce them, and copies of the fonts used (check your font license agreement for restrictions).

14.3 Before you hand over your files, be sure you and the printer *agree about who is responsible for what*. You, of course, are responsible for the content of your job, but you should also understand, for example, who is responsible for settings as obscure as the screen frequency or negative orientation.

14.4 And lastly, be sure to *see and sign off on a proof* of your job before it is printed. A proof is a printout that should, as closely as possible, show the final result.

There are many different types of proofs. Some printers still provide a blueline (named for its monochrome blue color) made by exposing a film negative on a sheet of light-sensitive paper. It shows a highly accurate representation of what to expect from the printing process minus actual color. If you specify more than one or two colors, a color proof is sometimes required to approximate the colors you should expect. Today, though, in an ever-changing print marketplace, new and more accurate ways of proofing are available. Your printing representative can show you an example of the system they use.

In any case, your responsibility is the same—to recheck the proof thoroughly. Once you sign off on it, responsibility for everything shown on the proof is yours—even if it is the printer's mistake. Something as simple as a line break that eliminates or obscures an important phone number can undermine an entire project.

Use a red pen or pencil to circle errors and make notes. Are pages printed at the right size? Are the photographs, artwork, and text in the right places? Are the images and text clear and focused? Are the typefaces correct? Did special characters such as fractions and copyright marks translate correctly? Circle scratches, dust, and broken characters. And if there are significant changes, request a second proof.

Step 14: PREPRESS CHECKLIST

14.1 Finalize and proofread the content

14.2 Preflight your files

14.3 Determine who is responsible for what

14.4 Review and sign off on a proof

STEP 15

Print and Proof It

Good printing is the absence of mistakes. The printer's proof you saw in the prepress process should have given you a good idea what your finished job would look like. So your final responsibility is to see that the results are a fair representation of what you approved.

There are two stages at which to intercept problems—during the printing process and after it is complete.

Many printers are receptive to, and in fact encourage, clients to *check their jobs at the beginning of the press run.* This is especially true if there is some part of the process that requires an aesthetic judgment—if you are using process colors, the press operator can often fine-tune the result by increasing or decreasing the intensity of individual colors. But remember, press time is expensive. If you choose to approve your job on press, be prepared to give clear directions and to make quick decisions. Check with your printing representative to see what their policy is and requirements are for press checks.

Coverage
Watch for inconsistent ink coverage—too little or too much.

Mottle
Check solid areas for mottle—uneven, spotty areas of ink.

Registration and trapping
All colors and shapes should be aligned, or registered, with great precision; and the nearly imperceptible overlap between colors, the trap, should be very precise.

Pinholes and hickies
A pinhole is the result of a hole in the printing plate negative. Erratically shaped hickies are caused by dirt or paper particles that adhere to the plate or rollers during printing.

Skew
A crooked or skewed image could be the result of a misaligned plate or careless trimming.

Trimming
Some of the most common problems occur after the job is printed. A page trimmed even slightly out of alignment can be drastically different.

Ghosting
A doubled or blurred image, termed "ghosting," is typically caused by a misapplication of ink on the rollers.

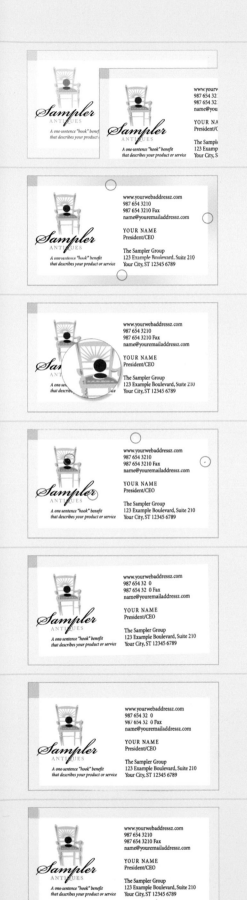

15.1 Whether you are looking at a job in progress or one that is complete, the figures show a few of the most obvious problems to look for. Though a small portion of just about every job will be spoiled by one or more of them, attentive press workers should spot and discard problem sheets. And, though quality varies from printer to printer, most would agree that problems this extreme are not considered deliverable.

Check your job in progress and, afterward, question anything that is distinctly different than the proof you approved.

15.2 Repeat the process by *rechecking your job when it is delivered*. Look at a representative sample of pieces from the beginning, middle, and end of the run. If the middle third of the job is spoiled, you don't want to discover it six months after the job is delivered.

15.3 Next, *do a rough count* to determine if your got the quantity of pieces you paid for. Count a stack of one hundred pieces, measure the height of the stack, and roughly calculate if you are within ten percent of the quantity you ordered. Most printers consider ten percent over or under the amount you requested as acceptable. Therefore, if you need exactly 500 envelopes, be sure to tell the printer beforehand that anything less is unacceptable. Some printers expect you to pay extra for overruns unless you agree otherwise in advance.

15.4 Finally, *negotiate an adjustment for printing problems*. If there are minor problems with your job, something even a meticulous reader would normally miss, you can request a reprint or ask for an adjustment of the price. If it is the printer's mistake, most are amenable to either option. If there are significant, obvious problems with your job, insist on a reprint. Though some readers might not notice a problem, it may cause others to judge your organization negatively.

Step 15: **PRINTING CHECKLIST**

15.1 Check your job in progress

15.2 Recheck your job after it is delivered

15.3 Do a rough count

15.4 Negotiate an adjustment for printing problems

This layout requires three colors and, therefore, three printing plates: one for black, one for red, and one for orange.

Design it Yourself

PART 2
Design Recipes

PART 2: DESIGN RECIPES

How to Use the Recipes

Now it's time to put the step-by-step process to work. The pages that follow present a cookbook of style recipes for a wide variety of letterhead, business card, and envelope designs.

The first two pages of each recipe show the development of a logo and the overall style of the letterhead, business card, and envelope. The third and fourth pages provide a detailed recipe and list of ingredients of the designs.

Don't limit your thinking to using a logo idea only with the style it is paired with. Some logos will work just as well with several other styles.

Above all, remember this: These designs were created specifically for the Design-it-Yourself series—you are free to copy any recipe in whole or in part to produce your own materials. The only restriction is that you cannot trademark the copied design.

A: Definition
The recipe begins with an explanation of the thinking behind its particular style.

B: The logo
The large version of the logo reveals the details you might miss at a smaller size.

C: Source links
The caption next to the logo lists the source of illustrations; the caption to the right, the source of the type families.

D: Software recommendations
This caption lists the type of software required to create the artwork.

E: Step-by-step design
From top to bottom, these are the primary steps of executing the style.

F: The result
To demonstrate the end result, here is the suite of letterhead, business card, and envelope.

G: Letterhead recipe
This is the recipe for creating the letterhead. The rulers show measurements in inches, and the light gray guides pinpoint the position of the primary elements.

H: Business card recipe
This is a recipe for the front and back of the business card. Color that extends outside the bold gray outline means the color bleeds off the edge of the page.

I: Envelope recipe
This is the envelope recipe, in most cases, for a standard 4.125-by-9.5-inch (#10) commercial business envelope.

J: The color palette
All the projects are created using either four-color process or Solid PANTONE Colors (see Step 9.3). The palette identifies compostion of CMYK mixes or the PANTONE Number and tint values of the solid colors.

K: The ingredients
The type used in each recipe is keyed, by number, to this list of ingredients—it includes the name of the typeface, the point size, line spacing (when there is more than one line of the same typeface), alignment, and the point size of lines.

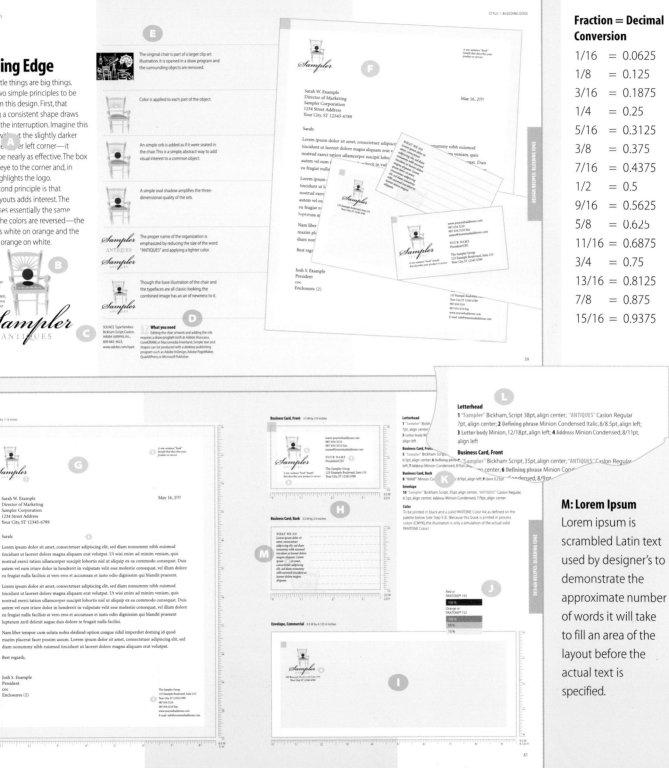

STYLE 1

Bleeding Edge

In design, little things are big things. There are two simple principles to be learned from this design. First, that interrupting a consistent shape draws your eye to the interruption. Imagine this letterhead without the slightly darker square in the lower left corner—it would not be nearly as effective. The box draws your eye to the corner and, in doing so, highlights the logo.

The second principle is that reversing layouts adds interest. The envelope uses essentially the same layout but the colors are reversed—the letterhead is white on orange and the envelope is orange on white.

SOURCES Illustrations Chair from *Designer's Club* from Dynamic Graphics 800-255-8800, 309-688-8800, www.dgusa.com © Dynamic Graphics, all rights reserved.

SOURCE Type families: Bickham Script, Caslon, Adobe Systems, Inc., 800-682-3623, www.adobe.com/type.

The original chair is part of a larger clip art illustration. It is opened in a draw program and the surrounding objects are removed.

Color is applied to each part of the object.

An simple orb is added as if it were seated in the chair. This is a simple, abstract way to add visual interest to a common object.

A simple oval shadow amplifies the three-dimensional quality of the orb.

The proper name of the organization is emphasized by reducing the size of the word "ANTIQUES" and applying a lighter color.

Though the base illustration of the chair and the typefaces are all classic-looking, the combined image has an air of newness to it.

What you need
Editing the chair artwork and adding the orb requires a draw program such as Adobe Illustrator, CorelDRAW, or Macromedia Freehand. Simple text and shapes can be produced with a desktop publishing program such as Adobe InDesign, Adobe PageMaker, QuarkXPress, or Microsoft Publisher.

STYLE 1: BLEEDING EDGE

DESIGN RECIPES: BLEEDING EDGE

Fraction	=	Decimal Conversion
1/16	=	0.0625
1/8	=	0.125
3/16	=	0.1875
1/4	=	0.25
5/16	=	0.3125
3/8	=	0.375
7/16	=	0.4375
1/2	=	0.5
9/16	=	0.5625
5/8	=	0.625
11/16	=	0.6875
3/4	=	0.75
13/16	=	0.8125
7/8	=	0.875
15/16	=	0.9375

Letterhead
1 "Sampler" Bickham, Script 38pt, align center; "ANTIQUES" Caslon Regular 7pt, align center; 2 **Defining phrase** Minion Condensed Italic, 8/8.5pt, align left; 3 **Letter body** Minion, 12/18pt, align left; 4 Address Minion Condensed, 8/11pt, align left

Business Card, Front
5 "Sampler" Bickham Script, 35pt, align center; "ANTIQUES" Caslon Regular 6.5pt, align center; 6 **Defining phrase** Minion Cond...

Letterhead
1 "Sampler" Bickha... 7pt, align center; 2... 3 Letter body M...

Business Card, Fron...
5 "Sampler" Bickham Scrip... 6.5pt, align center; 6 Defining phrase... 7 Address Minion Condensed, 8/9pt, align center; 6 **Defining phrase** Minion Cond...

Business Card, Back
8 "WHAT" Minion Condensed Italic c 8/9t, align left; 9 Lines 0.25pt... Condensed, 8/9

Envelope
10 "Sampler" Bickham Script, 35pt, align center; "ANTIQUES" Caslon Regular, 6.5pt, align center; Address Minion Condensed, 7/9pt, align center

Color
To be printed in black and a solid PANTONE Color ink as defined on the palette below (see Step 9.3). (Because this book is printed in process colors (CMYK), the illustration is only a simulation of the actual solid PANTONE Color.)

M: Lorem Ipsum
Lorem ipsum is scrambled Latin text used by designer's to demonstrate the approximate number of words it will take to fill an area of the layout before the actual text is specified.

L: The ingredient details
In this example, the number "2" points to the item; "Defining phrase" is the type of item; "Minion Condensed Italic" is the typeface;" 8/8.5pt" means 8-point type on 8.5 points of leading (the space between the baselines of two rows of type); and "align left" is the alignment—aligned left or right, centered, or justified. Several examples employ customizable Adobe Multiple Master (MM) fonts such as Myriad MM (see page 73, item 10). Settings such as "700bd, 300cn" following the typeface name, represent customized character weights and widths. See your Multiple Master documentation for details.

STYLE 1

Bleeding Edge

In design, little things are big things. There are two simple principles to be learned from this design. First, that interrupting a consistent shape draws your eye to the interruption. Imagine this letterhead without the slightly darker square in the upper left corner—it would not be nearly as effective. The box draws your eye to the corner and, in doing so, highlights the logo.

The second principle is that reversing layouts adds interest. The envelope uses essentially the same layout but the colors are reversed—the letterhead is white on orange and the envelope is orange on white.

SOURCE Illustrations: Chair from *Designer's Club* from Dynamic Graphics 800-255-8800, 309-688-8800, www.dgusa.com, © Dynamic Graphics, all rights reserved.

The original chair is part of a larger clip art illustration. It is opened in a draw program and the surrounding objects are removed.

Color is applied to each part of the object.

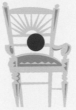

An simple orb is added as if it were seated in the chair. This is a simple, abstract way to add visual interest to a common object.

A simple oval shadow amplifies the three-dimensional quality of the orb.

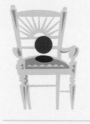

The proper name of the organization is emphasized by reducing the size of the word "ANTIQUES" and applying a lighter color.

Though the base illustration of the chair and the typefaces are all classic-looking, the combined image has an air of newness to it.

SOURCE Type families: Bickham Script, Caslon, Adobe Systems, Inc., 800-682-3623, www.adobe.com/type.

? What you need
Editing the chair artwork and adding the orb requires a draw program such as Adobe Illustrator, CorelDRAW, or Macromedia FreeHand. Simple text and shapes can be produced with a desktop publishing program such as Adobe InDesign, Adobe PageMaker, QuarkXPress, or Microsoft Publisher.

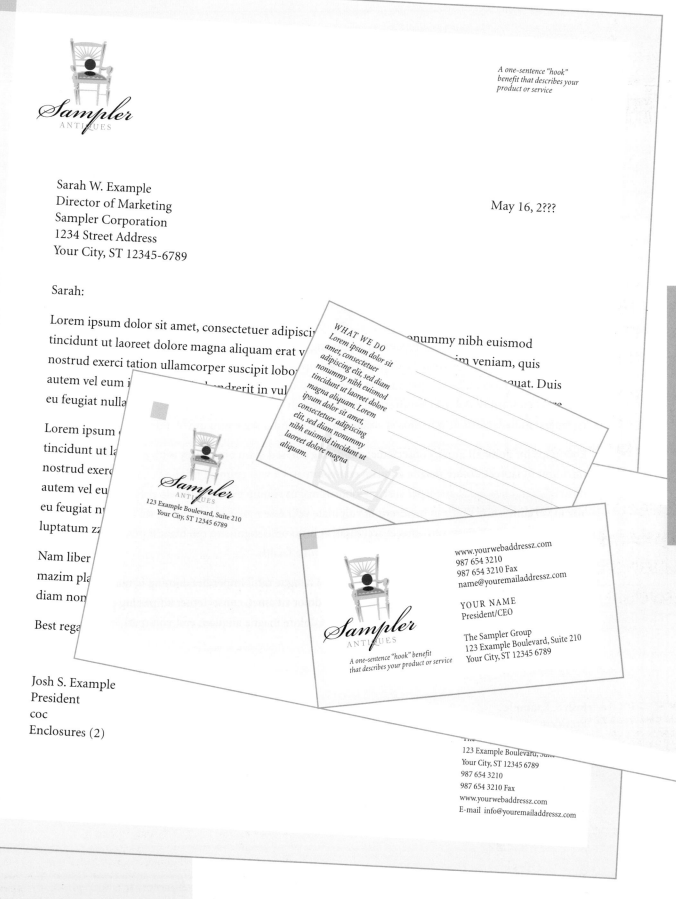

STYLE 2

Border

Document design has a long history, and you rarely go wrong reviving classic examples. These layouts borrow from the designs of the early 1900s, when the founders' art was so revered.

Borders have long been used to establish the boundaries of a layout. Visual boundaries give you a barrier to break. Notice how pushing the flower bud beyond the border adds depth to the design.

There are many versions of classic typefaces such as Caslon. Originally designed by William Caslon in the early 1700s, this one was reinterpreted for Adobe by Carol Twombly. Beautiful!

SOURCES Illustrations: Flower bud from Caslon Ornaments typeface, Adobe Systems, Inc., 800-682-3623, www.adobe.com/type; berries from *Signature Series 4*, PhotoDisc, 800-979-4413, 206-441-9355, www.photodisc.com, © CMCD, all rights reserved.

A simple thick/thin border establishes the boundaries of the design.

An ornament accents the text. In this case, it is from the Caslon Ornaments typeface—a collection of decorative elements designed to match the personality of the Caslon type family.

A subtle gray-on-gray version of the ornament and oval is used to add the flavor of a watermark—the delicate mark visible when you hold fine paper up to a light.

The sum of simple changes, such as making the "S" slightly larger than the "A" and subtracting and adding space between characters, make this logo one-of-a-kind.

The finished logo looks simple, but is actually quite complex. Though it is easy to produce, it requires five different typefaces: Charlemagne, Caslon Regular, Regular Italic, Swash Italic, and Caslon Ornaments.

Surprise! The back of the business card presents the benefit of the business—beautiful, fresh produce. Imagine the impression of sending a letter with the business card enclosed so the first thing the reader sees is that benefit.

SOURCE Type families: Caslon, Charlemagne, Minion, Adobe Systems, Inc., 800-682-3623, www.adobe.com/type.

? What you need
Simple text and shapes can be produced with a desktop publishing program such as Adobe InDesign, Adobe PageMaker, QuarkXPress, or Microsoft Publisher.

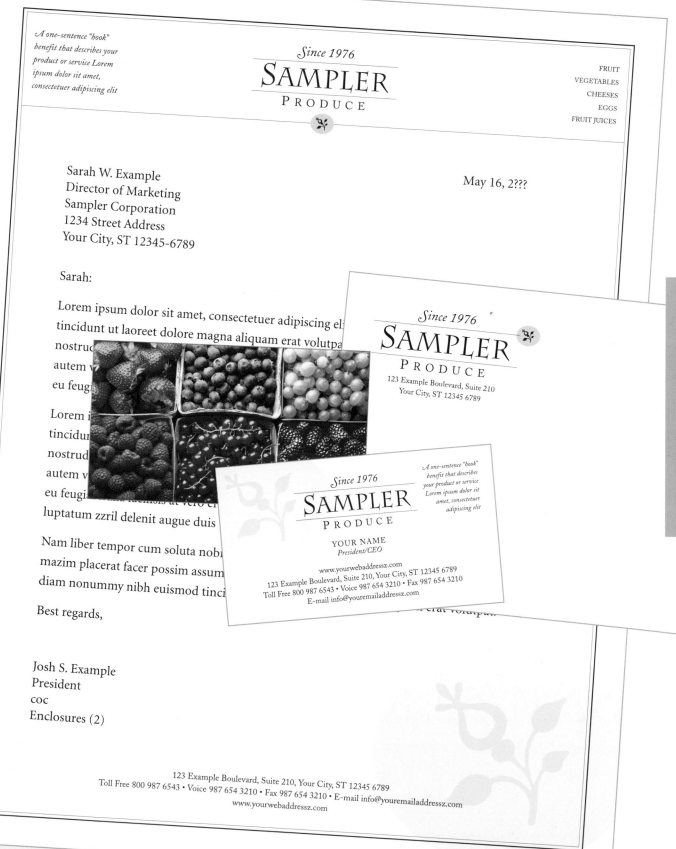

A one-sentence "hook" benefit that describes your product or service Lorem ipsum dolor sit amet, consectetuer adipiscing elit

Since 1976

SAMPLER
P R O D U C E

FRUIT
VEGETABLES
CHEESES
EGGS
FRUIT JUICES

Sarah W. Example
Director of Marketing
Sampler Corporation
1234 Street Address
Your City, ST 12345-6789

May 16, 2???

Sarah:

Lorem ipsum dolor sit amet, consectetuer adipiscing eli
tincidunt ut laoreet dolore magna aliquam erat volutpa
nostrud
autem v
eu feugi

Lorem i
tincidu
nostrud
autem v
eu feugi
luptatum zzril delenit augue duis

Nam liber tempor cum soluta nobi
mazim placerat facer possim assum
diam nonummy nibh euismod tinci

Best regards,

Josh S. Example
President
coc
Enclosures (2)

Since 1976

SAMPLER
P R O D U C E

123 Example Boulevard, Suite 210
Your City, ST 12345 6789

A one-sentence "hook" benefit that describes your product or service Lorem ipsum dolor sit amet, consectetuer adipiscing elit

Since 1976

SAMPLER
P R O D U C E

YOUR NAME
President/CEO

www.yourwebaddressz.com
123 Example Boulevard, Suite 210, Your City, ST 12345 6789
Toll Free 800 987 6543 • Voice 987 654 3210 • Fax 987 654 3210
E-mail info@youremailaddressz.com

123 Example Boulevard, Suite 210, Your City, ST 12345 6789
Toll Free 800 987 6543 • Voice 987 654 3210 • Fax 987 654 3210 • E-mail info@youremailaddressz.com
www.yourwebaddressz.com

DESIGN RECIPES: BORDER

A one-sentence "hook"
benefit that describes your
product or service Lorem
ipsum dolor sit amet,
consectetuer adipiscing elit

Since 1976

SAMPLER
PRODUCE

FRUIT
VEGETABLES
CHEESES
EGGS
FRUIT JUICES

May 16, 2???

Sarah W. Example
Director of Marketing
Sampler Corporation
1234 Street Address
Your City, ST 12345-6789

Sarah:

Lorem ipsum dolor sit amet, consectetuer adipiscing elit, sed diam nonummy nibh euismod tincidunt ut laoreet dolore magna aliquam erat volutpat. Ut wisi enim ad minim veniam, quis nostrud exerci tation ullamcorper suscipit lobortis nisl ut aliquip ex ea commodo consequat. Duis autem vel eum iriure dolor in hendrerit in vulputate velit esse molestie consequat, vel illum dolore eu feugiat nulla facilisis at vero eros et accumsan et iusto odio dignissim qui blandit praesent.

Lorem ipsum dolor sit amet, consectetuer adipiscing elit, sed diam nonummy nibh euismod tincidunt ut laoreet dolore magna aliquam erat volutpat. Ut wisi enim ad minim veniam, quis nostrud exerci tation ullamcorper suscipit lobortis nisl ut aliquip ex ea commodo consequat. Duis autem vel eum iriure dolor in hendrerit in vulputate velit esse molestie consequat, vel illum dolore eu feugiat nulla facilisis at vero eros et accumsan et iusto odio dignissim qui blandit praesent luptatum zzril delenit augue duis dolore te feugait nulla facilisi.

Nam liber tempor cum soluta nobis eleifend option congue nihil imperdiet doming id quod mazim placerat facer possim assum. Lorem ipsum dolor sit amet, consectetuer adipiscing elit, sed diam nonummy nibh euismod tincidunt ut laoreet dolore magna aliquam erat volutpat.

Best regards,

Josh S. Example
President
coc
Enclosures (2)

123 Example Boulevard, Suite 210, Your City, ST 12345 6789
Toll Free 800 987 6543 • Voice 987 654 3210 • Fax 987 654 3210 • E-mail info@youremailaddressz.com
www.yourwebaddressz.com

Business Card, Front 3.5 W by 2 H inches

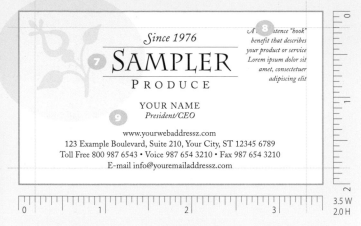

Business Card, Back 3.5 W by 2 H inches

Envelope, Commercial 9.5 W by 4.125 H inches

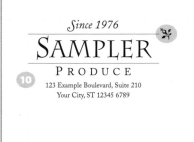

Letterhead

1 Lines Thick 1pt, thin 0.25pt; **2 Defining phrase** Caslon Regular Italic, 8/12pt, align left; **3 "S"** Caslon Swash Italic, 12pt, align center; **"ince"** Caslon Regular Italic, 12pt, align center; **"S"** Charlemagne, 28pt, align center; **"AMPLER"** Charlemagne, 24pt, align center; **"P"** Caslon Regular, 12pt, align center; **"RODUCE"** Caslon Regular, 10pt, align center; **Lines** 0.25pt; align center; **4 List** Caslon Regular, 6/12pt, align right; **Lines** 0.25pt; **5 Letter body** Minion, 12/18pt, align left; **6 Address** Caslon Regular, 8/11pt, align center

Business Card, Front

7 "S" Caslon Swash Italic, 10pt, align center; **"ince"** Caslon Regular Italic, 10pt, align center; **"S"** Charlemagne, 24pt, align center; **"AMPLER"** Charlemagne, 20pt, align center; **"P"** Caslon Regular, 10pt, align center; **"RODUCE"** Caslon Regular, 8.5pt, align center; **Lines** 0.25pt; **8 Defining phrase** Caslon Regular Italic, 6/8pt, align right; **9 Name** Caslon Regular, 7pt, align center; **Title** Caslon Regular Italic, 7pt, align center; **Address** Caslon Regular, 7/9pt, align center

Envelope

10 "S" Caslon Swash Italic, 12pt, align center; **"ince"** Caslon Regular Italic, 12pt, align center; **"S"** Charlemagne, 28pt, align center; **"AMPLER"** Charlemagne, 24pt, align center; **"P"** Caslon Regular, 12pt, align center; **"RODUCE"** Caslon Regular, 10pt, align center; **Lines** 0.25pt; **Address** Caslon Regular, 7/10pt; align center

Color

Printed in black and tints of black as defined on the palette below. The back of the business card is printed in four-color process (see Step 9.3) using values of cyan, magenta, yellow, and black (CMYK). Actual color will vary.

Black

100%	
20%	
10%	
5%	

STYLE 3

Boxes

Boxes—think outside them. Must a logo look like a logo? Only if you can't think beyond it. In this case, the defining phrase *is* the logo. After all, if you've invested the time to produce a compelling, customer-oriented benefit statement, why wouldn't you want it to take center stage?

Boxes are different than borders. Borders define boundaries, boxes encapsulate information.

Sampler defining phrase or mission statement. A one-paragraph "hook" benefit that describes your product or service.

This style, among the easiest to produce in this series, makes the all-important defining phrase (see page 18) the focus of attention.

A bold typeface is used for the initial cap and a light typeface for the text. If possible, begin your defining phrase with a visually interesting letter such as A, B, E, G, J, K, M, N, Q, R, S, or W.

Sampler defining phrase or mission statement: a one-paragraph "hook" benefit that describes your product or service SAMPLER LEGAL SERVICES

The relative size of each element—the initial cap, defining phrase, and the organization's name—are increased and decreased until they fill the box with a minimum of white space.

The layouts of all three pieces play on the box theme. Various-sized boxes each contain a different information element—the organization's name, defining phrase, letter body, address, and so on.

Various tints of the solid color are used to differentiate each box from the others.

Sampler defining phrase or mission statement: a one-paragraph "hook" benefit that describes your product or service SAMPLER LEGAL SERVICES

SOURCES Type families: Giza, Font Bureau, 617-423-8770, www.font bureau.com; Century Expanded, Franklin Gothic, Adobe Systems, Inc., 800-682-3623, www.adobe.com/type.

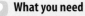 **What you need**
Simple text and shapes can be produced with a desktop publishing program such as Adobe InDesign, Adobe PageMaker, QuarkXPress, or Microsoft Publisher.

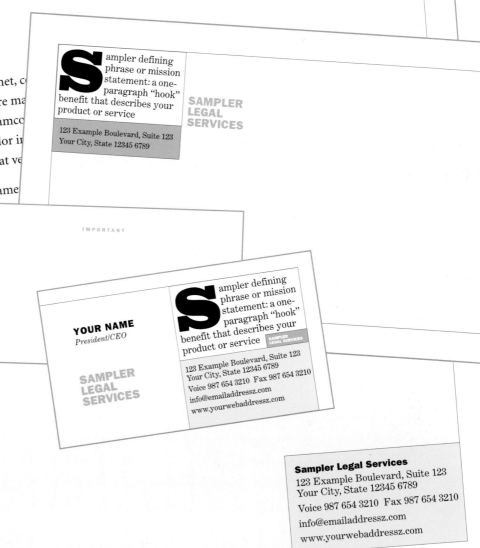

Sampler defining phrase or mission statement: a one-paragraph "hook" benefit that describes your product or service

SAMPLER LEGAL SERVICES

May 16, 2???

Sarah W. Example
Director of Marketing
Sampler Corporation
1234 Street Address
Your City, ST 12345-6789

Sarah:

Lorem ipsum dolor sit amet, c
tincidunt ut laoreet dolore ma
nostrud exerci tation ullamco
autem vel eum iriure dolor in
eu feugiat nulla facilisis at ve

Lorem ipsum dolor sit ame
tincidunt ut laore
nostrud exerci ta
autem vel eum i
eu feugiat nulla
luptatum zzril

Nam liber tem
mazim placera
diam nonummy

Best regards,

Josh S. Example
President
coc
Enclosures (2)

IMPORTANT

Sampler defining phrase or mission statement: a one-paragraph "hook" benefit that describes your product or service

123 Example Boulevard, Suite 123
Your City, State 12345 6789

YOUR NAME
President/CEO

SAMPLER LEGAL SERVICES

Sampler defining phrase or mission statement: a one-paragraph "hook" benefit that describes your product or service

SAMPLER LEGAL SERVICES

123 Example Boulevard, Suite 123
Your City, State 12345 6789
Voice 987 654 3210 Fax 987 654 3210
info@emailaddressz.com
www.yourwebaddressz.com

Sampler Legal Services
123 Example Boulevard, Suite 123
Your City, State 12345 6789
Voice 987 654 3210 Fax 987 654 3210
info@emailaddressz.com
www.yourwebaddressz.com

ampler defining phrase or mission statement: a one-paragraph "hook" benefit that describes your product or service SAMPLER LEGAL SERVICES

May 16, 2???

Sarah W. Example
Director of Marketing
Sampler Corporation
1234 Street Address
Your City, ST 12345-6789

Sarah:

Lorem ipsum dolor sit amet, consectetuer adipiscing elit, sed diam nonummy nibh euismod tincidunt ut laoreet dolore magna aliquam erat volutpat. Ut wisi enim ad minim veniam, quis nostrud exerci tation ullamcorper suscipit lobortis nisl ut aliquip ex ea commodo consequat. Duis autem vel eum iriure dolor in hendrerit in vulputate velit esse molestie consequat, vel illum dolore eu feugiat nulla facilisis at vero eros et accumsan et iusto odio dignissim qui blandit praesent.

Lorem ipsum dolor sit amet, consectetuer adipiscing elit, sed diam nonummy nibh euismod tincidunt ut laoreet dolore magna aliquam erat volutpat. Ut wisi enim ad minim veniam, quis nostrud exerci tation ullamcorper suscipit lobortis nisl ut aliquip ex ea commodo consequat. Duis autem vel eum iriure dolor in hendrerit in vulputate velit esse molestie consequat, vel illum dolore eu feugiat nulla facilisis at vero eros et accumsan et iusto odio dignissim qui blandit praesent luptatum zzril delenit augue duis dolore te feugait nulla facilisi.

Nam liber tempor cum soluta nobis eleifend option congue nihil imperdiet doming id quod mazim placerat facer possim assum. Lorem ipsum dolor sit amet, consectetuer adipiscing elit, sed diam nonummy nibh euismod tincidunt ut laoreet dolore magna aliquam erat volutpat.

Best regards,

Josh S. Example
President
coc
Enclosures (2)

Sampler Legal Services
123 Example Boulevard, Suite 123
Your City, State 12345 6789
Voice 987 654 3210 Fax 987 654 3210
info@emailaddressz.com
www.yourwebaddressz.com

Business Card, Front 3.5 W by 2 H inches

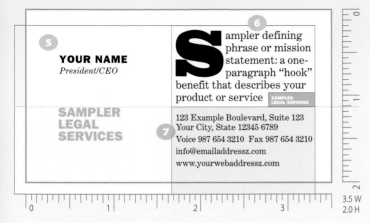

Business Card, Back 3.5 W by 2 H inches

IMPORTANT

Envelope, Commercial 9.5 W by 4.125 H inches

Letterhead

1 *"S"* Giza SevenSeven, 72pt, align left; **Defining phrase** Century Expanded, 12/14pt, align left; **Organization** Franklin Gothic Heavy, 5pt, align left; **2 Lines** 0.25pt; **3 Letter body** Minion, 12/18pt, align left; **4 Organization** Franklin Gothic Heavy, 9pt, align left; **Address** Century Expanded, 9/14pt, align left

Business Card, Front

5 Name Franklin Gothic Heavy, 9pt, align left; **Title** Century Expanded Italic, 7/9pt, align left; **Organization** Franklin Gothic Heavy, 11/10pt, align left; **6 Lines** 0.25pt; *"S"* Giza SevenSeven, 54pt; **Defining phrase** Century Expanded, 9/10.5pt, align left; **Organization** Franklin Gothic Heavy, 4pt, align left; **7 Address** Century Expanded, 7/10pt, align left

Business Card, Back

8 Lines 0.5pt; **"IMPORTANT"** Franklin Gothic Heavy, 4pt, align left

Envelope

9 Lines 0.25pt; *"S"* Giza SevenSeven, 54pt; **Defining phrase** Century Expanded, 9/10.5pt, align left; **Organization** Franklin Gothic Heavy, 11/10pt, align left; **10 Address** Century Expanded, //10pt, align left

Color

To be printed in black and a solid PANTONE Color Ink as defined on the palette below (see Step 9.3). (Because this book is printed in process colors (CMYK), the illustration is only a simulation of the actual solid PANTONE Color).

Mustard Yellow or
PANTONE® 123

100%	
30%	
15%	

STYLE 4

Burst

The success of this style rides on a kind of subtle visual complexity.

A burst is nothing more than a star with a small center and lots of points. Printing it in a light tint in the background of your design lends the air of an official document similar to that of paper money or a stock certificate.

In contrast, the logo is simple and bold. Though an acronym (using the initial letter of each word in the name) is not the ideal way to name an organization, it is a common solution, and this is an attractive way to present it.

A one-sentence "hook" benefit that describes your product or service

Sampler
Fire Alarm
Systems

Note the small but significant difference between two similar typefaces. The background "S" is slightly bolder and sleeker. As in the previous style, if you're creating a type logo, it pays to search for the most interesting typefaces.

The initials are grouped on a four-box foundation. The same design would work with three letters, perhaps using the last box for the spelled out name.

Using a draw program, the parts of the letters that overlap the edges of the box are cut and removed.

The defining phrase paragraph and the company name are sized as if to fill invisible boxes on the top left and bottom right.

The burst is created using the polygon or star tool of your desktop publishing or drawing program. The only difference is that the star, instead of having the conventional five points, has 500 points.

SOURCES Type families: Interstate, Font Bureau, 617-423-8770, www.fontbureau.com; Minion, Myriad, Adobe Systems, Inc., 800-682-3623, www.adobe.com/type.

? What you need
Simple text and shapes can be produced with a desktop publishing program such as Adobe InDesign, Adobe PageMaker, QuarkXPress, or Microsoft Publisher.

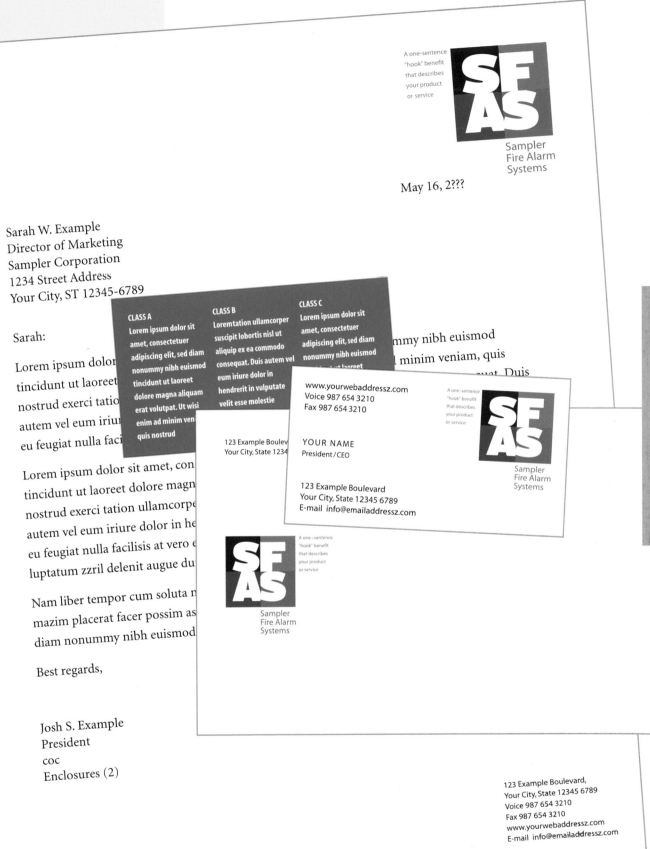

A one-sentence "hook" benefit that describes your product or service

SF AS

Sampler
Fire Alarm
Systems

May 16, 2???

Sarah W. Example
Director of Marketing
Sampler Corporation
1234 Street Address
Your City, ST 12345-6789

Sarah:

Lorem ipsum dolor ... mmy nibh euismod
tincidunt ut laoreet ... l minim veniam, quis
nostrud exerci tatio ... quat. Duis
autem vel eum iriur
eu feugiat nulla faci

CLASS A
Lorem ipsum dolor sit amet, consectetuer adipiscing elit, sed diam nonummy nibh euismod tincidunt ut laoreet dolore magna aliquam erat volutpat. Ut wisi enim ad minim veniam, quis nostrud

CLASS B
Loremtation ullamcorper suscipit lobortis nisl ut aliquip ex ea commodo consequat. Duis autem vel eum iriure dolor in hendrerit in vulputate velit esse molestie

CLASS C
Lorem ipsum dolor sit amet, consectetuer adipiscing elit, sed diam nonummy nibh euismod

Lorem ipsum dolor sit amet, con
tincidunt ut laoreet dolore magn
nostrud exerci tation ullamcorpe
autem vel eum iriure dolor in he
eu feugiat nulla facilisis at vero e
luptatum zzril delenit augue du

Nam liber tempor cum soluta n
mazim placerat facer possim as
diam nonummy nibh euismod

Best regards,

Josh S. Example
President
coc
Enclosures (2)

www.yourwebaddressz.com
Voice 987 654 3210
Fax 987 654 3210

123 Example Boulev
Your City, State 1234

YOUR NAME
President / CEO

123 Example Boulevard
Your City, State 12345 6789
E-mail info@emailaddressz.com

A one-sentence "hook" benefit that describes your product or service

SF AS

Sampler
Fire Alarm
Systems

A one-sentence "hook" benefit that describes your product or service

SF AS

Sampler
Fire Alarm
Systems

123 Example Boulevard,
Your City, State 12345 6789
Voice 987 654 3210
Fax 987 654 3210
www.yourwebaddressz.com
E-mail info@emailaddressz.com

A one-sentence
"hook" benefit
that describes
your product
or service

Sampler
Fire Alarm
Systems

May 16, 2???

Sarah W. Example
Director of Marketing
Sampler Corporation
1234 Street Address
Your City, ST 12345-6789

Sarah:

Lorem ipsum dolor sit amet, consectetuer adipiscing elit, sed diam nonummy nibh euismod
tincidunt ut laoreet dolore magna aliquam erat volutpat. Ut wisi enim ad minim veniam, quis
nostrud exerci tation ullamcorper suscipit lobortis nisl ut aliquip ex ea commodo consequat. Duis
autem vel eum iriure dolor in hendrerit in vulputate velit esse molestie consequat, vel illum dolore
eu feugiat nulla facilisis at vero eros et accumsan et iusto odio dignissim qui blandit praesent.

Lorem ipsum dolor sit amet, consectetuer adipiscing elit, sed diam nonummy nibh euismod
tincidunt ut laoreet dolore magna aliquam erat volutpat. Ut wisi enim ad minim veniam, quis
nostrud exerci tation ullamcorper suscipit lobortis nisl ut aliquip ex ea commodo consequat. Duis
autem vel eum iriure dolor in hendrerit in vulputate velit esse molestie consequat, vel illum dolore
eu feugiat nulla facilisis at vero eros et accumsan et iusto odio dignissim qui blandit praesent
luptatum zzril delenit augue duis dolore te feugait nulla facilisi.

Nam liber tempor cum soluta nobis eleifend option congue nihil imperdiet doming id quod
mazim placerat facer possim assum. Lorem ipsum dolor sit amet, consectetuer adipiscing elit, sed
diam nonummy nibh euismod tincidunt ut laoreet dolore magna aliquam erat volutpat.

Best regards,

Josh S. Example
President
coc
Enclosures (2)

123 Example Boulevard
Your City, State 12345 6789
Voice 987 654 3210
Fax 987 654 3210
www.yourwebaddressz.com
E-mail info@emailaddressz.com

Business Card, Front 3.5 W by 2 H inches

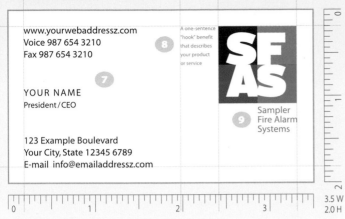

www.yourwebaddressz.com
Voice 987 654 3210
Fax 987 654 3210

YOUR NAME
President / CEO

123 Example Boulevard
Your City, State 12345 6789
E-mail info@emailaddressz.com

A one-sentence
"hook" benefit
that describes
your product
or service

SF
AS

Sampler
Fire Alarm
Systems

3.5 W
2.0 H

Business Card, Back 3.5 W by 2 H inches

CLASS A **10**
Lorem ipsum dolor sit amet, consectetuer adipiscing elit, sed diam nonummy nibh euismod tincidunt ut laoreet dolore magna aliquam erat volutpat. Ut wisi enim ad minim veniam, quis nostrud

CLASS B
Loremtation ullamcorper suscipit lobortis nisl ut aliquip ex ea commodo consequat. Duis autem vel eum iriure dolor in hendrerit in vulputate velit esse molestie consequat

CLASS C
Lorem ipsum dolor sit amet, consectetuer adipiscing elit, sed diam nonummy nibh euismod tincidunt ut laoreet dolore magna aliquam erat volutpat. Ut wisi enim ad minim veniam, quis nostrud

3.5 W
2.0 H

Envelope, Commercial 9.5 W by 4.125 H inches

123 Example Boulevard
Your City, State 12345 6789 **11**

12 SF
AS

A one-sentence
"hook" benefit
that describes
your product
or service

Sampler
Fire Alarm
Systems

9.5 W
4.125 H

Letterhead

1 Burst 500 points **2** Defining phrase Myriad Regular, 6/10pt, align left; **3** "SFAS" Interstate UltraBlack, 52pt; **4** Organization Myriad Regular, 10.5/10.5pt, align left; **5** Letter body Minion, 12/18pt, align left; **6** Address Myriad Regular, 7.5/10pt, align left

Business Card, Front

7 Address Myriad Regular, 7.5/10pt, align left; Title Myriad Regular, 7pt, align left; **8** Defining phrase Myriad Regular, 4.5/7pt, align left; "SFAS" Interstate UltraBlack, 39pt; **9** Organization Myriad Regular, 8.5/8.5pt, align left

Business Card, Back

10 Text Myriad Multiple Master (MM), 700bd, 300cn, 8/12pt, align left

Envelope

11 Address Myriad Regular, 7/9pt, align left; **12** "SFAS" Interstate UltraBlack, 39pt; Defining phrase Myriad Regular, 4.5/7pt, align left; Organization Myriad Regular, 8.5/8.5pt, align left

Color

Printed in four-color process (see Step 9.3) using values of cyan, magenta, yellow, and black (CMYK) as defined on the color palette below. Actual color will vary.

Process Colors

C0	M100	Y70	K10
C0	M60	Y100	K0
C60	M70	Y0	K10
C85	M0	Y35	K20
C30	M0	Y10	K5

STYLE 5

Circles

How do you represent a concept as abstract as intellectual property? By defining the term in its most literal form. Intellectual property is an idea—an invention, trademark, design, or artistic work. Therefore, what is the customer benefit of using a firm that offers protection of intellectual property? Simple: the protection of the client's ideas—idea security.

Start by identifying symbols that represent the concept of an idea—a question mark and a light bulb are two obvious choices. For security, how about a safe or a lock? Combine two—a lock and a light bulb—and the result is a simple, effective icon.

SOURCE Illustrations: Light bulb, lock from *Universal Symbols* by Image Club Clip Art, 800-661-9410, 403-294-3195, www.eyewire.com, © Image Club Graphics, all rights reserved.

Two simple symbols in a draw/vector file format: The light bulb represents ideas, and the lock represents security. (See *Symbol Logos* on page 34.)

Reducing the size of the lock to roughly 75 percent makes the "idea" bulb the anchoring element. Rotating it and overlapping the edge of the bulb results in a third idea: idea security.

Dividing the artwork allows you to edit individual elements. The black outlines show that the images are now divided into ten individual shapes.

Applying different screen values of the same color adds a sense of transparency. Where paths cross, colors darken. When one shape is behind the other (the top of the lock is behind the edge of the bulb), the shape behind is lighter.

The Sampler Group

The Sampler Group

Reducing the size of "The" and fitting the words together forms a simple but effective wordmark. (See *All-Type Logos* on page 30.)

The Sampler Group

Adding a circle pulls the elements together. These curved shapes work well with a circle. If your logo is square or rectangular, a square or rectangular background shape may work best.

SOURCE Type families: Myriad, Minion, Adobe Systems, Inc., 800-682-3623, www.adobe.com/type.

? What you need
Breaking apart draw/vector artwork and editing the pieces requires a draw program such as Adobe Illustrator, CorelDRAW, or Macromedia FreeHand. Simple text and shapes can be produced with a desktop publishing program such as Adobe InDesign, Adobe PageMaker, QuarkXPress, or Microsoft Publisher.

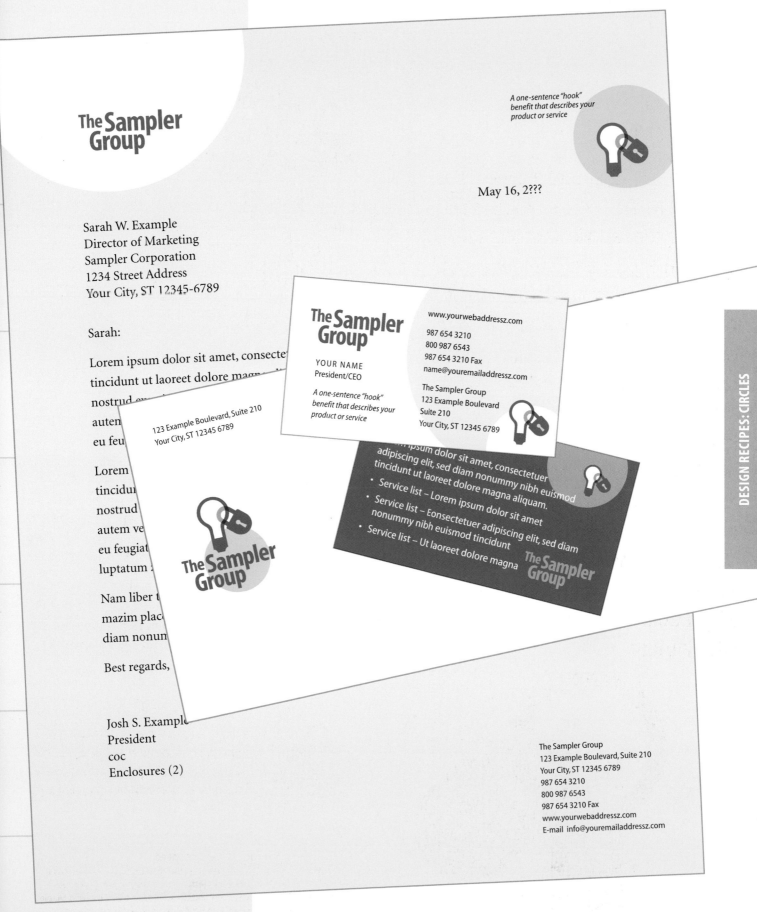

A one-sentence "hook" benefit that describes your product or service

May 16, 2???

Sarah W. Example
Director of Marketing
Sampler Corporation
1234 Street Address
Your City, ST 12345-6789

Sarah:

Lorem ipsum dolor sit amet, consectet
tincidunt ut laoreet dolore magn
nostrud ex
autem ve
eu feu

Lorem
tincidu
nostrud
autem ve
eu feugiat
luptatum 2

Nam liber t
mazim place
diam nonum

Best regards,

Josh S. Example
President
coc
Enclosures (2)

The Sampler Group

YOUR NAME
President/CEO

A one-sentence "hook" benefit that describes your product or service

www.yourwebaddressz.com

987 654 3210
800 987 6543
987 654 3210 Fax
name@youremailaddressz.com

The Sampler Group
123 Example Boulevard
Suite 210
Your City, ST 12345 6789

123 Example Boulevard, Suite 210
Your City, ST 12345 6789

The Sampler Group

ipsum dolor sit amet, consectetuer
adipiscing elit, sed diam nonummy nibh euismod
tincidunt ut laoreet dolore magna aliquam.

• Service list – Lorem ipsum dolor sit amet
• Service list – Eonsectetuer adipiscing elit, sed diam
 nonummy nibh euismod tincidunt
• Service list – Ut laoreet dolore magna

The Sampler Group

The Sampler Group
123 Example Boulevard, Suite 210
Your City, ST 12345 6789
987 654 3210
800 987 6543
987 654 3210 Fax
www.yourwebaddressz.com
E-mail info@youremailaddressz.com

DESIGN RECIPES: CIRCLES

The Sampler Group ①

② *A one-sentence "hook" benefit that describes your product or service*

May 16, 2???

Sarah W. Example
Director of Marketing
Sampler Corporation
1234 Street Address
Your City, ST 12345-6789

③

Sarah:

Lorem ipsum dolor sit amet, consectetuer adipiscing elit, sed diam nonummy nibh euismod tincidunt ut laoreet dolore magna aliquam erat volutpat. Ut wisi enim ad minim veniam, quis nostrud exerci tation ullamcorper suscipit lobortis nisl ut aliquip ex ea commodo consequat. Duis autem vel eum iriure dolor in hendrerit in vulputate velit esse molestie consequat, vel illum dolore eu feugiat nulla facilisis at vero eros et accumsan et iusto odio dignissim qui blandit praesent.

Lorem ipsum dolor sit amet, consectetuer adipiscing elit, sed diam nonummy nibh euismod tincidunt ut laoreet dolore magna aliquam erat volutpat. Ut wisi enim ad minim veniam, quis nostrud exerci tation ullamcorper suscipit lobortis nisl ut aliquip ex ea commodo consequat. Duis autem vel eum iriure dolor in hendrerit in vulputate velit esse molestie consequat, vel illum dolore eu feugiat nulla facilisis at vero eros et accumsan et iusto odio dignissim qui blandit praesent luptatum zzril delenit augue duis dolore te feugait nulla facilisi.

Nam liber tempor cum soluta nobis eleifend option congue nihil imperdiet doming id quod mazim placerat facer possim assum. Lorem ipsum dolor sit amet, consectetuer adipiscing elit, sed diam nonummy nibh euismod tincidunt ut laoreet dolore magna aliquam erat volutpat.

Best regards,

Josh S. Example
President
coc

Enclosures (2)

④ The Sampler Group
123 Example Boulevard, Suite 210
Your City, ST 12345 6789
987 654 3210
800 987 6543
987 654 3210 Fax
www.yourwebaddressz.com
E-mail info@youremailaddressz.com

Business Card, Front 3.5 W by 2 H inches

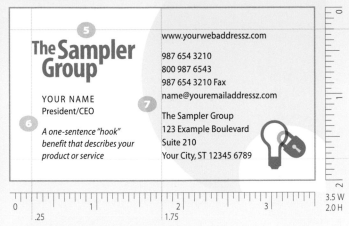

The Sampler Group

www.yourwebaddressz.com

987 654 3210
800 987 6543
987 654 3210 Fax
name@youremailaddressz.com

YOUR NAME
President/CEO

A one-sentence "hook" benefit that describes your product or service

The Sampler Group
123 Example Boulevard
Suite 210
Your City, ST 12345 6789

Business Card, Back 3.5 W by 2 H inches

WHAT WE DO
Lorem ipsum dolor sit amet, consectetuer adipiscing elit, sed diam nonummy nibh euismod tincidunt ut laoreet dolore magna aliquam.

- Service list – Lorem ipsum dolor sit amet
- Service list – Eonsectetuer adipiscing elit, sed diam nonummy nibh euismod tincidunt
- Service list – Ut laoreet dolore magna

The Sampler Group

Envelope, Commercial 9.5 W by 4.125 H inches

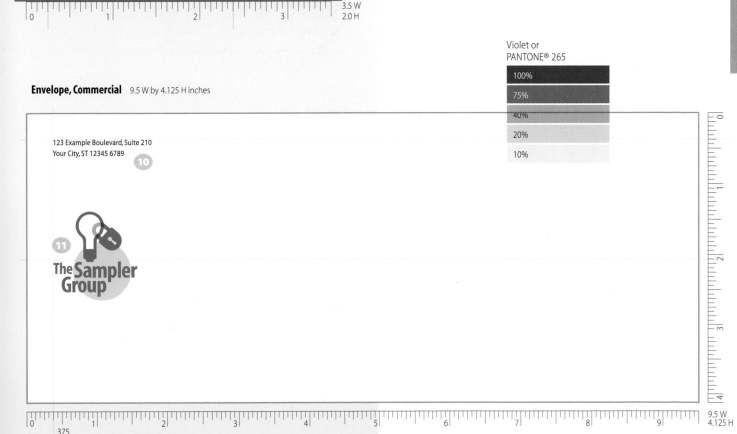

123 Example Boulevard, Suite 210
Your City, ST 12345 6789

The Sampler Group

Letterhead

1 "The" Myriad Multiple Master (MM), 700bd, 300cn, 18pt; "Sampler" Myriad MM, 700bd, 300cn, 26pt; **2 Defining phrase** Myriad MM Italic, 400 weight, 500 width, 8/11pt, align left; **3 Letter body** Minion, 12/18pt, align left; **4 Address** Myriad MM, 400 weight, 500 width, 8/10pt, align left

Business Card, Front

5 "The" Myriad MM, 700bd, 300cn, 18pt; "Sampler" Myriad MM, 700bd, 300cn, 26pt; **6 Name/Title** Myriad MM, 400 weight, 500 width, 8/10pt, align left; **Defining phrase** Myriad MM Italic, 400 weight, 500 width, 8/10pt, align left; **7 Address** Myriad MM, 400 weight, 500 width, 8/11pt, align left

Business Card, Back

8 "WHAT" Myriad MM, 400 weight, 500 width, 8/11pt, align left; **Text** Myriad MM Italic, 400 weight, 500 width, 9/11pt, align left; **9** "The" Myriad MM, 700bd, 300cn, 13pt; "Sampler" Myriad MM, 700bd, 300cn, 18pt

Envelope

10 Address Myriad MM, 400 weight, 500 width, 8/11pt; **11** "The" Myriad MM, 700bd, 300cn, 12pt; "Sampler" Myriad MM, 700bd, 300cn, 17pt, align left

Color

To be printed in black and a solid PANTONE Color Ink as defined on the palette below (see Step 9.3). (Because this book is printed in process colors (CMYK), the illustration is only a simulation of the actual solid PANTONE Color).

Violet or
PANTONE® 265

100%
75%
40%
20%
10%

STYLE 6

Comics

Being funny is serious business. When appropriate, humor is an effective way to win people to your way of thinking. The challenge is to determine if a funny or lighthearted logo and letterhead scheme projects an appropriate image for your organization. Only you can make that judgment.

If you do opt for this approach, insist on first-class artwork. Like a stand-up comic, you should not venture on stage without proven, professional material.

SOURCES Illustrations: Cartoons from *Task Force Image Gallery* by NVTech, 800-387-0732, 613-727-8184, www.nvtech.com, © NVTech, all rights reserved; spiral background from *Design Elements* by Ultimate Symbol, 800-611-4761, 914-942-0003, www.ultimatesymbol.com, © Ultimate Symbol, all rights reserved.

The style centers around a real comic book typeface called WildAndCrazy from Comic Book Fonts, a masterful group of real comic book illustrators. Using something that looks some-what like a comic typeface won't cut it.

The quality of the illustrations must be strong enough to carry the design. These are bright, colorful, and well executed. Using a different character on each layout maximizes the overall effect.

The radiating background pattern adds movement to the logo. The original artwork is stretched to give it perspective.

Adding a yellow tint to the background of the letterhead and business card makes the speech balloons and the character's eyes pop off the page.

SOURCES Type families: WildAndCrazy, Comic Book Fonts, www. comicbookfonts.com; Minion, Myriad, Adobe Systems, Inc., 800-682-3623, www.adobe.com/type.

What you need

Combining multiple pieces of artwork requires a draw program such as Adobe Illustrator, CorelDRAW, or Macromedia FreeHand. Simple text and shapes can be produced with a desktop publishing program such as Adobe InDesign, Adobe PageMaker, QuarkXPress, or Microsoft Publisher.

Business card:

www.yourwebaddressz.com
Voice 987 654 3210
Fax 987 654 3210

YOUR NAME
President/CEO

123 Example Boulevard
Your City, State 12345 6789
E-mail info@emailaddressz.com

SAMPLER CENTER
NUTRITION THERAPY FOR CHILDREN

A one-paragraph "hook" benefit that describes your product or service

DOLOR SIT AMET, CONSEC TETUER

SAMPLER CENTER
NUTRITION THERAPY FOR CHILDREN

Letter:

May 16, 2...

Sarah W. Example
Director of Marketing
Sampler Corporation
1234 Street Address
Your City, ST 12345-6789

Sarah:

Lorem ipsum dolor sit amet, consectetuer adipis... tincidunt ut laoreet dolore magna aliquam erat nostrud exerci tation ullamcorper suscipit lobo... autem vel eum iriure dolor in hendrerit in vul... eu feugiat nulla facilisis at vero eros et accum...

Lorem ipsum dolor sit amet, consectetuer ad... tincidunt ut laoreet dolore magna aliquam e... nostrud exerci tation ullamcorper suscipit l... autem vel eum iriure dolor in hendrerit in... eu feugiat nulla facilisis at vero eros et acc... luptatum zzril delenit augue duis dolore t...

Nam liber tempor cum soluta nobis eleifend option congue nihil imperdie... mazim placerat facer possim assum. Lorem ipsum dolor sit amet, consectetuer adipiscing elit, se... diam nonummy nibh euismod tincidunt ut laoreet dolore magna aliquam erat volutpat.

Best regards,

Josh S. Example
President

coc
Enclosures (2)

Envelope:

123 Example Boulevard
Your City, State 12345 6789

SAMPLER CENTER
NUTRITION THERAPY FOR CHILDREN

A one-paragraph "hook" benefit that describes your product or service

A one-paragraph "hook" benefit that describes your product or service

123 Example Boulevard,
Your City, State 12345 6789
Voice 987 654 3210
Fax 987 654 3210
www.yourwebaddressz.com
E-mail info@emailaddressz.com

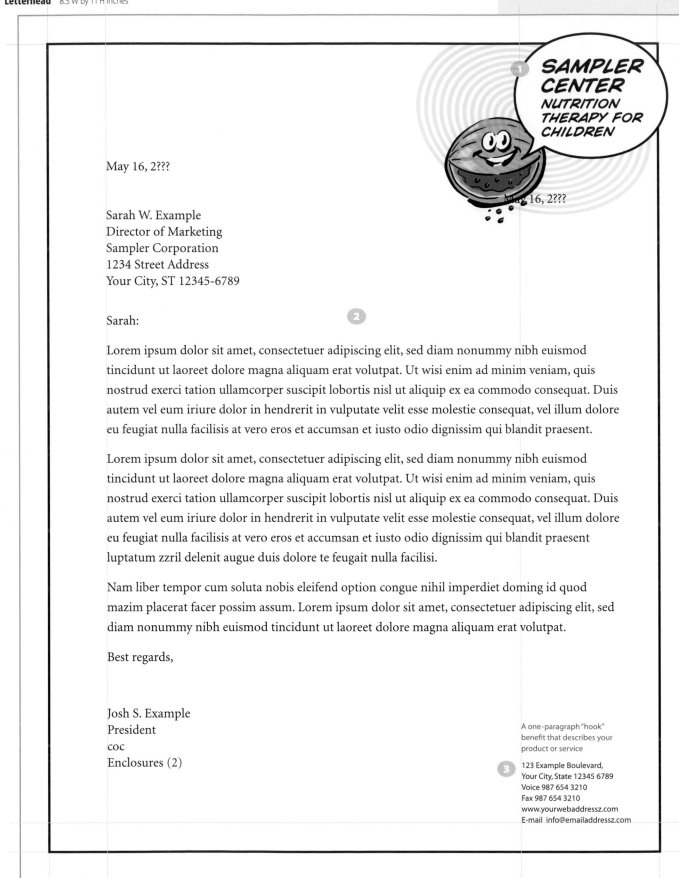

May 16, 2???

Sarah W. Example
Director of Marketing
Sampler Corporation
1234 Street Address
Your City, ST 12345-6789

Sarah:

Lorem ipsum dolor sit amet, consectetuer adipiscing elit, sed diam nonummy nibh euismod tincidunt ut laoreet dolore magna aliquam erat volutpat. Ut wisi enim ad minim veniam, quis nostrud exerci tation ullamcorper suscipit lobortis nisl ut aliquip ex ea commodo consequat. Duis autem vel eum iriure dolor in hendrerit in vulputate velit esse molestie consequat, vel illum dolore eu feugiat nulla facilisis at vero eros et accumsan et iusto odio dignissim qui blandit praesent.

Lorem ipsum dolor sit amet, consectetuer adipiscing elit, sed diam nonummy nibh euismod tincidunt ut laoreet dolore magna aliquam erat volutpat. Ut wisi enim ad minim veniam, quis nostrud exerci tation ullamcorper suscipit lobortis nisl ut aliquip ex ea commodo consequat. Duis autem vel eum iriure dolor in hendrerit in vulputate velit esse molestie consequat, vel illum dolore eu feugiat nulla facilisis at vero eros et accumsan et iusto odio dignissim qui blandit praesent luptatum zzril delenit augue duis dolore te feugait nulla facilisi.

Nam liber tempor cum soluta nobis eleifend option congue nihil imperdiet doming id quod mazim placerat facer possim assum. Lorem ipsum dolor sit amet, consectetuer adipiscing elit, sed diam nonummy nibh euismod tincidunt ut laoreet dolore magna aliquam erat volutpat.

Best regards,

Josh S. Example
President
coc
Enclosures (2)

A one-paragraph "hook" benefit that describes your product or service

123 Example Boulevard,
Your City, State 12345 6789
Voice 987 654 3210
Fax 987 654 3210
www.yourwebaddressz.com
E-mail info@emailaddressz.com

Business Card, Front — 3.5 W by 2 H inches

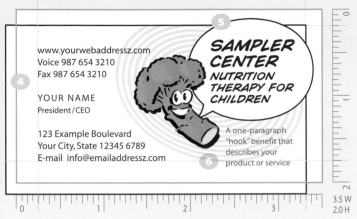

Business Card, Back — 3.5 W by 2 H inches

Letterhead

1 Lines 1.75pt; **Organization** WildAndCrazy, 16/18pt, align left; **"NUTRITION"** WildAndCrazy, 11/13pt, align left; **2** Letter body Minion, 12/18pt, align left; **3** Defining phrase Myriad Regular, 7.5/10pt, align left; **Address** Myriad Regular, 7.5/10pt, align left

Business Card, Front

4 Phone/Address/Name Myriad Regular, 8/10pt, align left; **Title** Myriad Regular, 7/10pt, align left; **5** Lines 1pt; **Organization** WildAndCrazy, 12/14pt, align left; **"NUTRITION"** WildAndCrazy, 9/10pt, align left; **6** Defining phrase Myriad Regular, 7/9pt, align left

Business Card, Back

7 Lines 1pt; **Organization** WildAndCrazy, 7/9pt, align left

Envelope

8 Address Myriad Regular, 7/9pt, align left; **9** Lines 1pt; **Organization** WildAndCrazy, 11/12pt, align left; **"NUTRITION"** WildAndCrazy, 7/8pt, align left; **10** Defining phrase Myriad Regular, 7/9pt, align left

Color

Printed in four-color process (see Step 9.3) using values of cyan, magenta, yellow, and black (CMYK) as defined in the clip art and on the color palette below. Actual color will vary.

Process Colors

C0	M80	Y100	K0	C0
C0	M10	Y40	K0	
C0	M0	Y10	K0	

Envelope, Commercial — 9.5 W by 4.125 H inches

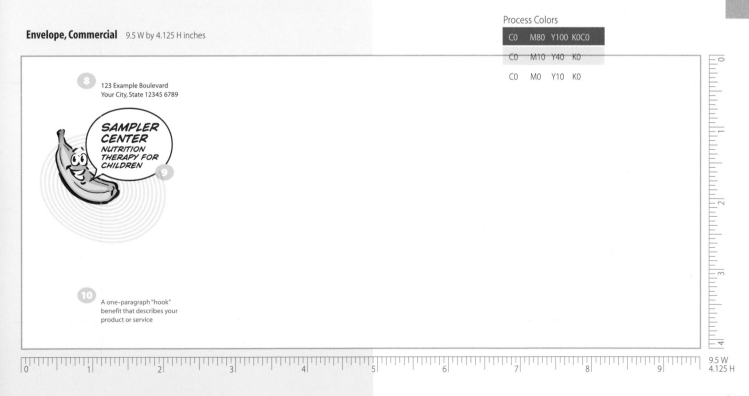

STYLE 7

Corners

For this style, the logo is pushed into the corner and off the edge of the page. Why? Because designing it that way is a little unexpected. And that is one sure way to attract attention—by showing your audience something they might not have pictured themselves.

Do something unexpected with the logo. Change any of the four basic elements used to design it—the box, the clip art image, the typeface, or the color—and you've added something new to the idea.

SOURCE Illustrations: Compass rose, bulbs, branches, from *Design Elements* by Ultimate Symbol, 800-611-4761, 914-942-0003, www.ultimate symbol.com, © Ultimate Symbol, all rights reserved.

How do you make clip art images unique? By adding two or three together. The basic artwork for these logos is nothing more than a combination of two or more simple images.

The artwork is sized and rotated to comfortably fill the space reserved for the type. Solid color and tints are applied and the portions of the image that extend beyond the edge of the box are removed.

SAMPLER
INDUSTRIAL
LIGHTING

The no-frills typeface is used to spell the name of the organization in three strips. You can add or subtract strips to accommodate your organization's name.

This and several other projects are printed using two colors—black and one solid color. By using the solid color and two or three different tints, you add a sense that there are more than two colors.

It is an easily adaptable design that can be used with a variety of different image combinations.

SOURCES Type families: OCR-A, AGFA/Monotype, 888-988-2432, 978-658-0200, www.agfamono type.com; Franklin Gothic, Minion, Adobe Systems, Inc., 800-682-3623, www.adobe.com/type.

? What you need

Breaking apart draw/vector artwork and editing the pieces requires a draw program such as Adobe Illustrator, CorelDRAW, or Macromedia FreeHand. Simple text and shapes can be produced with a desktop publishing program such as Adobe InDesign, Adobe PageMaker, QuarkXPress, or Microsoft Publisher.

May 16, 2???

Sarah W. Example
Director of Marketing
Sampler Corporation
1234 Street Address
Your City, ST 12345-6789

Sarah:

Lorem ipsum dolor sit amet, consect
tincidunt ut laoreet dolore magna a
nostrud exerci tation ullamcorper s
autem vel eum iriure dolor in hend
eu feugiat nulla facilisis at vero er

Lorem ipsum dolor sit amet, consectetuer ad
tincidunt ut lao
nostrud exerci t
autem vel eum
eu feugiat nulla
luptatum zzril

Nam liber ter
mazim place
diam nonummy nibh euismod

Best regards,

Josh S. Example
President
coc
Enclosures (2)

A one-sentence
"hook" benefit that
describes your
product or service

SAMPLER
INDUSTRIAL
LIGHTING

Furniture Mart, 4th Floor
123 Example Boulevard
Your City, ST 12345 6789

WHAT WE DO
Lorem ipsum dolor sit amet, consectetuer
adipiscing elit, sed diam nonummy nibh euis sit amet
ut laoreet dolore magna aliquam.

- Service list – Lorem ipsum dolor sit amet nibh euis
- Service list – Ipsum consectetuer adipiscing elit
 nonummy nibh euismod tincidunt
- Service list – Ut laoreet dolore magna
- Service list – Ipsum dolor sit amet nibh euis

A one-
sentence
"hook"
benefit that
describes
your product
or service

YOUR NAME
President/CEO
www.yourwebaddressz.com
987 654 3210
987 654 3210 Fax
name@emailaddressz.com
Furniture Mart, 4th Floor
123 Example Boulevard
Your City, ST 12345 6789

A one-sentence "hook"
benefit that describes
your product or service

sim qui blandit praesent

mperdiet doming id quod
consectetuer adipiscing elit, sed
aliquam erat volutpat.

Furniture Mart, 4th Floor
123 Example Boulevard
Your City, ST 12345 6789
987 654 3210
987 654 3210 Fax
www.yourwebaddressz.com
E-mail info@emailaddressz.com

DESIGN RECIPES: CORNERS

83

SAMPLER
INDUSTRIAL
LIGHTING

May 16, 2???

Sarah W. Example
Director of Marketing
Sampler Corporation
1234 Street Address
Your City, ST 12345-6789

Sarah:

Lorem ipsum dolor sit amet, consectetuer adipiscing elit, sed diam nonummy nibh euismod tincidunt ut laoreet dolore magna aliquam erat volutpat. Ut wisi enim ad minim veniam, quis nostrud exerci tation ullamcorper suscipit lobortis nisl ut aliquip ex ea commodo consequat. Duis autem vel eum iriure dolor in hendrerit in vulputate velit esse molestie consequat, vel illum dolore eu feugiat nulla facilisis at vero eros et accumsan et iusto odio dignissim qui blandit praesent.

Lorem ipsum dolor sit amet, consectetuer adipiscing elit, sed diam nonummy nibh euismod tincidunt ut laoreet dolore magna aliquam erat volutpat. Ut wisi enim ad minim veniam, quis nostrud exerci tation ullamcorper suscipit lobortis nisl ut aliquip ex ea commodo consequat. Duis autem vel eum iriure dolor in hendrerit in vulputate velit esse molestie consequat, vel illum dolore eu feugiat nulla facilisis at vero eros et accumsan et iusto odio dignissim qui blandit praesent luptatum zzril delenit augue duis dolore te feugait nulla facilisi.

Nam liber tempor cum soluta nobis eleifend option congue nihil imperdiet doming id quod mazim placerat facer possim assum. Lorem ipsum dolor sit amet, consectetuer adipiscing elit, sed diam nonummy nibh euismod tincidunt ut laoreet dolore magna aliquam erat volutpat.

Best regards,

Josh S. Example
President
coc
Enclosures (2)

A one-sentence
"hook" benefit that
describes your
product or service

Furniture Mart, 4th Floor
123 Example Boulevard
Your City, ST 12345 6789
987 654 3210
987 654 3210 Fax
www.yourwebaddressz.com
E-mail info@emailaddressz.com

84

Business Card, Front 3.5 W by 2 H inches

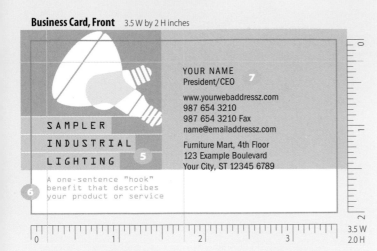

YOUR NAME
President/CEO

www.yourwebaddressz.com
987 654 3210
987 654 3210 Fax
name@emailaddressz.com

Furniture Mart, 4th Floor
123 Example Boulevard
Your City, ST 12345 6789

SAMPLER
INDUSTRIAL
LIGHTING

A one-sentence "hook"
benefit that describes
your product or service

3.5 W
2.0 H

Business Card, Back 3.5 W by 2 H inches

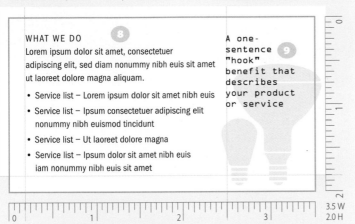

WHAT WE DO

Lorem ipsum dolor sit amet, consectetuer
adipiscing elit, sed diam nonummy nibh euis sit amet
ut laoreet dolore magna aliquam.

- Service list – Lorem ipsum dolor sit amet nibh euis
- Service list – Ipsum consectetuer adipiscing elit
 nonummy nibh euismod tincidunt
- Service list – Ut laoreet dolore magna
- Service list – Ipsum dolor sit amet nibh euis
 iam nonummy nibh euis sit amet

A one-
sentence
"hook"
benefit that
describes
your product
or service

3.5 W
2.0 H

Envelope, Commercial 9.5 W by 4.125 H inches

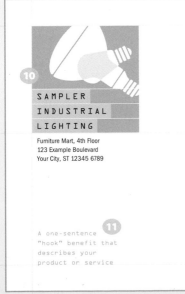

SAMPLER
INDUSTRIAL
LIGHTING

Furniture Mart, 4th Floor
123 Example Boulevard
Your City, ST 12345 6789

A one-sentence
"hook" benefit that
describes your
product or service

9.5 W
4.125 H

Letterhead

1 Lines 0.4pt; **Organization** OCR-A Regular, 9/15pt, align left; **2 Letter body** Minion, 12/18pt, align left; **3 Defining phrase** OCR-A Regular, 8/11pt, align left; **4 Address** Franklin Gothic Book, 8/12pt, align left

Business Card, Front

5 Lines 0.5pt; **Organization** OCR-A Regular, 9/15pt, align left; **6 Defining phrase** OCR-A Regular, 7/7pt, align left; **7 Address** Franklin Gothic Book, 8/9pt, align left

Business Card, Back

8 "WHAT" Franklin Gothic Book, 8/11pt, align left; **9 Defining phrase** OCR-A Regular, 8/9pt, align left

Envelope

10 Lines 0.35pt; **Organization** OCR-A Regular, 9/15pt, align left; **Address** Franklin Gothic Book, 7/9pt, align left; **11 Defining phrase** OCR-A Regular, 7/10pt, align left

Color

To be printed in black and a solid PANTONE Color Ink as defined on the palette below (see Step 9.3). (Because this book is printed in process colors (CMYK), the illustration is only a simulation of the actual solid PANTONE Color).

Light Olive or
PANTONE® 5845

100%
60%
30%

STYLE 8

Experimental

This layout breaks all the rules: The Z-folded letterhead and window envelope eliminate the need for a mailing label. The business card is designed to fit a rotary file. And every other aspect of the design—from the way the information is organized to the signature block on the right-hand column—flies in the face of convention.

Hopefully, it will cause you to question why we do things the way we've always done them and encourage you to rethink your letterhead, business card, and envelope.

SOURCE Illustrations: Penguin from *Designer's Club* from Dynamic Graphics 800-255-8800, 309-688-8800, www.dgusa.com, © Dynamic Graphics, all rights reserved.

Sampler Refrigeration

The letter is designed to be Z-folded so that the return and recipient's addresses show through the windows in the envelope. How much time and money will you save if you don't have to address an envelope?

Moving the address information to the left leaves a big space for your logo and defining phrase.

A clip art illustration is combined with a series of lines to give a sense of motion.

The design of the letterhead and rotary card use a windowpane grid to visually organize and present the information.

Lots of organizations would profit from offering its business card in the form of a rotary card. Your commercial printer can arrange to have it die-cut in the correct shape.

100%	
75%	
60%	
50%	
25%	
15%	

Tints are a cost-effective way to make a two-color layout far more visually interesting.

SOURCE Type families: Minion, Myriad, Adobe Systems, Inc., 800-682-3623, www.adobe.com/type.

? What you need

Breaking apart draw/vector artwork and editing the pieces requires a draw program such as Adobe Illustrator, CorelDRAW, or Macromedia FreeHand. Simple text and shapes can be produced with a desktop publishing program such as Adobe InDesign, Adobe PageMaker, QuarkXPress, or Microsoft Publisher.

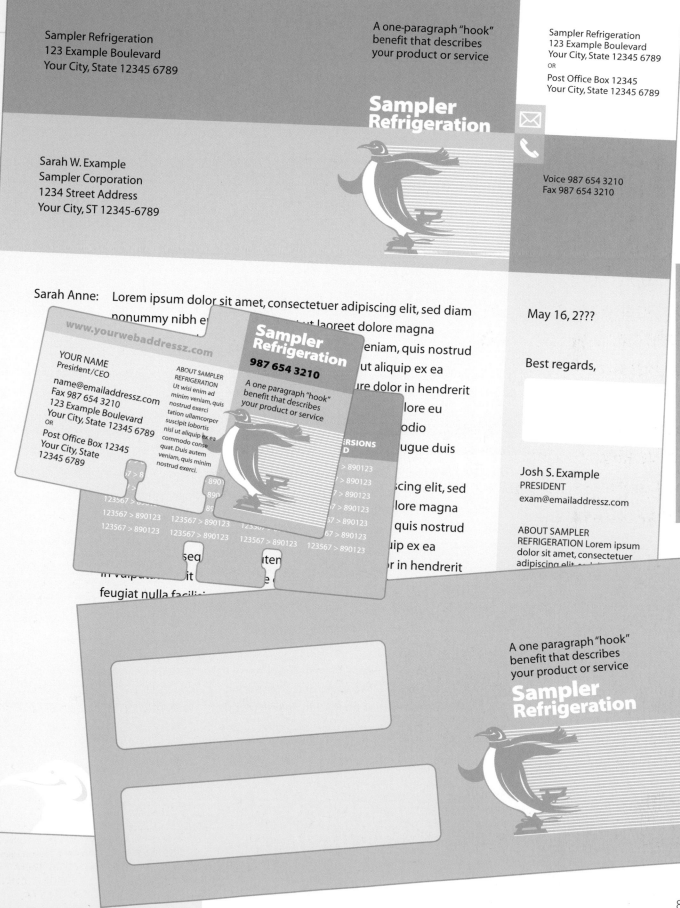

Sampler Refrigeration
123 Example Boulevard
Your City, State 12345 6789

1

A one-paragraph "hook"
benefit that describes
your product or service

3

Sampler Refrigeration
123 Example Boulevard
Your City, State 12345 6789
OR
Post Office Box 12345
Your City, State 12345 6789

5

**Sampler
Refrigeration**

4

Sarah W. Example
Sampler Corporation
1234 Street Address
Your City, ST 12345-6789

2

Voice 987 654 3210
Fax 987 654 3210

6

Sarah Anne: Lorem ipsum dolor sit amet, consectetuer adipiscing elit, sed diam nonummy nibh euismod tincidunt ut laoreet dolore magna aliquam erat volutpat. Ut wisi enim ad minim veniam, quis nostrud exerci tation ullamcorper suscipit lobortis nisl ut aliquip ex ea commodo consequat. Duis autem vel eum iriure dolor in hendrerit in vulputate velit esse molestie consequat, vel illum dolore eu feugiat nulla facilisis at vero eros et accumsan et iusto odio dignissim qui blandit praesent luptatum zzril delenit augue duis dolore te feugait nulla facilisi.

May 16, 2???

9

Best regards,

7

Lorem ipsum dolor sit amet, consectetuer adipiscing elit, sed diam nonummy nibh euismod tincidunt ut laoreet dolore magna aliquam erat volutpat. Ut wisi enim ad minim veniam, quis nostrud exerci tation ullamcorper suscipit lobortis nisl ut aliquip ex ea commodo consequat. Duis autem vel eum iriure dolor in hendrerit in vulputate velit esse molestie consequat, vel illum dolore eu feugiat nulla facilisis at vero eros et accumsan et iusto odio dignissim qui blandit praesent luptatum zzril delenit augue duis dolore te feugait nulla facilisi.

Nam liber tempor cum soluta nobis eleifend option congue nihil imperdiet doming id quod mazim placerat facer possim assum. Lorem ipsum dolor sit amet, consectetuer adipiscing elit, sed diam nonummy nibh euismod tincidunt ut laoreet dolore magna aliquam erat volutpat.

Josh S. Example
PRESIDENT
exam@emailaddressz.com

10

ABOUT SAMPLER
REFRIGERATION Lorem ipsum dolor sit amet, consectetuer adipiscing elit, sed diam nonummy nibh euismod tincidunt ut laoreet dolore magna aliquam erat volutpat.

11

ABOUT Mr. EXAMPLE Ut wisi enim ad minim veniam, quis nostrud exerci tation ullamcorper suscipit lobortis nisl ut aliquip ex ea commodo consequat. Duis autem vel eum iriure dolor in hendrerit in vulputate velit esse molestie consequat.

8

www.yourwebaddressz.com

Business Card, Front
4 W by 2.625 H inches

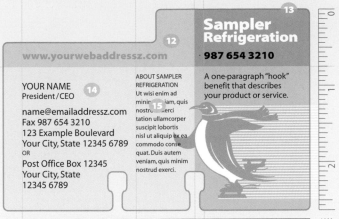

Business Card, Back
4 W by 2.625 H inches

CONVERSIONS TABLE A	CONVERSIONS TABLE B	CONVERSIONS TABLE C	CONVERSIONS TABLE D
123567 > 890123	123567 > 890123	123567 > 890123	123567 > 890123
123567 > 890123	123567 > 890123	123567 > 890123	123567 > 890123
123567 > 890123	123567 > 890123	123567 > 890123	123567 > 890123
123567 > 890123	123567 > 890123	123356/ > 890123	123567 > 890123
123567 > 890123	123567 > 890123	123567 > 890123	123567 > 890123
123567 > 890123	123567 > 890123	123567 > 890123	123567 > 890123
123567 > 890123	123567 > 890123	123567 > 890123	123567 > 890123

Envelope, Commercial
8.875 W by 3.875 H inches

Sampler Refrigeration
123 Example Boulevard
Your City, State 12345 6789

Sarah W. Example
Sampler Corporation
1234 Street Address
Your City, ST 12345-6789

A one-paragraph "hook" benefit that describes your product or service

Sampler Refrigeration

Letterhead

1 Return address Myriad Regular, 11/14pt, align left; **2** Send to address Myriad Regular, 11/14pt, align left; **3** Defining phrase Myriad Regular, 11/12pt, align left; **4** "Sampler" Myriad Multiple Master (MM), 830bl, 700se, 20pt, align left; "Refrigeration" Myriad MM, 830bl, 700se, 18pt, align left; **5** Address Myriad Regular, 9/10pt, align left; "OR" Myriad Regular, 6pt, align left; **6** Phone Myriad Regular, 9/10pt, align left; **7** Letter body Myriad Regular, 12/18pt, align left; **8** Web address Myriad MM, 830bl, 700se, 18pt; **9** Date/salutation Myriad Regular, 12pt, align left; **10** Name Myriad Regular, 12pt, align left; "PRESIDENT" Myriad Regular, 9/12pt, align left; **11** "ABOUT" Myriad Regular, 9/10pt, align left

Business Card, Front

12 Web address Myriad MM, 830bl, 700se, 10pt; **13** "Sampler" Myriad MM, 830bl, 700se, 17pt, align left; "Refrigeration" Myriad MM, 830bl, 700se, 14pt, align left; Phone Myriad MM, 830bl, 700se, 10pt, align left; Defining phrase Myriad Regular, 8/9pt, align left; **14** "NAME"/address Myriad Regular, 9/10pt, align left; Title Myriad Regular, 8pt, align left; "OR" Myriad Regular, 6pt, align left; **15** "ABOUT" Myriad Regular, 6/8pt, align left; **16** "CONVERSIONS" Myriad MM, 830bl, 700se, 7.5/7.5pt, align left; Numbers Myriad Regular, 7.5/12.5pt, align left

Envelope

17 Defining phrase Myriad Regular, 11/12pt, align left; "Sampler" Myriad MM, 830bl, 700se, 20pt, align left; "Refrigeration" Myriad MM, 830bl, 700se, 18pt, align left

Color

To be printed in black and a solid PANTONE Color Ink as defined on the palette below (see Step 9.3). (Because this book is printed in process colors (CMYK), the illustration is only a simulation of the actual solid PANTONE Color).

Sky Blue or PANTONE® 550

100%	
75%	
60%	
50%	
25%	
15%	

STYLE 9

Floating Objects

Everything on this layout is floating. Overlapping and offsetting the layers of type used to create the logo is a simple way to create the illusion of depth. Increasing the size of each instrument from top to bottom amplifies it.

When you include this many elements in a design, it is important to keep the background objects subtle. Too much contrast between the background and the instruments would make your letter difficult to read.

A drawing program is used to stack the four layers of the logo. The weight of the line that surrounds each letter (stroke weight) is adjusted to create the outlines.

A simple overlay of lines provides a background on which to position the logo.

Color is removed from the instrument clip art and the black lines are changed to a tint of the solid green spot color.

Increasing the size of the instruments from top to bottom creates the illusion of depth—larger images are closer, smaller images are farther away.

A one-paragraph "hook" benefit that describes your product or service

SOURCE Illustrations: Instruments from *Task Force Image Gallery* by NVTech, 800-387-0732, 613-727-8184, www.nvtech.com, © NVTech, all rights reserved.

SOURCES Type families: Giza, Font Bureau, 617-423-8770, www.fontbureau.com; Minion, Myriad, Adobe Systems, Inc., 800-682-3623, www.adobe.com/type.

? **What you need**

Breaking apart draw/vector artwork and editing the pieces requires a draw program such as Adobe Illustrator, CorelDRAW, or Macromedia FreeHand. Simple text and shapes can be produced with a desktop publishing program such as Adobe InDesign, Adobe PageMaker, QuarkXPress, or Microsoft Publisher.

SAMPLER
MUSIC

A one-paragraph "hook" benefit that describes
your product or service

Sarah W. Example
Director of Marketing
Sampler Corporation

May 16, 2???

SAMPLER
MUSIC

A one-paragraph "hook" benefit that describes
your product or service

YOUR NAME
President/CEO

EXAMPLE MALL 123 Example Boulevard, Your City, State 12345 6789
Voice 987 654 3210 Fax 987 654 3210
www.yourwebaddressz.com E-mail info@emailaddressz.com

amet, cons...
adipiscing elit, sed diam
nonummy nibh euismod
tincidunt ut laoreet
dolore magna aliquam
erat volutpat. Ut wisi
enim ad minim veniam,
quis nostrud.

adipiscing elit, sed diam nonummy nibh euismod
rat volutpat. Ut wisi enim ad minim veniam, quis
bortis nisl ut aliquip ex ea commodo consequat. Duis
lputate velit esse molestie consequat, vel illum dolore
san et iusto odio dignissim qui blandit praesent.

piscing e... nibh euismod
t volut...

corper suscipit lobortis ni...
autem vel eum iriure dolor in hendrerit in vulputate
eu feugiat nulla facilisis at vero eros et accumsan et
luptatum zzril delenit augue duis dolore te feugait

Nam liber tempor cum soluta nobis eleifend optio...
mazim placerat facer possim assum. Lorem ipsu...
diam nonummy nibh euismod tincidunt ut laore...

Best regards,

Josh S. Example
President
coc
Enclosures (2)

SAMPLER
MUSIC

A one-paragraph "hook" benefit that describes
your product or service

EXAMPLE MALL
123 Example Boulevard
Your City, State 12345 6789

S A M P L E R
MUSIC

A one-paragraph "hook" benefit that describes
your product or service

May 16, 2???

Sarah W. Example
Director of Marketing
Sampler Corporation
1234 Street Address
Your City, ST 12345-6789

Sarah:

Lorem ipsum dolor sit amet, consectetuer adipiscing elit, sed diam nonummy nibh euismod tincidunt ut laoreet dolore magna aliquam erat volutpat. Ut wisi enim ad minim veniam, quis nostrud exerci tation ullamcorper suscipit lobortis nisl ut aliquip ex ea commodo consequat. Duis autem vel eum iriure dolor in hendrerit in vulputate velit esse molestie consequat, vel illum dolore eu feugiat nulla facilisis at vero eros et accumsan et iusto odio dignissim qui blandit praesent.

Lorem ipsum dolor sit amet, consectetuer adipiscing elit, sed diam nonummy nibh euismod tincidunt ut laoreet dolore magna aliquam erat volutpat. Ut wisi enim ad minim veniam, quis nostrud exerci tation ullamcorper suscipit lobortis nisl ut aliquip ex ea commodo consequat. Duis autem vel eum iriure dolor in hendrerit in vulputate velit esse molestie consequat, vel illum dolore eu feugiat nulla facilisis at vero eros et accumsan et iusto odio dignissim qui blandit praesent luptatum zzril delenit augue duis dolore te feugait nulla facilisi.

Nam liber tempor cum soluta nobis eleifend option congue nihil imperdiet doming id quod mazim placerat facer possim assum. Lorem ipsum dolor sit amet, consectetuer adipiscing elit, sed diam nonummy nibh euismod tincidunt ut laoreet dolore magna aliquam erat volutpat.

Best regards,

Josh S. Example
President
coc
Enclosures (2)

EXAMPLE MALL 123 Example Boulevard, Your City, State 12345 6789
Voice 987 654 3210 Fax 987 654 3210 www.yourwebaddressz.com E-mail info@emailaddressz.com

Business Card, Front 3.5 W by 2 H inches

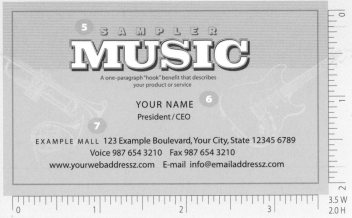

Business Card, Back 3.5 W by 2 H inches

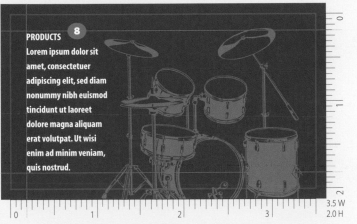

Envelope, Commercial 9.5 W by 4.125 H inches

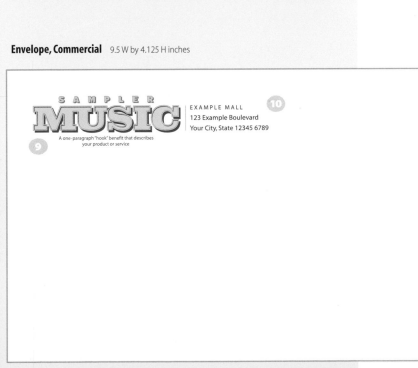

Letterhead

1 "SAMPLER" Interstate UltraBlack, 13.5pt, align center; "MUSIC" Giza SevenSeven, 54pt, align center; **2** Defining phrase Myriad Regular, 7/8pt, align center; **3** Letter body Minion, 12/18pt, align left; **4** "EXAMPLE" Myriad Regular, 6/10.5pt, align center; Address Myriad Regular, 7.5/10.5pt, align center

Business Card, Front

5 "SAMPLER" Interstate UltraBlack, 9pt, align center; "MUSIC" Giza SevenSeven, 35pt, align center; Defining phrase Myriad Regular, 5/6pt, align center; **6** Name Myriad Regular, 8pt, align center; Title Myriad Regular, 7pt, align center; **7** "EXAMPLE" Myriad Regular, 6/10pt, align center; Address Myriad Regular, 7.5/10pt, align center

Business Card, Back

8 Text Myriad Multiple Master (MM), 700bd, 300cn, 8/12pt, align left

Envelope

9 "SAMPLER" Interstate UltraBlack, 9pt, align center; "MUSIC" Giza SevenSeven, 35pt, align center; Defining phrase Myriad Regular, 5/6pt, align center; **10** "EXAMPLE" Myriad Regular, 6/10.5pt, align center; Address Myriad Regular, 7/10.5pt, align center

Color

To be printed in black and a solid PANTONE Color Ink as defined on the palette below (see Step 9.3). (Because this book is printed in process colors (CMYK), the illustration is only a simulation of the actual solid PANTONE Color).

Dark Green or PANTONE® 555

| 100% |
| 70% |
| 35% |
| 20% |
| 15% |

Warm Gray or PANTONE® 406

| 100% |
| 50% |

Black

| 75% |
| 60% |

STYLE 10

Flowchart

This is a "non-logo" logo. The closest thing to a conventional logo is the rectangle that holds the company name. Used alone, it is something less than exciting, but when combined with other brightly colored boxes and arrows, the overall effect is both interesting and versatile.

The same idea could easily be adapted to a brochure, signage, and packaging—each different from the next, incorporating the various angles of the marketing message.

The idea of a flowchart is almost universally understood and ideal for any organization that follows a series of steps to a solution.

To ensure they complement each other, the colors are a consecutive series from a standard color wheel.

The colors, tinted backgrounds, and borders visually punctuate the difference between one element and the next.

Sampler Network SYSTEMS

Sampler Network SYSTEMS

Note the differences between the rough and finished type. "Sampler" is reduced slightly, space is added between the letters of "SYSTEMS," and the space between lines and individual letters is tightened.

Sampler Network SYSTEMS

The name of the organization and the flowchart box form the logo. It is the one element that remains the same relative shape and size throughout the design.

you

Inserting "you" on each piece emphasizes your recognition of the fact that clients are the cornerstone of every business.

SOURCE Type families: Franklin Gothic, Minion, Adobe Systems, Inc., 800-682-3623, www.adobe.com/type.

What you need
The easiest way to create, position, and color these arrows, boxes, and text is a draw/vector program such as Adobe Illustrator, CorelDRAW, or Macromedia FreeHand. Simple text and shapes can be produced with a desktop publishing program such as Adobe InDesign, Adobe PageMaker, QuarkXPress, or Microsoft Publisher.

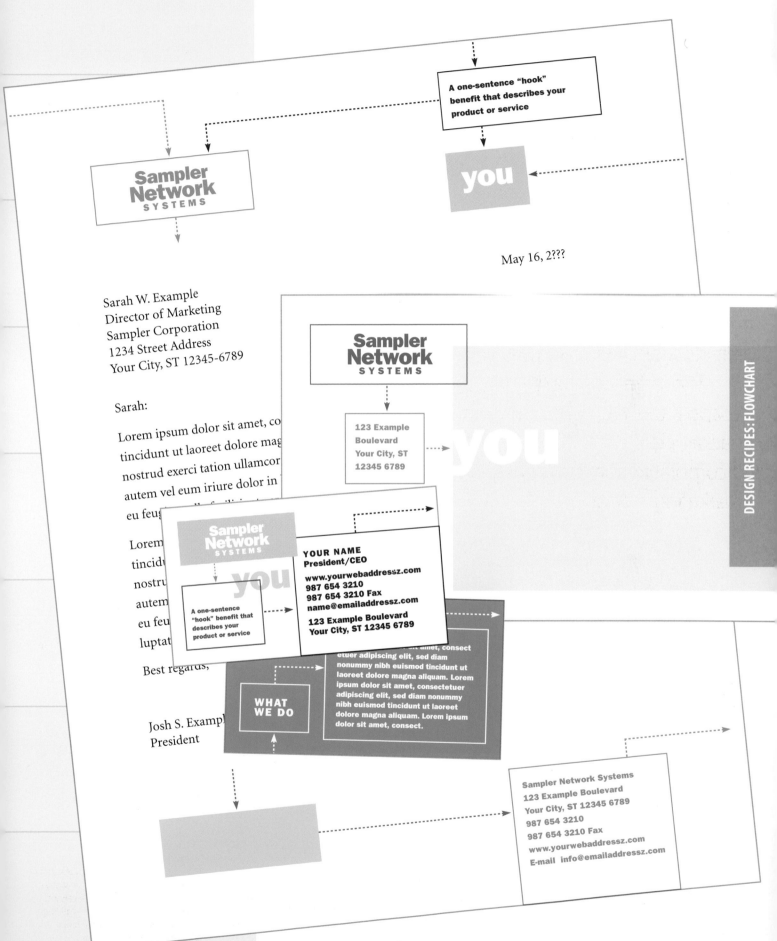

A one-sentence "hook" benefit that describes your product or service

you

May 16, 2???

Sarah W. Example
Director of Marketing
Sampler Corporation
1234 Street Address
Your City, ST 12345-6789

Sarah:

Lorem ipsum dolor sit amet, co
tincidunt ut laoreet dolore mag
nostrud exerci tation ullamcor
autem vel eum iriure dolor in
eu feug

Lorem
tincidu
nostru
autem
eu feu
luptat

Best regards,

Josh S. Exampl
President

Sampler Network SYSTEMS

123 Example Boulevard Your City, ST 12345 6789

you

YOUR NAME
President/CEO

www.yourwebaddressz.com
987 654 3210
987 654 3210 Fax
name@emailaddressz.com
123 Example Boulevard
Your City, ST 12345 6789

A one-sentence "hook" benefit that describes your product or service

you

amet, consect
etuer adipiscing elit, sed diam
nonummy nibh euismod tincidunt ut
laoreet dolore magna aliquam. Lorem
ipsum dolor sit amet, consectetuer
adipiscing elit, sed diam nonummy
nibh euismod tincidunt ut laoreet
dolore magna aliquam. Lorem ipsum
dolor sit amet, consect.

WHAT WE DO

Sampler Network Systems
123 Example Boulevard
Your City, ST 12345 6789
987 654 3210
987 654 3210 Fax
www.yourwebaddressz.com
E-mail info@emailaddressz.com

A one-sentence "hook" benefit that describes your product or service

you

Sampler Network SYSTEMS

Sarah W. Example
Director of Marketing
Sampler Corporation
1234 Street Address
Your City, ST 12345-6789

May 16, 2???

Sarah:

Lorem ipsum dolor sit amet, consectetuer adipiscing elit, sed diam nonummy nibh euismod tincidunt ut laoreet dolore magna aliquam erat volutpat. Ut wisi enim ad minim veniam, quis nostrud exerci tation ullamcorper suscipit lobortis nisl ut aliquip ex ea commodo consequat. Duis autem vel eum iriure dolor in hendrerit in vulputate velit esse molestie consequat, vel illum dolore eu feugiat nulla facilisis at vero eros et accumsan et iusto odio dignissim qui blandit praesent.

Lorem ipsum dolor sit amet, consectetuer adipiscing elit, sed diam nonummy nibh euismod tincidunt ut laoreet dolore magna aliquam erat volutpat. Ut wisi enim ad minim veniam, quis nostrud exerci tation ullamcorper suscipit lobortis nisl ut aliquip ex ea commodo consequat. Duis autem vel eum iriure dolor in hendrerit in vulputate velit esse molestie consequat, vel illum dolore eu feugiat nulla facilisis at vero eros et accumsan et iusto odio dignissim qui blandit praesent luptatum zzril delenit augue duis dolore te feugait nulla facilisi.

Best regards,

Josh S. Example
President

Sampler Network Systems
123 Example Boulevard
Your City, ST 12345 6789
987 654 3210
987 654 3210 Fax
www.yourwebaddressz.com
E-mail info@emailaddressz.com

Business Card, Front 3.5 W by 2 H inches

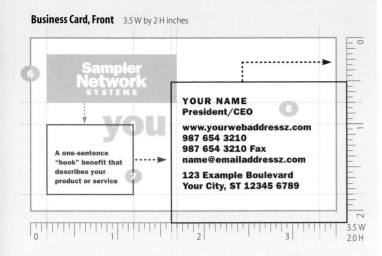

Business Card, Back 3.5 W by 2 H inches

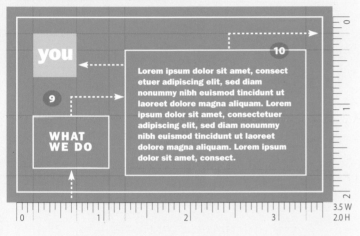

Letterhead

1 Lines 0.9pt; "Sampler" Franklin Gothic Heavy, 17pt, align center; "Network" Franklin Gothic Heavy, 20pt, align center; "SYSTEMS" Franklin Gothic Heavy, 9pt, align center; **2** Defining phrase Franklin Gothic Heavy, 8/12pt, align left; **3** "you" Franklin Gothic Heavy, 28pt; **4** Letter body Minion, 12/18pt, align left; **5** Address Franklin Gothic Heavy, 8/12pt, align left

Business Card, Front

6 Lines 0.9pt; Organization "Sampler" Franklin Gothic Heavy, 13pt, align center; "Network" Franklin Gothic Heavy, 15pt, align center; "SYSTEMS" Franklin Gothic Heavy, 7pt, align center; **7** Defining phrase Franklin Gothic Heavy, 6/8pt, align left; "you" Franklin Gothic Heavy, 32pt; **8** Address Franklin Gothic Heavy, 8/9pt, align left

Business Card, Back

9 "you" Franklin Gothic Heavy, 18pt; "WHAT" Franklin Gothic Heavy, 10pt, align left; **10** Lines 0.9pt; Text Franklin Gothic Heavy, 7/8pt, align left

Envelope

11 Lines 0.9pt; "Sampler" Franklin Gothic Heavy, 17pt, align center; "Network" Franklin Gothic Heavy, 20pt, align center; "SYSTEMS" Franklin Gothic Heavy, 9pt, align center; **12** Address Franklin Gothic Heavy, 8/12pt, align left; "you" Franklin Gothic Heavy, 60pt

Color

Printed in four-color process (see Step 9.3) using values of cyan, magenta, yellow, and black (CMYK) as defined on the color palette below. Actual color will vary.

Envelope, Commercial 9.5 W by 4.125 H inches

Process Colors

C0	M50	Y100	K0
C0	M25	Y50	K0
C0	M100	Y70	K10
C15	M20	Y0	K3
C60	M70	Y0	K10
C25	M10	Y0	K0
C85	M35	Y0	K0
C35	M0	Y5	K2
C75	M0	Y15	K5
C12	M0	Y5	K3

STYLE 11

Form

A well-designed form effectively organizes lots of information. The same principles can be applied to your letterhead, business card, and envelope.

The goal is to create an feeling of both elegance and organization—an image that might also be appropriate for an accounting or legal firm, a Web designer, a consultant, and so on.

Each cell of the form holds an important tidbit of information—the mission or defining phrase, the date the organization was founded, affiliations, a list of products and services, and the phone, fax, and street, Web site and e-mail addresses.

SAMPLER JEWELERS

The spot color and a tint of that color is added to a simple black and white jewel icon.

The background for the jewel is a heart-shaped, diamond-cut illustration colored with a subtle tint of the same spot color.

The icons from several different sources are centered on a solid circle to make them look as if they were designed for just this purpose.

The "S" is slightly larger than the "AMPLER"— a simple but important detail.

S A

To play on the form theme, a list of the company's products and services is listed as if they might be checked off.

SOURCES Illustrations: Gem, page, from *Objects & Icons* from Image Club Clip Art, 800-661-9410, 403-294-3195, www.eyewire.com, © Image Club Graphics, all rights reserved; heart, mail, phone, from *Design Elements* by Ultimate Symbol, 800-611-4761, 914-942-0003, www.ultimatesymbol.com, © Ultimate Symbol, all rights reserved.

SOURCE Type families: Caslon, Franklin Gothic, Minion, Adobe Systems, Inc., 800-682-3623, www.adobe.com/type.

? What you need

Breaking apart draw/vector artwork and editing the pieces requires a draw program such as Adobe Illustrator, CorelDRAW, or Macromedia FreeHand. Simple text and shapes can be produced with a desktop publishing program such as Adobe InDesign, Adobe PageMaker, QuarkXPress, or Microsoft Publisher.

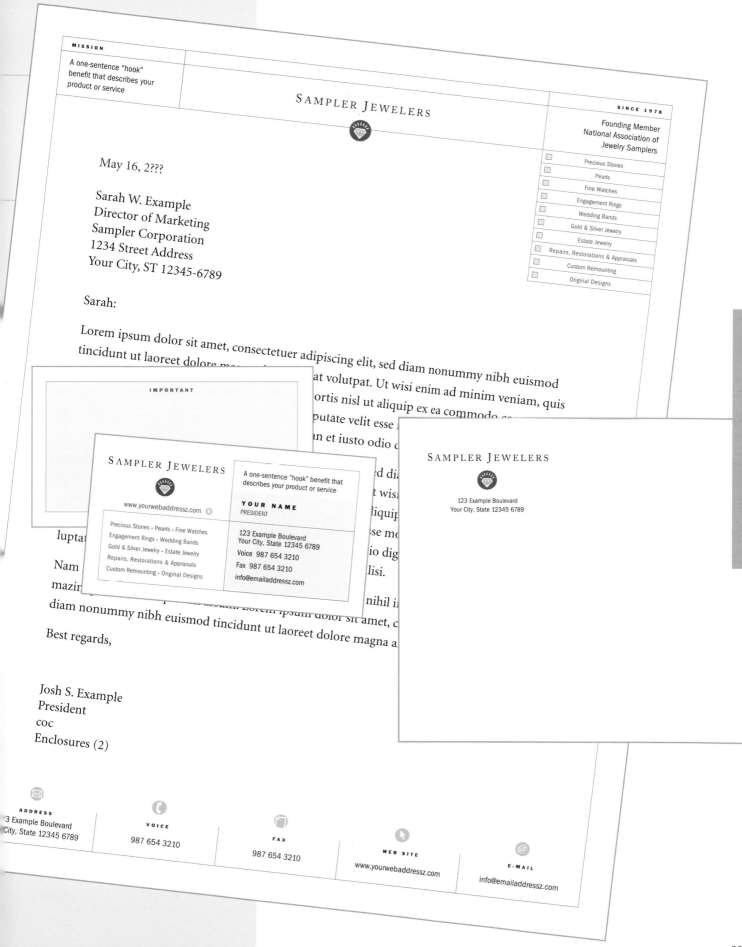

MISSION

A one-sentence "hook" benefit that describes your product or service

S A M P L E R J E W E L E R S

SINCE 1978

Founding Member
National Association of
Jewelry Samplers

☐ Precious Stones
☐ Pearls
☐ Fine Watches
☐ Engagement Rings
☐ Wedding Bands
☐ Gold & Silver Jewelry
☐ Estate Jewelry
☐ Repairs, Restorations & Appraisals
☐ Custom Remounting
☐ Original Designs

May 16, 2???

Sarah W. Example
Director of Marketing
Sampler Corporation
1234 Street Address
Your City, ST 12345-6789

Sarah:

Lorem ipsum dolor sit amet, consectetuer adipiscing elit, sed diam nonummy nibh euismod tincidunt ut laoreet dolore ma... ...at volutpat. Ut wisi enim ad minim veniam, quis ...ortis nisl ut aliquip ex ea commodoputate velit essen et iusto odio d... ...d dia...

IMPORTANT

S A M P L E R J E W E L E R S

www.yourwebaddressz.com

A one-sentence "hook" benefit that describes your product or service

YOUR NAME
PRESIDENT

Precious Stones · Pearls · Fine Watches
Engagement Rings · Wedding Bands
Gold & Silver Jewelry · Estate Jewelry
Repairs, Restorations & Appraisals
Custom Remounting · Original Designs

123 Example Boulevard
Your City, State 12345 6789
Voice 987 654 3210
Fax 987 654 3210
info@emailaddressz.com

S A M P L E R J E W E L E R S

123 Example Boulevard
Your City, State 12345 6789

luptat...

Nam ...
mazin...
diam nonummy nibh euismod tincidunt ut laoreet dolore magna a...

Best regards,

Josh S. Example
President
coc
Enclosures (2)

ADDRESS
3 Example Boulevard
City, State 12345 6789

VOICE
987 654 3210

FAX
987 654 3210

WEB SITE
www.yourwebaddressz.com

E-MAIL
info@emailaddressz.com

MISSION

A one-sentence "hook" benefit that describes your product or service

SAMPLER JEWELERS

SINCE 1978

Founding Member
National Association of
Jewelry Samplers

☐ Precious Stones
☐ Pearls
☐ Fine Watches
☐ Engagement Rings
☐ Wedding Bands
☐ Gold & Silver Jewelry
☐ Estate Jewelry
☐ Repairs, Restorations & Appraisals
☐ Custom Remounting
☐ Original Designs

May 16, 2???

Sarah W. Example
Director of Marketing
Sampler Corporation
1234 Street Address
Your City, ST 12345-6789

Sarah:

Lorem ipsum dolor sit amet, consectetuer adipiscing elit, sed diam nonummy nibh euismod tincidunt ut laoreet dolore magna aliquam erat volutpat. Ut wisi enim ad minim veniam, quis nostrud exerci tation ullamcorper suscipit lobortis nisl ut aliquip ex ea commodo consequat. Duis autem vel eum iriure dolor in hendrerit in vulputate velit esse molestie consequat, vel illum dolore eu feugiat nulla facilisis at vero eros et accumsan et iusto odio dignissim qui blandit praesent.

Lorem ipsum dolor sit amet, consectetuer adipiscing elit, sed diam nonummy nibh euismod tincidunt ut laoreet dolore magna aliquam erat volutpat. Ut wisi enim ad minim veniam, quis nostrud exerci tation ullamcorper suscipit lobortis nisl ut aliquip ex ea commodo consequat. Duis autem vel eum iriure dolor in hendrerit in vulputate velit esse molestie consequat, vel illum dolore eu feugiat nulla facilisis at vero eros et accumsan et iusto odio dignissim qui blandit praesent luptatum zzril delenit augue duis dolore te feugait nulla facilisi.

Nam liber tempor cum soluta nobis eleifend option congue nihil imperdiet doming id quod mazim placerat facer possim assum. Lorem ipsum dolor sit amet, consectetuer adipiscing elit, sed diam nonummy nibh euismod tincidunt ut laoreet dolore magna aliquam erat volutpat.

Best regards,

Josh S. Example
President

ADDRESS
123 Example Boulevard
Your City, State 12345 6789

VOICE
987 654 3210

FAX
987 654 3210

WEB SITE
www.yourwebaddressz.com

E-MAIL
info@emailaddressz.com

Business Card, Front 3.5 W by 2 H inches

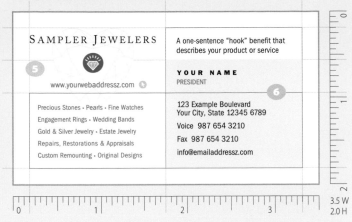

Business Card, Back 3.5 W by 2 H inches

Envelope, Commercial 9.5 W by 4.125 H inches

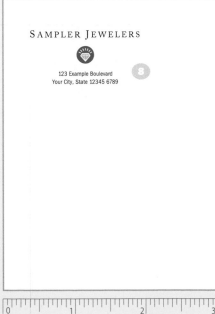

Letterhead

1 "MISSION" Franklin Gothic Roman Bold, 4pt, align left; **Defining phrase** Franklin Gothic Book Condensed, 8/10pt, align left; "**S**" Adobe Caslon Regular, 11pt, align center; "**AMPLER**" Adobe Caslon Regular, 9pt, align center; **2 Lines** 0.25pt; "**SINCE**" Franklin Gothic Roman Bold, 4pt, align right; "**Founding**" Franklin Gothic Book Condensed, 8/10pt, align right; "**Precious**" Franklin Gothic Book Condensed, 6/12pt, align center; **3 Letter body** Minion, 12/18pt, align left; **4** "ADDRESS" Franklin Gothic Roman Bold, 4pt, align center; **Address** Franklin Gothic Book Condensed, 8/10pt, align center

Business Card, Front

5 "**S**" Adobe Caslon Regular, 9.5pt, align center; "**AMPLER**" Adobe Caslon Regular, 7.5pt, align center; **Web Address** Franklin Gothic Book Condensed, 7/8pt, align center; **Lines** 0.25pt; "**Precious**" Franklin Gothic Book Condensed, 7/8pt, align left; **6 Defining phrase** Franklin Gothic Book Condensed, 8/10pt, align left; **Name** Franklin Gothic Roman Bold, 5pt, align left; **Title** Franklin Gothic Book Condensed, 6pt, align left; **Address** Franklin Gothic Book Condensed, 7/11pt, align left

Business Card, Back

7 "IMPORTANT" Franklin Gothic Roman Bold, 4pt, align center; **Lines** 0.25pt

Envelope

8 "**S**" Adobe Caslon Regular, 10pt; "**AMPLER**" Adobe Caslon Regular, 8pt, align center; **Address** Franklin Gothic Book Condensed, 6/8pt, align center

Color

To be printed in black and a solid PANTONE Color Ink as defined on the palette below (see Step 9.3). (Because this book is printed in process colors (CMYK), the illustration is only a simulation of the actual solid PANTONE Color).

Teal or
PANTONE® 569

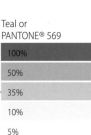

STYLE 12

Horizontal Bar

Want to witness the real power of design? Do you doubt that if this organization used the Border Style on page 63, your impression would be significantly different?

This style is modern and progressive, while the Border Style has a historical, traditional look and feel. It's not a case of one being better than the other—it simply serves to demonstrate how style helps define your organization.

If you can't put your finger on the attitude a particular design portrays, survey your audience.

The church photograph is scanned in grayscale. The rotated and cropped version looks as if you are zooming in on the subject with a hand-held camera.

The original color image is converted to black and white and cropped to match the size, shape, and feel of the church photograph.

The sans serif typeface builds on the progressive attitude of the photographs. A traditional serif typeface such as Caslon or a script such as Bickham (see page 31) would change the look completely.

No space is wasted. Printing the back of your business card only costs a little more but gives you twice as much usable space. In this case, a valuable addition is a map that pinpoints the church's location.

SOURCE Illustrations: Church/steeple from author; stained glass from *ClickArt 200,000* from Broderbund, available from software retailers worldwide, © T/Maker, all rights reserved.

SOURCE Type families: Berthold Akzidenz-Grotesk, Minion, Adobe Systems, Inc., 800-682-3623, www.adobe.com/type.

? What you need

Creating artwork for the map requires a draw program such as Adobe Illustrator, CorelDRAW, or Macromedia FreeHand. Editing photographic images requires a paint or digital imaging program such as Adobe Photoshop or Jasc Software's Paint Shop Pro. Simple text and shapes can be produced with a desktop publishing program such as Adobe InDesign, Adobe PageMaker, QuarkXPress, or Microsoft Publisher.

First Sampler Church
A one-sentence "hook" benefit that describes your product or service

Sarah W. Example
Director of Marketing
Sampler Corporation
1234 Street Address
Your City, ST 12345-6789

May 16, 2???

Sarah:

Lorem ipsum dolor sit amet, c
tincidunt ut laoreet dolore ma
nostrud exerci tation ullamco
autem vel eum iriure dolor ir
eu feugiat nulla facilisis at vero eros et accumsa

Lorem ipsum dolor sit amet, consectetu
tincidunt ut laore
nostrud exerci tat
autem vel eum iri
eu feugiat nulla fa
luptatum zzril del

Nam liber tempor
mazim placerat fac
diam nonummy nil

Best regards,

Josh S. Example
President
coc
Enclosures (2)

YOUR NAME
Minister of Music

www.yourwebaddressz.com
987 654 3210
987 654 3210 Fax
name@emailaddressz.com

123 Example Boulevard
Your City, ST 12345 6789

First Sampler Church
A one-sentence "hook" benefit that describes your product or service

First Sampler C
123 Example Boulevard, Y

Sampler Road
Sampler Road
Sampler Road

★ First Sampler Church
123 Example Boulevard
Your City, ST 12345
987 654 3210

34
6
45

DESIGN RECIPES: HORIZONTAL BAR

First Sampler Church
A one-sentence "hook" benefit that describes your product or service

Sarah W. Example May 16, 2???
Director of Marketing
Sampler Corporation
1234 Street Address
Your City, ST 12345-6789

Sarah:

Lorem ipsum dolor sit amet, consectetuer adipiscing elit, sed diam nonummy nibh euismod tincidunt ut laoreet dolore magna aliquam erat volutpat. Ut wisi enim ad minim veniam, quis nostrud exerci tation ullamcorper suscipit lobortis nisl ut aliquip ex ea commodo consequat. Duis autem vel eum iriure dolor in hendrerit in vulputate velit esse molestie consequat, vel illum dolore eu feugiat nulla facilisis at vero eros et accumsan et iusto odio dignissim qui blandit praesent.

Lorem ipsum dolor sit amet, consectetuer adipiscing elit, sed diam nonummy nibh euismod tincidunt ut laoreet dolore magna aliquam erat volutpat. Ut wisi enim ad minim veniam, quis nostrud exerci tation ullamcorper suscipit lobortis nisl ut aliquip ex ea commodo consequat. Duis autem vel eum iriure dolor in hendrerit in vulputate velit esse molestie consequat, vel illum dolore eu feugiat nulla facilisis at vero eros et accumsan et iusto odio dignissim qui blandit praesent luptatum zzril delenit augue duis dolore te feugait nulla facilisi.

Nam liber tempor cum soluta nobis eleifend option congue nihil imperdiet doming id quod mazim placerat facer possim assum. Lorem ipsum dolor sit amet, consectetuer adipiscing elit, sed diam nonummy nibh euismod tincidunt ut laoreet dolore magna aliquam erat volutpat.

Best regards,

Josh S. Example
President
coc
Enclosures (2)

First Sampler Church 123 Example Boulevard, Your City, ST 12345 6789
987 654 3210 987 654 3210 Fax www.yourwebaddressz.com E-mail info@emailaddressz.com

Business Card, Front
3.5 W by 2 H inches

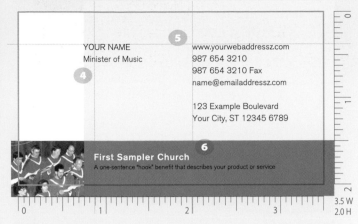

Business Card, Back
3.5 W by 2 H inches

Letterhead

1 Organization Berthold Akzidenz-Grotesk Medium, 10pt, align left; Defining phrase Berthold Akzidenz-Grotesk Light, 7pt, align left; **2** Letter body Minion, 12/18pt, align left; **3** Address Berthold Akzidenz-Grotesk Light, 7/10pt, align left

Business Card, Front

4 Name Berthold Akzidenz-Grotesk Light, 7/10pt, align left; **5** Address Berthold Akzidenz-Grotesk Light, 7/10pt, align left; **6** Organization Berthold Akzidenz-Grotesk Medium, 7.5pt, align left; Defining phrase Berthold Akzidenz-Grotesk Light, 5.25pt, align left

Business Card, Back

7 Organization Berthold Akzidenz-Grotesk Medium, 6pt, align center; Text Berthold Akzidenz-Grotesk Light, 6/7pt, align left

Envelope

8 Organization Berthold Akzidenz-Grotesk Medium, 10pt, align left; Address Berthold Akzidenz-Grotesk Light, 7pt, align left

Color

To be printed in black and a solid PANTONE Color Ink as defined on the palette below (see Step 9.3). (Because this book is printed in process colors (CMYK) the illustration is only a simulation of the actual solid PANTONE Color).

Envelope, Commercial
9.5 W by 4.125 H inches

Steel Blue or PANTONE® 652

100%	
50%	
10%	

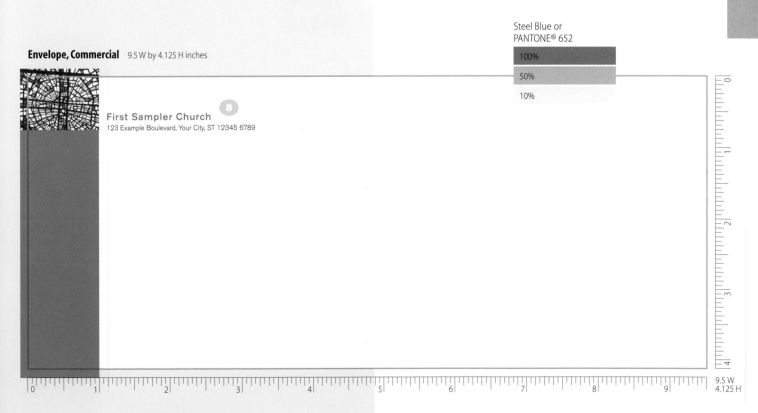

STYLE 13

Lines

A design grid is an invisible series of lines used as the framework of a layout (see Step 9.6). This style uses grid-like lines as the foundation of the design itself. They are not only decorative; they form spaces for each information element.

This bright, fresh-looking photograph makes a great "non-logo" logo. The life jacket is a symbol of water and also promotes water safety. But the reason it works well is because it's an unexpected solution.

The grid is slightly taller than it is wide to better accommodate the photograph. Adjust yours to match the shape of your visual.

A one-paragr
hook benefit
describes you
product or se
lorem ipsum
sit amet, con
adipiscing el

The type in all the cells is equidistant from the corner—at least one whole letterspace away. Space is added between lines of type to make the paragraph fit the space top to bottom.

A line pattern is used to decorate the front and back of the business card. The kind of simple change that makes each piece—letterhead, business card, and envelope—unique.

A slight shadow is added to the life jacket to raise it off the page.

S A M P L E R
M A R I N A

A one-paragraph
hook benefit that
describes your
product or service
lorem ipsum dolo
sit amet, consecr
adipiscing elit

A bold typeface is used to emphasize the importance of the defining phrase.

S A M P L E R
M A R I N A

? What you need

Editing photographic images requires a paint or digital imaging program such as Adobe Photoshop or Jasc Software's Paint Shop Pro. Simple text, lines, and shapes can be produced with a desktop publishing program such as Adobe InDesign, Adobe PageMaker, QuarkXPress, or Microsoft Publisher.

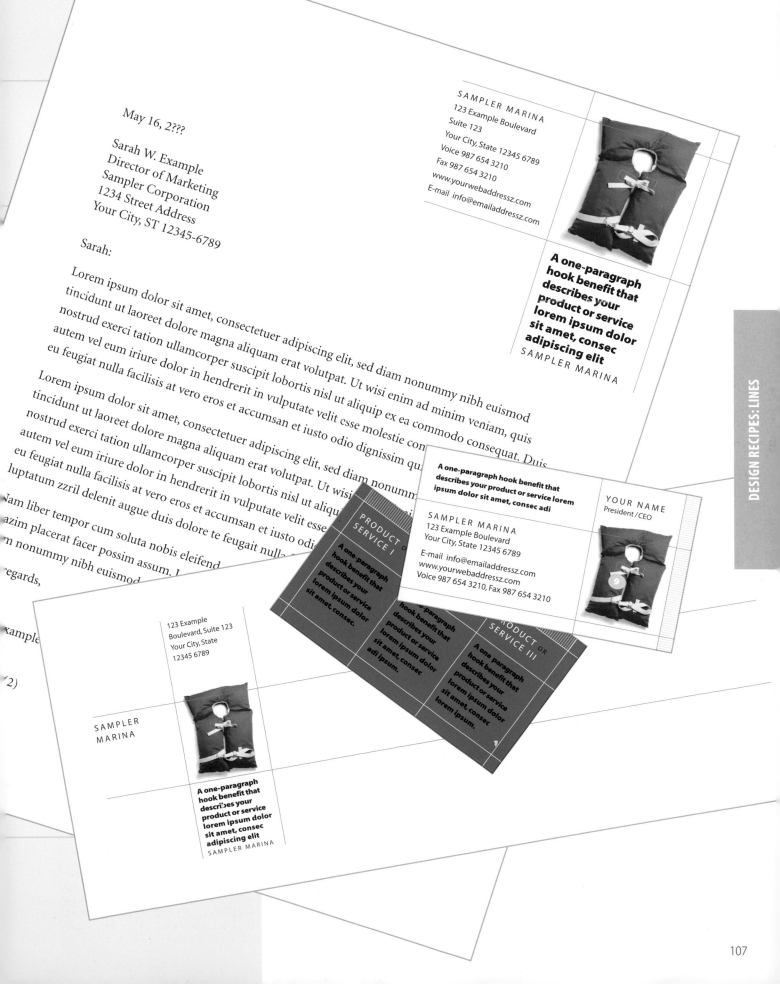

May 16, 2???

Sarah W. Example
Director of Marketing
Sampler Corporation
1234 Street Address
Your City, ST 12345-6789

Sarah:

Lorem ipsum dolor sit amet, consectetuer adipiscing elit, sed diam nonummy nibh euismod tincidunt ut laoreet dolore magna aliquam erat volutpat. Ut wisi enim ad minim veniam, quis nostrud exerci tation ullamcorper suscipit lobortis nisl ut aliquip ex ea commodo consequat. Duis autem vel eum iriure dolor in hendrerit in vulputate velit esse molestie con eu feugiat nulla facilisis at vero eros et accumsan et iusto odio dignissim qu

Lorem ipsum dolor sit amet, consectetuer adipiscing elit, sed diam nonumm tincidunt ut laoreet dolore magna aliquam erat volutpat. Ut wisi nostrud exerci tation ullamcorper suscipit lobortis nisl ut aliqu autem vel eum iriure dolor in hendrerit in vulputate velit esse eu feugiat nulla facilisis at vero eros et accumsan et iusto odi luptatum zzril delenit augue duis dolore te feugait nulla

Nam liber tempor cum soluta nobis eleifend azim placerat facer possim assum. L n nonummy nibh euismod

egards,

xample

2)

SAMPLER MARINA
123 Example Boulevard
Suite 123
Your City, State 12345 6789
Voice 987 654 3210
Fax 987 654 3210
www.yourwebaddressz.com
E-mail info@emailaddressz.com

A one-paragraph hook benefit that describes your product or service lorem ipsum dolor sit amet, consec adipiscing elit
SAMPLER MARINA

A one-paragraph hook benefit that describes your product or service lorem ipsum dolor sit amet, consec adi

SAMPLER MARINA
123 Example Boulevard
Your City, State 12345 6789

E-mail info@emailaddressz.com
www.yourwebaddressz.com
Voice 987 654 3210, Fax 987 654 3210

YOUR NAME
President / CEO

PRODUCT OR SERVICE I
A one-paragraph hook benefit that describes your product or service lorem ipsum dolor sit amet consec.

A one-paragraph hook benefit that describes your product or service lorem ipsum dolor sit amet, consec adi ipsum.

PRODUCT OR SERVICE III
A one-paragraph hook benefit that describes your product or service lorem ipsum dolor sit amet, consec lorem ipsum.

123 Example
Boulevard, Suite 123
Your City, State
12345 6789

SAMPLER MARINA

A one-paragraph hook benefit that describes your product or service lorem ipsum dolor sit amet, consec adipiscing elit
SAMPLER MARINA

SAMPLER MARINA
123 Example Boulevard
Suite 123
Your City, State 12345 6789
Voice 987 654 3210
Fax 987 654 3210
www.yourwebaddressz.com
E-mail info@emailaddressz.com

A one-paragraph hook benefit that describes your product or service lorem ipsum dolor sit amet, consec adipiscing elit
SAMPLER MARINA

May 16, 2???

Sarah W. Example
Director of Marketing
Sampler Corporation
1234 Street Address
Your City, ST 12345-6789

Sarah:

Lorem ipsum dolor sit amet, consectetuer adipiscing elit, sed diam nonummy nibh euismod tincidunt ut laoreet dolore magna aliquam erat volutpat. Ut wisi enim ad minim veniam, quis nostrud exerci tation ullamcorper suscipit lobortis nisl ut aliquip ex ea commodo consequat. Duis autem vel eum iriure dolor in hendrerit in vulputate velit esse molestie consequat, vel illum dolore eu feugiat nulla facilisis at vero eros et accumsan et iusto odio dignissim qui blandit praesent.

Lorem ipsum dolor sit amet, consectetuer adipiscing elit, sed diam nonummy nibh euismod tincidunt ut laoreet dolore magna aliquam erat volutpat. Ut wisi enim ad minim veniam, quis nostrud exerci tation ullamcorper suscipit lobortis nisl ut aliquip ex ea commodo consequat. Duis autem vel eum iriure dolor in hendrerit in vulputate velit esse molestie consequat, vel illum dolore eu feugiat nulla facilisis at vero eros et accumsan et iusto odio dignissim qui blandit praesent luptatum zzril delenit augue duis dolore te feugait nulla facilisi.

Nam liber tempor cum soluta nobis eleifend option congue nihil imperdiet doming id quod mazim placerat facer possim assum. Lorem ipsum dolor sit amet, consectetuer adipiscing elit, sed diam nonummy nibh euismod tincidunt ut laoreet dolore magna aliquam erat volutpat.

Best regards,

Josh S. Example
President
coc
Enclosures (2)

Business Card, Front
3.5 W by 2 H inches

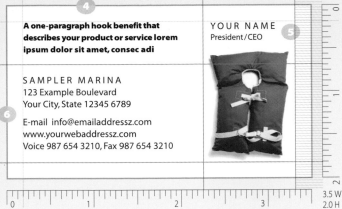

A one-paragraph hook benefit that describes your product or service lorem ipsum dolor sit amet, consec adi

SAMPLER MARINA
123 Example Boulevard
Your City, State 12345 6789

E-mail info@emailaddressz.com
www.yourwebaddressz.com
Voice 987 654 3210, Fax 987 654 3210

YOUR NAME
President/CEO

3.5 W
2.0 H

Business Card, Back
3.5 W by 2 H inches

PRODUCT OR SERVICE I

PRODUCT OR SERVICE II

PRODUCT OR SERVICE III

A one-paragraph hook benefit that describes your product or service lorem ipsum dolor sit amet, consec.

A one-paragraph hook benefit that describes your product or service lorem ipsum dolor sit amet, consec adi ipsum.

A one-paragraph hook benefit that describes your product or service lorem ipsum dolor sit amet, consec lorem ipsum.

3.5 W
2.0 H

Envelope, Commercial
9.5 W by 4.125 H inches

123 Example Boulevard, Suite 123 Your City, State 12345 6789

SAMPLER MARINA

A one-paragraph hook benefit that describes your product or service lorem ipsum dolor sit amet, consec adipiscing elit
SAMPLER MARINA

9.5 W
4.125 H

Letterhead
1 Organization/Address Myriad Regular, 8/13pt, align left; **Lines** 0.5pt; **2 Defining phrase** Myriad Multiple Master (MM), 830bl, 700se, 11/12.5pt, align left; **"SAMPLER"** Myriad Regular, 9pt, align left; **3 Letter body** Minion, 12/18pt, align left

Business Card, Front
4 Defining phrase Myriad MM, 830bl, 700se, 7/10pt, align left; **Lines** 0.5pt; **5 Name** Myriad Regular, 8pt, align left; **Title** Myriad Regular, 7pt, align left; **6 Organization/Address** Myriad Regular, 8/10pt, align left

Business Card, Back
7 "PRODUCT" Myriad Regular, 8/10pt, align left; **"OR"** Myriad Regular, 6pt, align left; **8 Lines** 0.5pt; **Text** Myriad MM, 830bl, 700se, 7/10pt, align left

Envelope
9 Lines .5pt; **Address** Myriad Regular, 7/10pt, align left; **10 Organization** Myriad Regular, 8/11pt, align left; **Defining phrase** Myriad MM, 830bl, 700se, 7/8pt, align left; **"SAMPLER"** Myriad Regular, 6pt, align left

Color
Printed in four-color process (see Step 9.3) using values of cyan, magenta, yellow, and black (CMYK) as defined on the color palette below. Actual color will vary.

Process Colors

C5	M75	Y100	K0
C0	M60	Y80	K0
C0	M25	Y35	K0

STYLE 14

Opposing Elements

Convention suggests we group elements together—if nothing else, certainly the logo artwork and the organization's name.

Most of the logos explored in this book follow that convention. But there's something to be said for exploring the idea of opposing elements. It adds interest and can be used to draw attention to a specific area of the page.

On this letterhead, the logo is on the left and the name is opposite on the right. On the business card, the logo is offset from all the text. It is a small distinction but worth considering.

SOURCE Illustrations: Cat from Dick & Jane font from DsgnHaus, Inc., 800-942-9110, 203-367-1993, www.fonthaus.com.

The cat is from a picture font. Instead of typing characters, each key of a picture font produces a different picture. Because the characters are often used at small sizes, they're good germs for logo design ideas.

A simple shape is added to give the image a boundary and weight.

A combination of very bold and very light typeface weights adds emphasis to one word or the other.

SamplerKennels **Sampler**Kennels

Kennels
Kennels
eee

The lighter word is stretched slightly to compensate for the difference in the width of the letters. Lighter weights of type are typically more condensed than bolder weights.

The back of the business card is put to good use. In this case, a floor plan of the kennel's guest accommodations.

SOURCE Type families: Fruitger, Minion, Adobe Systems, Inc., 800-682-3623, www.adobe.com/type.

? What you need
Breaking apart draw/vector artwork and editing the pieces requires a draw program such as Adobe Illustrator, CorelDRAW, or Macromedia FreeHand. Simple text and shapes can be produced with a desktop publishing program such as Adobe InDesign, Adobe PageMaker, QuarkXPress, or Microsoft Publisher.

A one-paragraph "hook" benefit that describes your product or service

SamplerKennels

May 16, 2???

Sarah W. Example
Director of Marketing
Sampler Corporation
1234 Street Address
Your City, ST 12345-6789

Sarah·

Lorem ipsum dolor sit amet, consectetuer ad
tincidunt ut laoreet dolore magna aliquam e
nostrud exerci tation ullamcorper suscipit lo
autem vel eum iriure dolor in hendrerit in vu
eu feugiat nulla facilisis at v

Lorem ipsum dolor sit am
tincidunt ut laoreet dolor
nostrud exerci tation ulla
autem vel eum iriure do
eu feugiat nulla facilisis
luptatum zzril delenit

Nam liber tempor cu
mazim placerat face
diam nonummy nil

Best regards,

Josh S. Example
President
coc
Enclosures (2)

Guest Suite floorplan

Sleep Area — Fresh Air Vent — **Guest Suite** — Clean Area — Porch — Spring Bowl — Food Dispensers

123 Example Boulevard
Your City, State 12345 6789
A one-paragraph "hook"
benefit that describes your
product or service

my nibh euismod

SamplerKennels

123 Examp
Your City, State 12345 6
www.yourwebaddressz.com
E-mail info@emailaddressz.com

A one-paragraph "hook"
benefit that describes your
product or service

SamplerKennels

May 16, 2???

Sarah W. Example
Director of Marketing
Sampler Corporation
1234 Street Address
Your City, ST 12345-6789

Sarah:

Lorem ipsum dolor sit amet, consectetuer adipiscing elit, sed diam nonummy nibh euismod
tincidunt ut laoreet dolore magna aliquam erat volutpat. Ut wisi enim ad minim veniam, quis
nostrud exerci tation ullamcorper suscipit lobortis nisl ut aliquip ex ea commodo consequat. Duis
autem vel eum iriure dolor in hendrerit in vulputate velit esse molestie consequat, vel illum dolore
eu feugiat nulla facilisis at vero eros et accumsan et iusto odio dignissim qui blandit praesent.

Lorem ipsum dolor sit amet, consectetuer adipiscing elit, sed diam nonummy nibh euismod
tincidunt ut laoreet dolore magna aliquam erat volutpat. Ut wisi enim ad minim veniam, quis
nostrud exerci tation ullamcorper suscipit lobortis nisl ut aliquip ex ea commodo consequat. Duis
autem vel eum iriure dolor in hendrerit in vulputate velit esse molestie consequat, vel illum dolore
eu feugiat nulla facilisis at vero eros et accumsan et iusto odio dignissim qui blandit praesent
luptatum zzril delenit augue duis dolore te feugait nulla facilisi.

Nam liber tempor cum soluta nobis eleifend option congue nihil imperdiet doming id quod
mazim placerat facer possim assum. Lorem ipsum dolor sit amet, consectetuer adipiscing elit, sed
diam nonummy nibh euismod tincidunt ut laoreet dolore magna aliquam erat volutpat.

Best regards,

Josh S. Example
President
coc
Enclosures (2)

Voice 987 654 3210
Fax 987 654 3210
123 Example Boulevard
Your City, State 12345 6789
www.yourwebaddressz.com
E-mail info@emailaddressz.com

Business Card, Front 3.5 W by 2 H inches

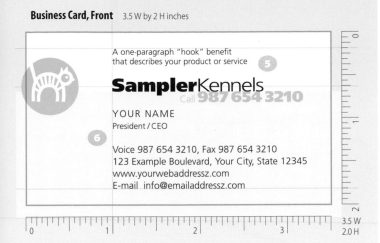

A one-paragraph "hook" benefit
that describes your product or service **5**

SamplerKennels
Call **987 654 3210**

YOUR NAME
President / CEO

6

Voice 987 654 3210, Fax 987 654 3210
123 Example Boulevard, Your City, State 12345
www.yourwebaddressz.com
E-mail info@emailaddressz.com

3.5 W
2.0 H

Business Card, Back 3.5 W by 2 H inches

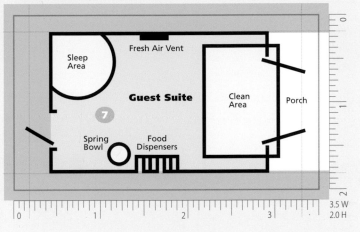

3.5 W
2.0 H

Envelope, Commercial 9.5 W by 4.125 H inches

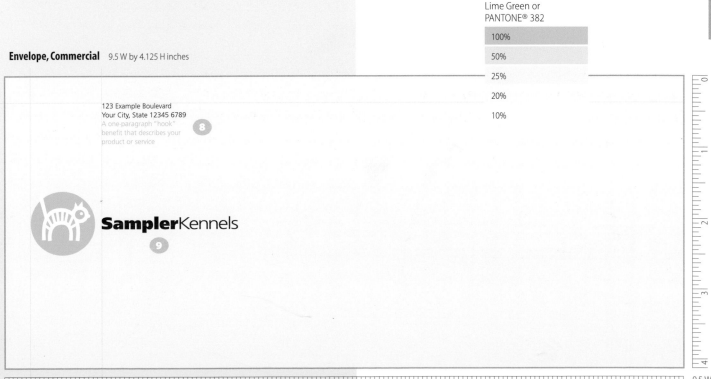

123 Example Boulevard
Your City, State 12345 6789
A one-paragraph "hook"
benefit that describes your
product or service **8**

SamplerKennels
9

9.5 W
4.125 H

Letterhead

1 Defining phrase Frutiger 45 Light, 7/8pt, align left; **2** "Sampler" Frutiger 95 UltraBlack, 20pt; "Kennels" Frutiger 45 Light, 20pt; **3** Letter body Minion, 12/18pt, align left; **4** Address Frutiger 45 Light, 7.5/10pt, align left

Business Card, Front

5 Defining phrase Frutiger 45 Light, 7/8pt, align left; "Sampler" Frutiger 95 UltraBlack, 16pt; "Kennels" Frutiger 45 Light, 16pt; "Call" Frutiger 45 Light, 8pt; Phone number Frutiger 95 UltraBlack, 13pt; **6** Name Frutiger 45 Light, 8pt, align left; Title Frutiger 45 Light, 7pt, align left; Address Frutiger 45 Light, 8/10pt, align left

Business Card, Back

7 Text Frutiger 45 Light, 7/8pt, align left or center; Title Frutiger 95 UltraBlack, 8pt, align center

Envelope

8 Address Frutiger 45 Light, 7/9pt, align left; Defining phrase Frutiger 45 Light, 7/9pt, align left; **9** "Sampler" Frutiger 95 UltraBlack, 17pt; "Kennels" Frutiger 45 Light, 17pt

Color

To be printed in black and a solid PANTONE Color Ink as defined on the palette below (see Step 9.3). (Because this book is printed in process colors (CMYK), the illustration is only a simulation of the actual solid PANTONE Color).

Lime Green or
PANTONE® 382

100%
50%
25%
20%
10%

STYLE 15

Outlines

For this style, the logo is the layout. The only element on the letterhead other than the address is the single horizontal line that visually separates the logo from the letter. The business card and envelope don't even need that.

The layout is plain because the logo is so visually complex. The outlines not only spell out the name of the organization, they pronounce the products and services it sells. In this case, good design is as much about restraint as it is about excess.

A drawing program is used to remove the fill color from the words and to thicken the outline (stroke) of each letter.

Words that describe the organization's products and services are added to the background. To increase the visual interest, some are capitalized, some are all caps, and some are all lowercase.

Various tones and colors are added to the background words. In each case, the tone for these supporting elements are significantly lighter than the name. Some words are enlarged, and others are reduced.

The words are assembled like a puzzle. Taking the time to experiment with how each word fits a particular space is what makes this technique work.

SOURCE Type families: Frutiger, Minion, Adobe Systems, Inc., 800-682-3623, www.adobe.com/type.

? What you need
Creating the outlines requires a draw program such as Adobe Illustrator, CorelDRAW, or Macromedia FreeHand. Simple text and shapes can be produced with a desktop publishing program such as Adobe InDesign, Adobe PageMaker, QuarkXPress, or Microsoft Publisher.

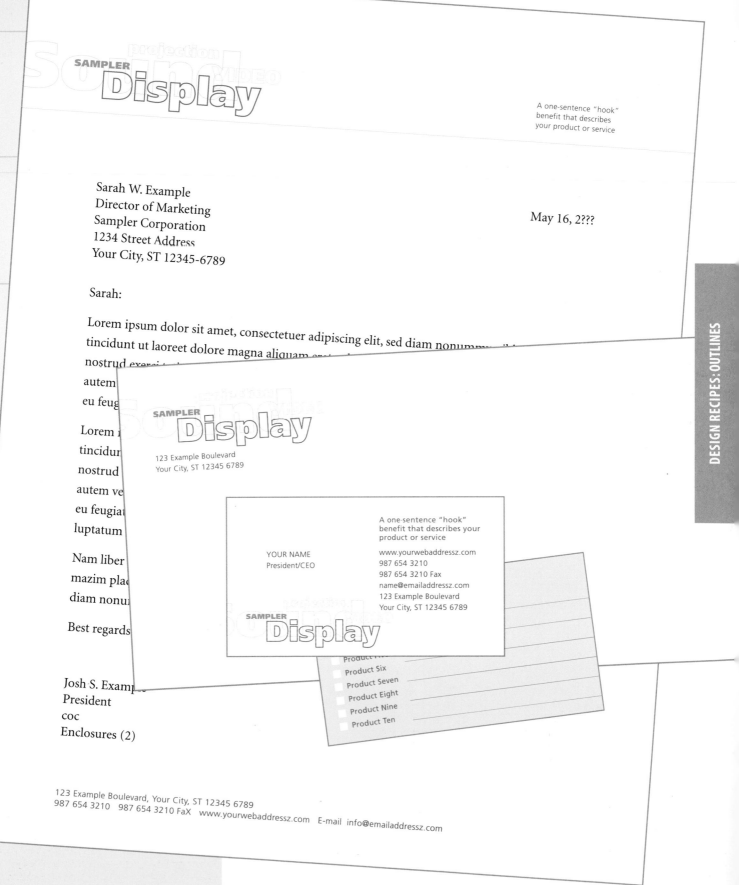

SAMPLER projection VIDEO Sound **Display**

A one-sentence "hook"
benefit that describes
your product or service

Sarah W. Example
Director of Marketing
Sampler Corporation
1234 Street Address
Your City, ST 12345-6789

May 16, 2???

Sarah:

Lorem ipsum dolor sit amet, consectetuer adipiscing elit, sed diam nonummy nibh
tincidunt ut laoreet dolore magna aliquam erat volutpat.
nostrud exerci

autem

eu feug

Lorem i

tincidun

nostrud

autem ve

eu feugia

luptatum

Nam liber

mazim plac

diam nonu

Best regards

Josh S. Example
President
coc
Enclosures (2)

SAMPLER Display

123 Example Boulevard
Your City, ST 12345 6789

A one-sentence "hook"
benefit that describes your
product or service

YOUR NAME
President/CEO

www.yourwebaddressz.com
987 654 3210
987 654 3210 Fax
name@emailaddressz.com
123 Example Boulevard
Your City, ST 12345 6789

SAMPLER Display

☐ Product Five
☐ Product Six
☐ Product Seven
☐ Product Eight
☐ Product Nine
☐ Product Ten

123 Example Boulevard, Your City, ST 12345 6789
987 654 3210 987 654 3210 FaX www.yourwebaddressz.com E-mail info@emailaddressz.com

DESIGN RECIPES: OUTLINES

sound SAMPLER **Display** projection VIDEO

A one-sentence "hook" benefit that describes your product or service

Sarah W. Example May 16, 2???
Director of Marketing
Sampler Corporation
1234 Street Address
Your City, ST 12345-6789

Sarah:

Lorem ipsum dolor sit amet, consectetuer adipiscing elit, sed diam nonummy nibh euismod tincidunt ut laoreet dolore magna aliquam erat volutpat. Ut wisi enim ad minim veniam, quis nostrud exerci tation ullamcorper suscipit lobortis nisl ut aliquip ex ea commodo consequat. Duis autem vel eum iriure dolor in hendrerit in vulputate velit esse molestie consequat, vel illum dolore eu feugiat nulla facilisis at vero eros et accumsan et iusto odio dignissim qui blandit praesent.

Lorem ipsum dolor sit amet, consectetuer adipiscing elit, sed diam nonummy nibh euismod tincidunt ut laoreet dolore magna aliquam erat volutpat. Ut wisi enim ad minim veniam, quis nostrud exerci tation ullamcorper suscipit lobortis nisl ut aliquip ex ea commodo consequat. Duis autem vel eum iriure dolor in hendrerit in vulputate velit esse molestie consequat, vel illum dolore eu feugiat nulla facilisis at vero eros et accumsan et iusto odio dignissim qui blandit praesent luptatum zzril delenit augue duis dolore te feugait nulla facilisi.

Nam liber tempor cum soluta nobis eleifend option congue nihil imperdiet doming id quod mazim placerat facer possim assum. Lorem ipsum dolor sit amet, consectetuer adipiscing elit, sed diam nonummy nibh euismod tincidunt ut laoreet dolore magna aliquam erat volutpat.

Best regards,

Josh S. Example
President
coc
Enclosures (2)

123 Example Boulevard, Your City, ST 12345 6789
987 654 3210 987 654 3210 FaX www.yourwebaddressz.com E-mail info@emailaddressz.com

Business Card, Front 3.5 W by 2 H inches

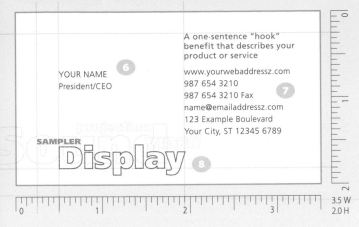

A one-sentence "hook" benefit that describes your product or service

YOUR NAME
President/CEO

www.yourwebaddressz.com
987 654 3210
987 654 3210 Fax
name@emailaddressz.com
123 Example Boulevard
Your City, ST 12345 6789

3.5 W
2.0 H

Business Card, Back 3.5 W by 2 H inches

Product One	Information
Product Two	
Product Three	
Product Four	
Product Five	
Product Six	
Product Seven	
Product Eight	
Product Nine	
Product Ten	

3.5 W
2.0 H

Envelope, Commercial 9.5 W by 4.125 H inches

123 Example Boulevard
Your City, ST 12345 6789

9.5 W
4.125 H

Letterhead

1 "SAMPLER" Frutiger 95 UltraBlack, 9pt; "Display" Frutiger 95 UltraBlack, 36pt, 1pt outline; "projection" Frutiger 95 UltraBlack, 15pt, 0.5pt outline; "Sound" Frutiger 95 UltraBlack, 60pt, 0.5pt outline; "VIDEO" Frutiger 95 UltraBlack, 18pt, 0.5pt outline; **2** Defining phrase Frutiger 45 Light, 7/9pt, align left; **3** Line 0.5pt; **4** Letter body Minion, 12/18pt, align left; **5** Address Frutiger 45 Light, 8/10pt, align left

Business Card, Front

6 Name Frutiger 45 Light, 7/10pt, align left; **7** Defining phrase Frutiger 45 Light, 7/8pt, align left; Address Frutiger 45 Light, 7/10pt, align left; **8** "SAMPLER" Frutiger 95 UltraBlack, 6.5pt; "Display" Frutiger 95 UltraBlack, 26pt, 0.75pt outline; "projection" Frutiger 95 UltraBlack, 9pt, .36pt outline; "Sound" Frutiger 95 UltraBlack, 43pt, 0.36pt outline; "VIDEO" Frutiger 95 UltraBlack, 13pt, 0.36pt outline

Business Card, Back

9 List Frutiger 55 Roman, 7/12pt, align left; **10** "Information" Frutiger 55 Roman, 7pt, align left; Lines 0.25pt

Envelope

11 "SAMPLER" Frutiger 95 UltraBlack, 7.5pt; "Display" Frutiger 95 UltraBlack, 30pt, 0.85pt outline; "projection" Frutiger 95 UltraBlack, 12.75pt, 0.43pt outline; "Sound" Frutiger 95 UltraBlack, 51pt, 0.43pt outline; "VIDEO" Frutiger 95 UltraBlack, 15pt, 0.43pt outline; **12** Address Frutiger 45 Light, 7/10pt, align left

Color

To be printed in black and a solid PANTONE Color Ink as defined on the palette below (see Step 9.3). (Because this book is printed in process colors (CMYK), the illustration is only a simulation of the actual solid PANTONE Color).

Violet or
PANTONE® 265

| 100% |
| 20% |

Sea Blue
PANTONE® 293

| 100% |
| 50% |
| 20% |
| 10% |

STYLE 16

Photographs

When you think about designing a logo, a photograph is probably not the first solution that comes to mind. That is what makes the style so enticing.

A photograph adds something to a design that a drawing cannot—evidence. It gives the reader a sense that they are witnessing the benefit of using your organization with their own eyes.

Would you visit a resort that is unwilling to show you a photograph of its facilities? Or buy a deck from a builder who shows no examples? If your story is enhanced by visual evidence, a photograph is a persuasive way to provide it.

The strips are assembled in a paint program. Each is a separate piece of artwork and is added to the layout like a long, thin photograph.

Because the photographs will be used at such a small size, close-up pictures-within-pictures are selected, and the outside is cropped away.

| C10 | M10 | Y50 | K10 |
| C0 | M15 | Y50 | K0 |

The color palette is created by selecting areas of color from the photographs.

Type is added to the strips in a coordinated color.

SOURCE Illustrations: Home photographs from *Home Comforts* from PhotoDisc, 800-979-4413, 206-441-9355, www.photo disc.com, © PhotoDisc, all rights reserved.

SOURCE Type families: Bickham Script, Frutiger, Minion, Adobe Systems, Inc., 800-682-3623, www.adobe.com/type.

? **What you need**

Editing photographic images requires a paint or digital imaging program such as Adobe Photoshop or Jasc Software's Paint Shop Pro. Simple text and shapes can be produced with a desktop publishing program such as Adobe InDesign, Adobe PageMaker, QuarkXPress, or Microsoft Publisher.

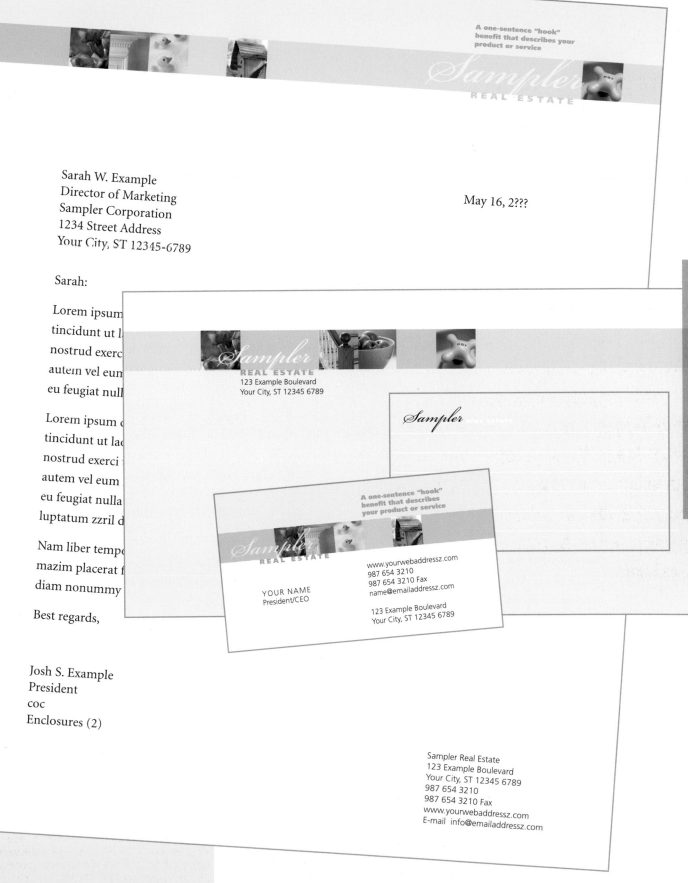

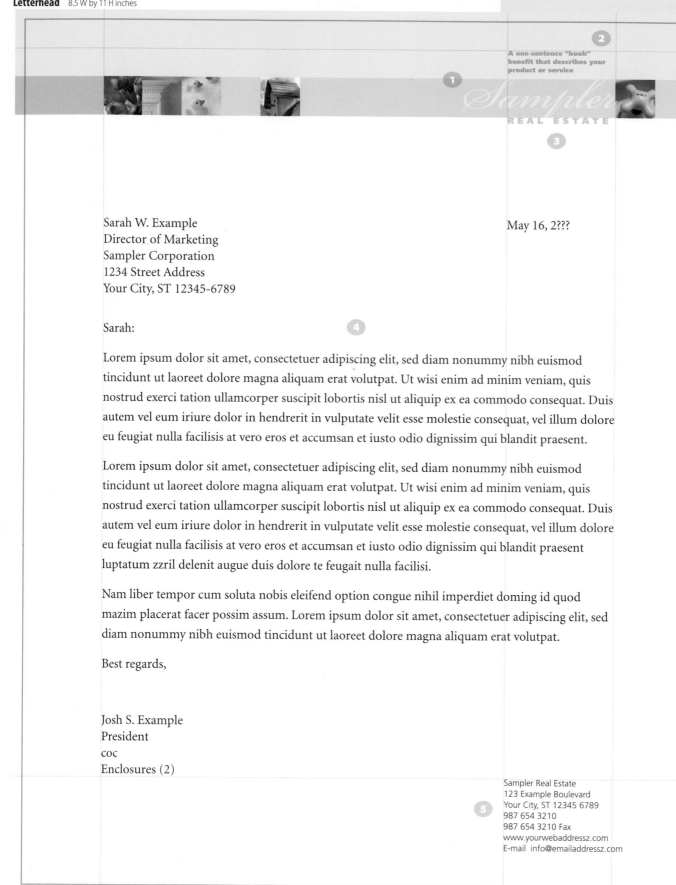

A one-sentence "hook"
benefit that describes your
product or service

Sampler
REAL ESTATE

Sarah W. Example May 16, 2???
Director of Marketing
Sampler Corporation
1234 Street Address
Your City, ST 12345-6789

Sarah:

Lorem ipsum dolor sit amet, consectetuer adipiscing elit, sed diam nonummy nibh euismod
tincidunt ut laoreet dolore magna aliquam erat volutpat. Ut wisi enim ad minim veniam, quis
nostrud exerci tation ullamcorper suscipit lobortis nisl ut aliquip ex ea commodo consequat. Duis
autem vel eum iriure dolor in hendrerit in vulputate velit esse molestie consequat, vel illum dolore
eu feugiat nulla facilisis at vero eros et accumsan et iusto odio dignissim qui blandit praesent.

Lorem ipsum dolor sit amet, consectetuer adipiscing elit, sed diam nonummy nibh euismod
tincidunt ut laoreet dolore magna aliquam erat volutpat. Ut wisi enim ad minim veniam, quis
nostrud exerci tation ullamcorper suscipit lobortis nisl ut aliquip ex ea commodo consequat. Duis
autem vel eum iriure dolor in hendrerit in vulputate velit esse molestie consequat, vel illum dolore
eu feugiat nulla facilisis at vero eros et accumsan et iusto odio dignissim qui blandit praesent
luptatum zzril delenit augue duis dolore te feugait nulla facilisi.

Nam liber tempor cum soluta nobis eleifend option congue nihil imperdiet doming id quod
mazim placerat facer possim assum. Lorem ipsum dolor sit amet, consectetuer adipiscing elit, sed
diam nonummy nibh euismod tincidunt ut laoreet dolore magna aliquam erat volutpat.

Best regards,

Josh S. Example
President
coc
Enclosures (2)

Sampler Real Estate
123 Example Boulevard
Your City, ST 12345 6789
987 654 3210
987 654 3210 Fax
www.yourwebaddressz.com
E-mail info@emailaddressz.com

8.5 W
11 H

Business Card, Front
3.5 W by 2 H inches

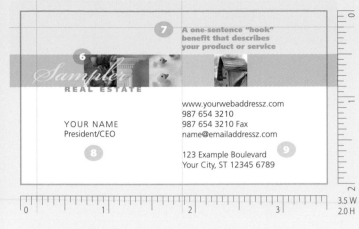

A one-sentence "hook" benefit that describes your product or service

www.yourwebaddressz.com
987 654 3210
987 654 3210 Fax
name@emailaddressz.com

YOUR NAME
President/CEO

123 Example Boulevard
Your City, ST 12345 6789

3.5 W
2.0 H

Business Card, Back
3.5 W by 2 H inches

3.5 W
2.0 H

Envelope, Commercial
9.5 W by 4.125 H inches

123 Example Boulevard
Your City, ST 12345 6789

9.5 W
4.125 H

Letterhead
1 "Sampler" Bickham Script, 60pt; **2** Defining phrase Frutiger 95 UltraBlack, 6/7.5pt, align left; **3** "REAL" Frutiger 95 UltraBlack, 8pt, align left; **4** Letter body Minion, 12/18pt, align left; **5** Address Frutiger 45 Light, 8/10pt, align left

Business Card, Front
6 "Sampler" Bickham Script, 33pt; **7** Defining phrase Frutiger 95 UltraBlack, 6/7pt, align left; **8** Name Frutiger 45 Light, 7/8pt, align left; **9** Address Frutiger 45 Light, 7/8.5pt, align left

Business Card, Back
10 "Sampler" Bickham Script, 24pt; "REAL" Frutiger 95 UltraBlack, 4pt; Lines 0.5pt

Envelope
11 "Sampler" Bickham Script, 36pt; **12** "REAL" Frutiger 95 UltraBlack, 7pt; Address Frutiger 45 Light, 7/9pt, align left

Color
Printed in four-color process (see Step 9.3) using values of cyan, magenta, yellow, and black (CMYK) as defined on the color palette below. Actual color will vary.

Process Colors			
C0	M45	Y60	K0
C0	M30	Y50	K0
C0	M10	Y20	K0
C0	M15	Y50	K0
C0	M7	Y25	K0
C10	M10	Y50	K10
C5	M5	Y20	K0

STYLE 17

Products

Everyone has a product, whether it's a physical product or, as in this case, objects that represent an intangible.

Showing your product provides evidence of its value and a unique way to visualize your organization.

This is how you might present a service. A manufacturer could use the same style to present photographs of its best-selling product or feature a different product on each its letterhead, business card, and envelope.

SOURCE Illustration: Marker/pens from author.

The original photograph is cleaned up and brightened in a paint program. This photograph was shot on a white sheet of paper using a digital camera. If you don't have the equipment or the desire to do it yourself, commission a photograph by a professional photographer. Many photographers have the skill not only to shoot the picture but to compose it in an attractive way using special lighting, effects, and props.

This photograph is posterized in the paint program—it reduces the number of colors, resulting in a photograph that has the color quality of a painting.

The words of the name are typed out in a drawing program, and each is individually reduced to fit the with of a hypothetical box. Then space is added between the lines of the defining phrase to produce a visual element of the same relative size and weight.

The word "stet" is created using a typeface that simulates handwriting. It is a proofreader's mark that means "let it stand." To a writer or editor, the meaning is obvious; for the uninitiated, it adds a little mystery to the design.

SOURCES Type families: Emmascript, DsgnHaus, Inc., 203-367-1993, www.fonthaus.com; Franklin Gothic, Minion, Adobe Systems, Inc., 800-682-3623, www.adobe.com/type.

❓ What you need
Editing photographic images requires a paint or digital imaging program such as Adobe Photoshop or Jasc Software's Paint Shop Pro. Simple text and shapes can be produced with a desktop publishing program such as Adobe InDesign, Adobe PageMaker, QuarkXPress, or Microsoft Publisher.

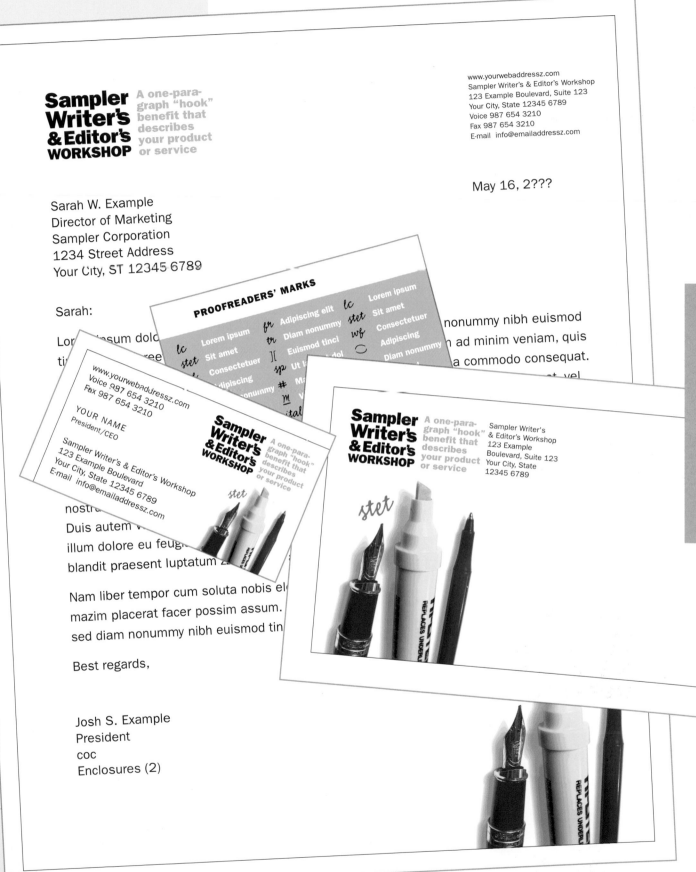

Sampler Writer's & Editor's WORKSHOP

A one-paragraph "hook" benefit that describes your product or service

www.yourwebaddressz.com
Sampler Writer's & Editor's Workshop
123 Example Boulevard, Suite 123
Your City, State 12345 6789
Voice 987 654 3210
Fax 987 654 3210
E-mail info@emailaddressz.com

Sarah W. Example
Director of Marketing
Sampler Corporation
1234 Street Address
Your City, ST 12345-6789

May 16, 2???

Sarah:

Lorem ipsum dolor sit amet, consectetuer adipiscing elit, sed diam nonummy nibh euismod tincidunt ut laoreet dolore magna aliquam erat volutpat. Ut wisi enim ad minim veniam, quis nostrud exerci tation ullamcorper suscipit lobortis nisl ut aliquip ex ea commodo consequat. Duis autem vel eum iriure dolor in hendrerit in vulputate velit esse molestie consequat, vel illum dolore eu feugiat nulla facilisis at vero eros et accumsan et iusto odio dignissim qui blandit praesent luptatum zzril delenit augue duis dolore te feugait nulla facilisi.

Lorem ipsum dolor sit amet, consectetuer adipiscing elit, sed diam nonummy nibh euismod tincidunt ut laoreet dolore magna aliquam erat volutpat. Ut wisi enim ad minim veniam, quis nostrud exerci tation ullamcorper suscipit lobortis nisl ut aliquip ex ea commodo consequat. Duis autem vel eum iriure dolor in hendrerit in vulputate velit esse molestie consequat, vel illum dolore eu feugiat nulla facilisis at vero eros et accumsan et iusto odio dignissim qui blandit praesent luptatum zzril delenit augue duis dolore te feugait nulla facilisi.

Nam liber tempor cum soluta nobis eleifend option congue nihil imperdiet doming id quod mazim placerat facer possim assum. Lorem ipsum dolor sit amet, consectetuer adipiscing elit, sed diam nonummy nibh euismod tincidunt ut laoreet dolore magna aliquam erat volutpat.

Best regards,

Josh S. Example
President
COC
Enclosures (2)

stet

124

Business Card, Front 3.5 W by 2 H inches

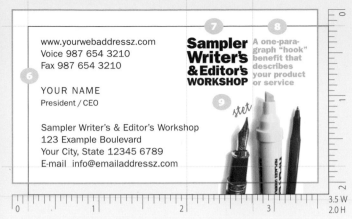

www.yourwebaddressz.com
Voice 987 654 3210
Fax 987 654 3210

YOUR NAME
President / CEO

Sampler Writer's & Editor's Workshop
123 Example Boulevard
Your City, State 12345 6789
E-mail info@emailaddressz.com

Sampler Writer's & Editor's WORKSHOP

A one-para-graph "hook" benefit that describes your product or service

stet

Business Card, Back 3.5 W by 2 H inches

PROOFREADERS' MARKS

lc	Lorem ipsum	*fr*	Adipiscing elit	*lc*	Lorem ipsum
stet	Sit amet	*tr*	Diam nonummy	*stet*	Sit amet
wf	Consectetuer][Euismod tinci	*wf*	Consectetuer
⌣	Adipiscing	*sp*	Ut laoreet dol	⌣	Adipiscing
˅	Diam nonummy	#	Magna aliqua	˅	Diam nonummy
caps	Euismod	*M*	Volutpat	*caps*	Euismod
x	Ut laoreet	*ital*	Enim ad mini	*x*	Ut laoreet

Envelope, Commercial 9.5 W by 4.125 H inches

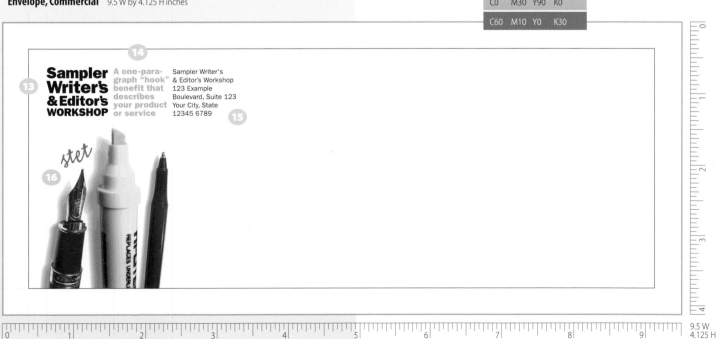

Sampler Writer's & Editor's WORKSHOP

A one-para-graph "hook" benefit that describes your product or service

Sampler Writer's
& Editor's Workshop
123 Example
Boulevard, Suite 123
Your City, State
12345 6789

stet

Letterhead

1 Line 0.5pt; "Sampler" Franklin Gothic Heavy, 21pt, align justified; "Writer's" Franklin Gothic Heavy, 23pt, align justified; "& Editor's" Franklin Gothic Heavy, 19pt, align justified; "WORKSHOP" Franklin Gothic Heavy, 14pt, align justified; **2** Defining phrase Franklin Gothic Heavy, 11/10.5pt, align left; **3** Address Franklin Gothic Book, 7/9pt, align left; **4** Letter body Franklin Gothic Book, 12/18pt, align left; **5** "Stet" Emmascript, 28pt

Business Card, Front

6 Line 0.5pt; Address/Name Franklin Gothic Book, 8/10pt, align left; Title Franklin Gothic Book, 7/10pt, align left; **7** "Sampler" Franklin Gothic Heavy, 13.5pt, align justified; "Writer's" Franklin Gothic Heavy, 15pt, align justified; "& Editor's" Franklin Gothic Heavy, 12pt, align justified; "WORKSHOP" Franklin Gothic Heavy, 9pt, align justified; **8** Defining phrase Franklin Gothic Heavy, 7/7pt, align left; **9** "Stet" Emmascript, 14pt

Business Card, Back

10 "PROOFREADERS'" Franklin Gothic Heavy, 9pt, align left; **11** Marks Emmascript, 15pt; **12** Text Franklin Gothic Demi, 8/14pt, align left

Envelope

13 Line 0.5pt; "Sampler" Franklin Gothic Heavy, 17pt, align justified; "Writer's" Franklin Gothic Heavy, 18.5pt, align justified; "& Editor's" Franklin Gothic Heavy, 15pt, align justified; "WORKSHOP" Franklin Gothic Heavy, 11pt, align justified; **14** Defining phrase Franklin Gothic Heavy, 9/9pt, align left; **15** Address Franklin Gothic Book, 7/8.5pt, align left; **16** "Stet" Emmascript, 28pt

Color

Printed in four-color process (see Step 9.3) using values of cyan, magenta, yellow, and black (CMYK) as defined on the color palette below. Actual color will vary.

Process Colors

C0	M30	Y90	K0
C60	M10	Y0	K30

STYLE 18

Rectangles

If you use rectangles to divide your letter from your logo, your logo from your organization's name, and your organization's name from its defining phrase, what will your reader focus on? The circle.

It is a design mainstay—when you build your design on a consistent pattern of shapes, the shape that breaks the pattern becomes the focal point.

The logo is nothing more than a simple light bulb and burst.

To ensure the colors complement each other, they are chosen as a consecutive series from a standard color wheel.

Where the gray, teal, and violet rectangles overlap, two more rectangular shapes are formed. By making the outside shapes lighter, you create a sense of transparency.

The circle breaks the border of the box on which it is positioned.

SAMPLER STUDIO ideas

The name of the organization is typed in all capital letters. The word "idea" is not a part of the name but part of its logo—a design element meant to shout the benefit of the organization.

The type butts up to the edge of the color precisely.

SOURCE Illustration: Light bulb from Dick & Jane font from DsgnHaus, Inc., 203-367-1993, www.fonthaus.com.

SOURCE Type families: Franklin Gothic, Minion, Adobe Systems, Inc., 800-682-3623, www.adobe.com/type.

? What you need
Breaking apart draw/vector artwork and editing the pieces requires a draw program such as Adobe Illustrator, CorelDRAW, or Macromedia FreeHand. Simple text and shapes can be produced with a desktop publishing program such as Adobe InDesign, Adobe PageMaker, QuarkXPress, or Microsoft Publisher.

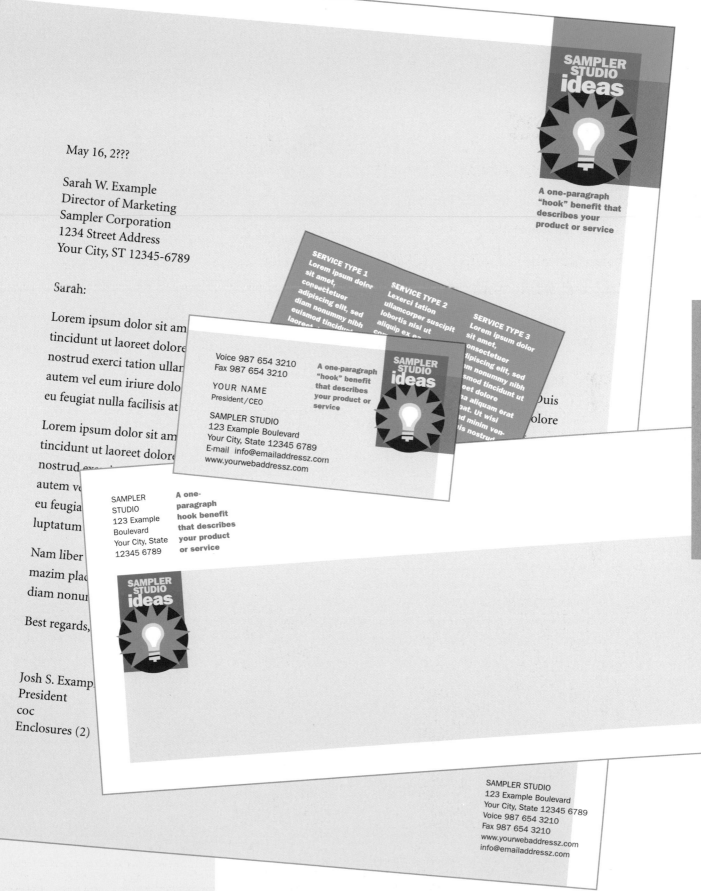

A one-paragraph
"hook" benefit that
describes your
product or service

May 16, 2???

Sarah W. Example
Director of Marketing
Sampler Corporation
1234 Street Address
Your City, ST 12345-6789

Sarah:

Lorem ipsum dolor sit amet, consectetuer adipiscing elit, sed diam nonummy nibh euismod tincidunt ut laoreet dolore magna aliquam erat volutpat. Ut wisi enim ad minim veniam, quis nostrud exerci tation ullamcorper suscipit lobortis nisl ut aliquip ex ea commodo consequat. Duis autem vel eum iriure dolor in hendrerit in vulputate velit esse molestie consequat, vel illum dolore eu feugiat nulla facilisis at vero eros et accumsan et iusto odio dignissim qui blandit praesent.

Lorem ipsum dolor sit amet, consectetuer adipiscing elit, sed diam nonummy nibh euismod tincidunt ut laoreet dolore magna aliquam erat volutpat. Ut wisi enim ad minim veniam, quis nostrud exerci tation ullamcorper suscipit lobortis nisl ut aliquip ex ea commodo consequat. Duis autem vel eum iriure dolor in hendrerit in vulputate velit esse molestie consequat, vel illum dolore eu feugiat nulla facilisis at vero eros et accumsan et iusto odio dignissim qui blandit praesent luptatum zzril delenit augue duis dolore te feugait nulla facilisi.

Nam liber tempor cum soluta nobis eleifend option congue nihil imperdiet doming id quod mazim placerat facer possim assum. Lorem ipsum dolor sit amet, consectetuer adipiscing elit, sed diam nonummy nibh euismod tincidunt ut laoreet dolore magna aliquam erat volutpat.

Best regards,

Josh S. Example
President
coc
Enclosures (2)

SAMPLER STUDIO
123 Example Boulevard
Your City, State 12345 6789
Voice 987 654 3210
Fax 987 654 3210
www.yourwebaddressz.com
info@emailaddressz.com

Business Card, Front 3.5 W by 2 H inches

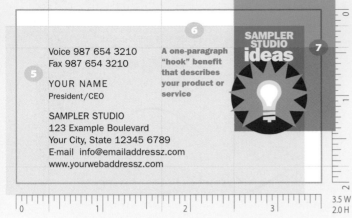

Voice 987 654 3210
Fax 987 654 3210

YOUR NAME
President/CEO

SAMPLER STUDIO
123 Example Boulevard
Your City, State 12345 6789
E-mail info@emailaddressz.com
www.yourwebaddressz.com

A one-paragraph
"hook" benefit
that describes
your product or
service

3.5 W
2.0 H

Business Card, Back 3.5 W by 2 H inches

SERVICE TYPE 1
Lorem ipsum dolor
sit amet,
consectetuer
adipiscing elit, sed
diam nonummy nibh
euismod tincidunt ut
laoreet dolore
magna aliquam erat
volutpat. Ut wisi
enim ad minim
veniam, quis nostrud

SERVICE TYPE 2
Lexerci tation
ullamcorper suscipit
lobortis nisl ut
aliquip ex ea
commodo consequat.
Duis autem vel eum
iriure dolor in
hendrerit in
vulputate velit esse
molestie consequat

SERVICE TYPE 3
Lorem ipsum dolor
sit amet,
consectetuer
adipiscing elit, sed
diam nonummy nibh
euismod tincidunt ut
laoreet dolore
magna aliquam erat
volutpat. Ut wisi
enim ad minim ven-
iam, quis nostrud

3.5 W
2.0 H

Envelope, Commercial 9.5 W by 4.125 H inches

SAMPLER
STUDIO
123 Example
Boulevard
Your City, State
12345 6789

A one-
paragraph
hook benefit
that describes
your product
or service

9.5 W
4.125 H

Letterhead

1 Organization Franklin Gothic Heavy, 12/13pt, align center; "ideas" Franklin Gothic Heavy, 24pt, align center; **2 Defining phrase** Franklin Gothic Heavy, 8/10pt, align center; **3 Letter body** Minion, 12/18pt, align left; **4 Address** Franklin Gothic Book, 7.5/10pt; align left

Business Card, Front

5 Phone/Name/Address Franklin Gothic Book, 8/10pt, align left; **Title** Franklin Gothic Book, 7pt, align left; **6 Defining phrase** Franklin Gothic Heavy, 7/9pt, align left; **7 Organization** Franklin Gothic Heavy, 9/7pt, align center; "ideas" Franklin Gothic Heavy, 17pt, align center

Business Card, Back

8 Text Franklin Gothic Heavy, 7/9pt, align left

Envelope

9 Address Franklin Gothic Book, 7.5/10pt, align left; **10 Defining phrase** Franklin Gothic Heavy, 7.5/10pt, align left; **11 Organization** Franklin Gothic Heavy, 9/7pt, align center; "ideas" Franklin Gothic Heavy, 17pt, align center

Color

Printed in four-color process (see Step 9.3) using values of cyan, magenta, yellow, and black (CMYK) as defined on the color palette below. Actual color will vary.

Process Colors

C0	M0	Y4	K10
C95	M0	Y40	K0
C70	M0	Y30	K0
C25	M0	Y15	K0
C60	M50	Y0	K0
C50	M40	Y0	K0
C0	M10	Y75	K0
C0	M0	Y50	K5
C0	M100	Y70	K10
C0	M50	Y85	K0

STYLE 19

Scribbles

Those years of scribbling and doodling in idle moments are about to pay off.

Scribbles make great logos. They portray a relaxed, lighthearted attitude that may not be appropriate for a law firm or an elegant hotel, but perfectly suited to hundreds of other types of organizations.

The key to success is to find a natural artist. If you can't do it yourself, recruit someone with particularly good handwriting. Sometimes even children can invent natural, free-form scribbles that make excellent logos.

Start by brainstorming ideas. Using a fountain pen on color laserjet paper produces very fluid, thin and thick strokes.

Settle on an object and draw it at least twenty-five times. The trick is to draw it small (roughly one-inch square) and rapidly, using as few strokes as necessary. Return after a couple of hours and see if you've created a winner.

This version is a scan of the original that was traced in a drawing program. The oval focuses the eye on the contents of the glass, and the horizontal lines add an interesting background.

Sampler CAFE
SAMPLER RESTAURANT
Sampler VILLA

The typeface should emphasize the effect you're trying to achieve. The top typeface is fun, the middle version is more traditional, and the bottom is almost elegant.

The lines from the logo are repeated on the background of the business card. Subtle changes on each piece—the letterhead, business card, and envelope—improve the combined effect.

Take advantage of the space on the back of your business card. Valuable information encourages your prospect to keep it on hand—in this case, the recipe for the cafe's signature cocktail.

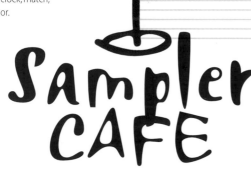

SOURCE Illustrations: Wine glass, clock, match, by the author.

SOURCE Type families: Airstream, Frutiger, Minion, Adobe Systems, Inc., 800-682-3623, www.adobe.com/type.

? What you need
Scanning and editing your scribbles requires a paint or digital imaging program such as Adobe Photoshop or Jasc Software's Paint Shop Pro. Simple text and shapes can be produced with a desktop publishing program such as Adobe InDesign, Adobe PageMaker, QuarkXPress, or Microsoft Publisher.

A one-sentence
"hook" benefit
that describes
your product
or service

Sampler CAFE

Sarah W. Example
Director of Marketing
Sampler Corporation
1234 Street Address
Your City, ST 12345-6789

May 16, 2???

Sarah:

Lorem ipsum dolor sit amet, consectetuer adipiscing elit, sed diam nonummy nibh euismod tincidunt ut laoreet dolore magna aliquam erat volutpat. Ut wisi enim ad minim veniam, quis nostrud exerci tation ullamcorper suscipit lobortis nisl ut aliquip ex ea commodo consequat. Duis autem vel eum iriure dolor in hendrerit in vulputate velit esse molestie consequat, vel illum dolore eu feugiat nulla facilisis at vero eros et accumsan et iusto odio dignissim qui blandit praesent.

Lorem ipsum dolor sit amet, consectetuer adipiscing elit, sed diam nonummy tincidunt ut laoreet dolore magna aliquam erat volutpat. Ut wisi enim ad minim nostrud exerci tation ullamcorper suscipit lobortis nisl ut aliquip ex ea commo autem vel eum iriure dolor in hendrerit in vulputate velit esse molestie consequ eu feugiat nulla facilisis at vero eros et accumsan et iusto odio dignissim qui bla lup

www.yourwebaddressz.com
Voice 987 654 3210
Fax 987 654 3210

YOUR NAME
Proprietor

123 Example Boulevard
Your City, State 12345 6789
E-mail info@emailaddressz.com

A one-sentence
"hook" benefit
that describes
your product
or service

Sampler CAFE

Nan
mazi
diam

World-
Famous
Sampler
CAFE
Key Lime
Custard

2 cups item two
1 item three
2 tsp item four
1 tbsp item five
15 item

sed dia
euismod tincidunt ut lao
dolore magna aliquam erat
volutpat. Ut wisi enim ad
minim veniam, quis nostrud
exerci tation ullam corper
suscipit lobortis nisl ut aliquip
ex ea commodo consequat.
Duis autem vel eum iriure
dolor in hendrerit.

e nihil imperdiet dom
amet, consectetuer ad
magna aliquam erat vo

Best re

A one-sentence
"hook" benefit
that describes
your product
or service

Sampler CAFE

123 Example Boulevard
Your City, State 12345 6789

Josh S. Example
President
coc

Enclosures (2)

123 Example Boulevard
Your City, State 12345 6789
Voice 987 654 3210
Fax 987 654 3210
www.yourwebaddressz.com
E-mail info@emailaddressz.com

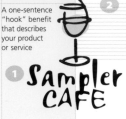

A one-sentence "hook" benefit that describes your product or service

Sarah W. Example
Director of Marketing
Sampler Corporation
1234 Street Address
Your City, ST 12345-6789

May 16, 2???

Sarah:

Lorem ipsum dolor sit amet, consectetuer adipiscing elit, sed diam nonummy nibh euismod tincidunt ut laoreet dolore magna aliquam erat volutpat. Ut wisi enim ad minim veniam, quis nostrud exerci tation ullamcorper suscipit lobortis nisl ut aliquip ex ea commodo consequat. Duis autem vel eum iriure dolor in hendrerit in vulputate velit esse molestie consequat, vel illum dolore eu feugiat nulla facilisis at vero eros et accumsan et iusto odio dignissim qui blandit praesent.

Lorem ipsum dolor sit amet, consectetuer adipiscing elit, sed diam nonummy nibh euismod tincidunt ut laoreet dolore magna aliquam erat volutpat. Ut wisi enim ad minim veniam, quis nostrud exerci tation ullamcorper suscipit lobortis nisl ut aliquip ex ea commodo consequat. Duis autem vel eum iriure dolor in hendrerit in vulputate velit esse molestie consequat, vel illum dolore eu feugiat nulla facilisis at vero eros et accumsan et iusto odio dignissim qui blandit praesent luptatum zzril delenit augue duis dolore te feugait nulla facilisi.

Nam liber tempor cum soluta nobis eleifend option congue nihil imperdiet doming id quod mazim placerat facer possim assum. Lorem ipsum dolor sit amet, consectetuer adipiscing elit, sed diam nonummy nibh euismod tincidunt ut laoreet dolore magna aliquam erat volutpat.

Best regards,

Josh S. Example
President
coc
Enclosures (2)

123 Example Boulevard
Your City, State 12345 6789
Voice 987 654 3210
Fax 987 654 3210
www.yourwebaddressz.com
E-mail info@emailaddressz.com

Business Card, Front
3.5 W by 2 H inches

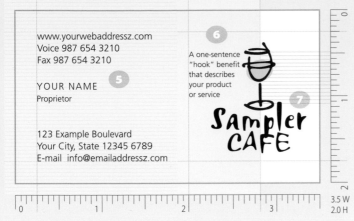

www.yourwebaddressz.com
Voice 987 654 3210
Fax 987 654 3210

5

YOUR NAME
Proprietor

123 Example Boulevard
Your City, State 12345 6789
E-mail info@emailaddressz.com

6

A one-sentence
"hook" benefit
that describes
your product
or service

7

Business Card, Back
3.5 W by 2 H inches

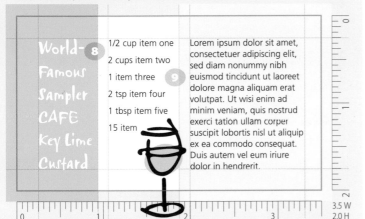

World-
Famous
Sampler
CAFE
Key Lime
Custard

8

1/2 cup item one

2 cups item two

1 item three

2 tsp item four

1 tbsp item five

15 item

9

Lorem ipsum dolor sit amet,
consectetuer adipiscing elit,
sed diam nonummy nibh
euismod tincidunt ut laoreet
dolore magna aliquam erat
volutpat. Ut wisi enim ad
minim veniam, quis nostrud
exerci tation ullam corper
suscipit lobortis nisl ut aliquip
ex ea commodo consequat.
Duis autem vel eum iriure
dolor in hendrerit.

Envelope, Commercial
9.5 W by 4.125 H inches

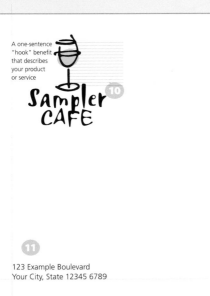

A one-sentence
"hook" benefit
that describes
your product
or service

10

11

123 Example Boulevard
Your City, State 12345 6789

Letterhead
1 "Sampler" Airstream, 30pt, align center; "CAFE" Airstream, 24pt, align center; **Defining phrase** Frutiger 45 Light, 7/9pt, align left; **2 Lines** 0.5pt; **3 Letter body** Minion 12/18pt, align left; **4 Address** Frutiger 45 Light, 7.5/10pt, align left

Business Card, Front
5 Address Frutiger 45 Light, 8/10pt, align left; **Title** Frutiger 45 Light, 7pt, align left; **6 Defining phrase** Frutiger 45 Light, 6/8pt, align left; **7** "Sampler" Airstream, 27pt, align center; "CAFE" Airstream, 21pt, align center; **Lines** 0.5pt

Business Card, Back
8 Headline Frutiger 45 Light, 14/19pt, align left; **9 Ingredients** Frutiger 45 Light, 7.5/14pt, align left; **Recipe** Frutiger 45 Light, 7.5/9pt, align left

Envelope
10 Defining phrase Frutiger 45 Light, 6/8pt, align left; "Sampler" Airstream, 27pt, align center; "CAFE" Airstream, 21pt, align center; **Lines** 0.5pt; **11 Address** Frutiger 45 Light, 8/10pt, align left

Color
To be printed in black and a solid PANTONE Color Ink as defined on the palette below (see Step 9.3). (Because this book is printed in process colors (CMYK), the illustration is only a simulation of the actual solid PANTONE Color).

Lemon Green or
PANTONE® 458

100%	
50%	
30%	

STYLE 20

Shadows

Paint programs make using subtle shadows, with all types of artwork, practical. And those shadows have a significant impact on the desktop publishing world: They add a third dimension to conventional two-dimensional layouts. A simple shadow can create the illusion of an object floating above the page or, as shown here, cut into the surface.

On these layouts, the photographs are the visual center around which the name, defining phrase, and address orbit. Rather than repeat the same photograph on all three pieces, the scope of the organization is expanded by featuring a different image on each.

The shadow is created in a paint program using a photograph that is cropped and sized to fit the layout.

A black angle shape is added to a layer above the photograph.

The angle shape is blurred.

The opacity of the angle layer is adjusted to lighten it.

And the final image is cropped to size and saved.

The back of the card lists all the locations the tour company visits—information that encourages the prospect to keep it on hand.

? What you need

Editing photographic images requires a paint or digital imaging program such as Adobe Photoshop or Jasc Software's Paint Shop Pro. Creating artwork for the map requires a draw program such as Adobe Illustrator, CorelDRAW, or Macromedia FreeHand. Simple text and shapes can be produced with a desktop publishing program such as Adobe InDesign, Adobe PageMaker, QuarkXPress, or Microsoft Publisher.

SAMPLER TOURS

A one-paragraph "hook" benefit that describes your product or service

123 Example Boulevard
Suite 100
Your City, State 12345 6789
Voice 987 654 3210
Fax 987 654 3210
www.yourwebaddressz.com
info@emailaddressz.com

May 16, 2???

Sarah W. Example
Director of Marketing
Sampler Corporation
1234 Street Address
Your City, ST 12345-6789

Sarah:

Lorem ipsu
tincidunt
nostrud e
autem vi
eu feug

Lorem
tinc
no
a

ing elit, sed diam nonummy nibh euismod
isi enim ad minim veniam, quis
mmodo consequat. Duis
l illum dolore

SAMPLER TOURS

123 Example
Boulevard, Suite 100
Your City, State
12345 6789

A one-paragraph "hook"
benefit that describes
your product or service

www.yourwebaddressz.com
Voice 987 654 3210
Fax 987 654 3210

SAMPLER TOURS

YOUR NAME
President / CEO

123 Example Boulevard,
Your City, State 6
E-mail info@emailaddr

A one-paragraph
"hook" benefit that
describes your

TOP DESTINATIONS
Lorem ipsum
amet, consectetuer
adipiscing elit, sed diam
nonummy nibh euismod
tincidunt ut laoreet
dolore magna aliquam
erat volutpat. Ut wisi
enim ad minim veniam,
quis nostrud.

Lorem ipsum 1
Consectetuer 2
Sed diam 3
Nonummy nibh 4
Euismod tinci 5
Dolore magna 6
Aliquam erat 7
Volutpat ut wisi 8
Enim ad 9

diam nonum

Best regards,

Josh S. Example
President
coc
Enclosures (2)

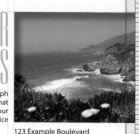

A one-paragraph
"hook" benefit that
describes your
product or service

123 Example Boulevard
Suite 100
Your City, State 12345 6789
Voice 987 654 3210
Fax 987 654 3210
www.yourwebaddressz.com
info@emailaddressz.com

May 16, 2???

Sarah W. Example
Director of Marketing
Sampler Corporation
1234 Street Address
Your City, ST 12345-6789

Sarah:

Lorem ipsum dolor sit amet, consectetuer adipiscing elit, sed diam nonummy nibh euismod
tincidunt ut laoreet dolore magna aliquam erat volutpat. Ut wisi enim ad minim veniam, quis
nostrud exerci tation ullamcorper suscipit lobortis nisl ut aliquip ex ea commodo consequat. Duis
autem vel eum iriure dolor in hendrerit in vulputate velit esse molestie consequat, vel illum dolore
eu feugiat nulla facilisis at vero eros et accumsan et iusto odio dignissim qui blandit praesent.

Lorem ipsum dolor sit amet, consectetuer adipiscing elit, sed diam nonummy nibh euismod
tincidunt ut laoreet dolore magna aliquam erat volutpat. Ut wisi enim ad minim veniam, quis
nostrud exerci tation ullamcorper suscipit lobortis nisl ut aliquip ex ea commodo consequat. Duis
autem vel eum iriure dolor in hendrerit in vulputate velit esse molestie consequat, vel illum dolore
eu feugiat nulla facilisis at vero eros et accumsan et iusto odio dignissim qui blandit praesent
luptatum zzril delenit augue duis dolore te feugait nulla facilisi.

Nam liber tempor cum soluta nobis eleifend option congue nihil imperdiet doming id quod
mazim placerat facer possim assum. Lorem ipsum dolor sit amet, consectetuer adipiscing elit, sed
diam nonummy nibh euismod tincidunt ut laoreet dolore magna aliquam erat volutpat.

Best regards,

Josh S. Example
President
coc
Enclosures (2)

Business Card, Front 3.5 W by 2 H inches

www.yourwebaddressz.com
Voice 987 654 3210
Fax 987 654 3210

YOUR NAME 4
President / CEO

5 SAMPLER TOURS

6 A one-paragraph "hook" benefit that describes your product or service

123 Example Boulevard, Suite 100
Your City, State 12345 6789
E-mail info@emailaddressz.com

3.5 W
2.0 H

Business Card, Back 3.5 W by 2 H inches

TOP DESTINATIONS
Lorem ipsum
amet, consectetuer
7 adipiscing elit, sed diam
nonummy nibh euismod
tincidunt ut laoreet
dolore magna aliquam
erat volutpat. Ut wisi
enim ad minim veniam,
quis nostrud.

Lorem ipsum 1
Consectetuer 2
Sed diam 3
Nonummy nibh 4
Euismod tinci 5
Dolore magna 6
Aliquam erat 7
Volutpat ut wisi 8
Enim ad 9

3.5 W
2.0 H

Envelope, Commercial 9.5 W by 4.125 H inches

SAMPLER TOURS

8

123 Example
Boulevard, Suite 100
Your City, State
12345 6789

10

A one-paragraph "hook"
benefit that describes
your product or service

9

9.5 W
4.125 H

Letterhead

1 Organization Iris, 48/35pt, align right; **Defining phrase** Myriad Regular, 7/8pt, align right; **2** Address Myriad Regular, 7/9pt, align left; **3** Letter body Minion, 12/18pt, align left

Business Card, Front

4 Address Myriad Regular, 8/10pt, align left; Title Myriad Regular, 7pt, align left; **5** Organization Iris, 50/37pt, align right; **6** Defining phrase Myriad Regular, 7/8pt, align left

Business Card, Back

7 Address Myriad Multiple Master (MM), 700bd, 300cn, 8/12pt, align left; Numbers Myriad MM, 700bd, 300cn, 6pt, align center

Envelope

8 Organization Iris, 48/35pt, align right; **9** Defining phrase Myriad Regular, 7/8pt, align right; **10** Address Myriad Regular, 7/8pt, align left

Color

Printed in four-color process (see Step 9.3) using values of cyan, magenta, yellow, and black (CMYK) as defined on the color palette below. Actual color will vary.

Process Colors

C50	M15	Y0	K0
C0	M55	Y75	K0
C40	M15	Y0	K0
C50	M20	Y0	K0
C15	M35	Y75	K5

STYLE 21

Simplicity

Seals are the definition of simplicity. Historians tell us they are among the first design artifacts, reaching back to centuries before the birth of Christ. They have been used throughout the ages, stamped in clay, wax, and ink as the authenticating signature and proof of their owner's authority.

Today seals still are used for both practical and ceremonial purposes. The random shape and three-dimensional effect of this version imitates an imprint in sealing wax.

Because the seal will be used at a small size, the artwork must be simple, bold, and easily recognizable. The original apple here was simplified and centered within a circle.

The sealing wax is a free-form outline.

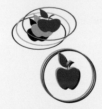
The sealing wax outline is filled with the desired color and a second, black copy for a shadow is positioned beneath it.

The three-dimensional effect is nothing more than three copies of the same artwork slightly offset—the light version up and to the left; the black shadow, down and to the right.

That seal layer is sandwiched with the sealing wax layer to create the finished seal.

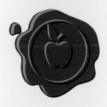
A simple edge highlight is made by duplicating the sealing wax shape.

SOURCE Type families: Caslon, Minion, Adobe Systems, Inc., 800-682-3623, www.adobe.com/type.

? What you need
Drawing the shape of the seal and editing the apple artwork requires a draw program such as Adobe Illustrator, CorelDRAW, or Macromedia FreeHand. Simple text and shapes can be produced with a desktop publishing program such as Adobe InDesign, Adobe PageMaker, QuarkXPress, or Microsoft Publisher.

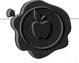

SAMPLER CIDER MILLS
SINCE 1823

Sarah W. Example
Director of Marketing
Sampler Corporation
1234 Street Address
Your City, ST 12345-6789

May 16, 2???

Sarah:

Lorem ipsum dolor sit amet, consectetue
tincidunt ut laoreet dolore magna aliqua
nostrud exerci tation ullamcorper suscip
autem vel eum iriure dolor in hendrerit
eu feugiat nulla facilisis at vero eros et ac

Lorem ipsum dolor sit amet, consectetue
tincidunt ut laoreet dolore magna aliqua
nostrud exerci tation ullan
autem vel eum iriure dolor
eu feugiat nulla facilisis at
luptatum zzril delenit augu

Nam liber tempor cum sol
mazim placerat facer possi
diam nonummy nibh euis

Best regards,

Josh S. Example
President
coc
Enclosures (2)

SAMPLER CIDER MILLS
123 Example Boulevard
Your City, ST 12345 6789

IMPORTANT

SINCE 1823

SAMPLER CIDER MILLS

A one-sentence "hook" benefit that describes your product or service

g elit, sed

YOUR NAME
President/CEO

Voice 987 654 3210 Fax 987 654 3210 www.yourwebaddressz.com
E-mail info@emailaddressz.com
123 Example Boulevard, Your City, State 12345 6789

A one-sentence "hook" benefit that describes your product or service

123 Example Boulevard, Your City, State 12345 6789
Voice 987 654 3210 Fax 987 654 3210 www.yourwebaddressz.com E-mail info@emailaddressz.com

DESIGN RECIPES:SIMPLICITY

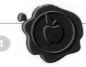

Sᴀᴍᴘʟᴇʀ Cɪᴅᴇʀ Mɪʟʟs

sɪɴᴄᴇ 1823

Sarah W. Example May 16, 2???
Director of Marketing
Sampler Corporation
1234 Street Address
Your City, ST 12345-6789

Sarah:

Lorem ipsum dolor sit amet, consectetuer adipiscing elit, sed diam nonummy nibh euismod
tincidunt ut laoreet dolore magna aliquam erat volutpat. Ut wisi enim ad minim veniam, quis
nostrud exerci tation ullamcorper suscipit lobortis nisl ut aliquip ex ea commodo consequat. Duis
autem vel eum iriure dolor in hendrerit in vulputate velit esse molestie consequat, vel illum dolore
eu feugiat nulla facilisis at vero eros et accumsan et iusto odio dignissim qui blandit praesent.

Lorem ipsum dolor sit amet, consectetuer adipiscing elit, sed diam nonummy nibh euismod
tincidunt ut laoreet dolore magna aliquam erat volutpat. Ut wisi enim ad minim veniam, quis
nostrud exerci tation ullamcorper suscipit lobortis nisl ut aliquip ex ea commodo consequat. Duis
autem vel eum iriure dolor in hendrerit in vulputate velit esse molestie consequat, vel illum dolore
eu feugiat nulla facilisis at vero eros et accumsan et iusto odio dignissim qui blandit praesent
luptatum zzril delenit augue duis dolore te feugait nulla facilisi.

Nam liber tempor cum soluta nobis eleifend option congue nihil imperdiet doming id quod
mazim placerat facer possim assum. Lorem ipsum dolor sit amet, consectetuer adipiscing elit, sed
diam nonummy nibh euismod tincidunt ut laoreet dolore magna aliquam erat volutpat.

Best regards,

Josh S. Example
President
coc
Enclosures (2)

A one-sentence "hook" benefit that describes your product or service

123 Example Boulevard, Your City, State 12345 6789
Voice 987 654 3210 Fax 987 654 3210 www.yourwebaddressz.com E-mail info@emailaddressz.com

Business Card, Front 3.5 W by 2 H inches

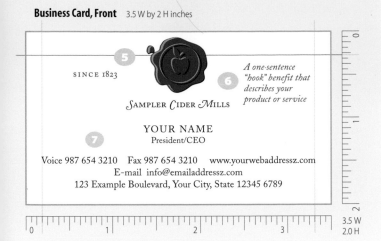

SINCE 1823

Sampler Cider Mills

A one-sentence "hook" benefit that describes your product or service

YOUR NAME
President/CEO

Voice 987 654 3210 Fax 987 654 3210 www.yourwebaddressz.com
E-mail info@emailaddressz.com
123 Example Boulevard, Your City, State 12345 6789

3.5 W
2.0 H

Business Card, Back 3.5 W by 2 H inches

IMPORTANT

3.5 W
2.0 H

Envelope, Commercial 9.5 W by 4.125 H inches

Sampler Cider Mills
123 Example Boulevard
Your City, ST 12345 6789

9.5 W
4.125 H

Letterhead

1 "S" Adobe Caslon Swash Italic, 10pt, align center; "AMPLER" Adobe Caslon Expert, 10pt, align center; "SINCE" Adobe Caslon Expert, 9pt, align center; **2** Line 0.25pt; **3** Letter body Minion, 12/18pt, align left; **4** Defining phrase Adobe Caslon Regular Italic, 8/12pt, align center; Address Adobe Caslon Regular, 8/11pt, align center

Business Card, Front

5 Line 0.25pt; "SINCE" Adobe Caslon Expert, 8pt, align left; **6** "S" Adobe Caslon Swash Italic, 8.5pt, align center; "AMPLER" Adobe Caslon Expert, 8.5pt, align center; Defining phrase Adobe Caslon Italic, 8/9pt, align left; **7** Name Adobe Caslon Regular, 8/9pt, align center; Address Adobe Caslon Regular, 8/10pt, align center

Business Card, Back

8 "IMPORTANT" Adobe Caslon Expert, 9pt, align center; Lines 0.25pt

Envelope

9 "S" Adobe Caslon Swash Italic, 8.5pt, align center; "AMPLER" Adobe Caslon Expert, 8.5pt, align center

Color

To be printed in black and a solid PANTONE Color Ink as defined on the palette below (see Step 9.3). (Because this book is printed in process colors (CMYK), the illustration is only a simulation of the actual solid PANTONE Color).

Burgundy or
PANTONE® 187

| 100 % |
| 50 % |

STYLE 22

Stack

Who's to say that a letterhead has to be eleven inches tall—every desktop printer can print an 8.5-by-14-inch sheet. This letterhead easily folds to fit a standard #10 envelope, and it provides twenty-five percent more space for little or no cost. Stacking a standard letterhead on top of an 8.5-by-3.5-inch extension makes simple sense.

The idea of a stack letterhead is to include an extension beyond the letter. The extension for this version includes space for a sample travel itinerary. Yours might use the space as a form for replying to the body of the letter, a coupon, a ticket to an event, a company profile, a map, and so on.

The illustration is extracted from an old advertising sign found in a clip art collection. With a full-featured paint program and some practice, it is possible to add and remove objects and type, and to change colors. The result of learning to use such a program is you can repurpose beautifully executed illustrations, one of which may satisfy your need perfectly.

Sampler Excursions

Sampler Excursions

A typeface is chosen to match the flavor of the illustration. "Sampler" is reduced slightly so the "E" and "S" don't touch.

SOURCE Illustration: Camel from *ClickArt 200,000* from Broderbund, available from software retailers worldwide, © T/Maker, all rights reserved.

SOURCE Type families: Burlington, Caslon, Minion, Adobe Systems, Inc., 800-682-3623, www.adobe.com/type.

? What you need
Editing the camel illustration requires a paint or digital imaging program such as Adobe Photoshop or Jasc Software's Paint Shop Pro. Simple text and shapes can be produced with a desktop publishing program such as Adobe InDesign, Adobe PageMaker, QuarkXPress, or Microsoft Publisher.

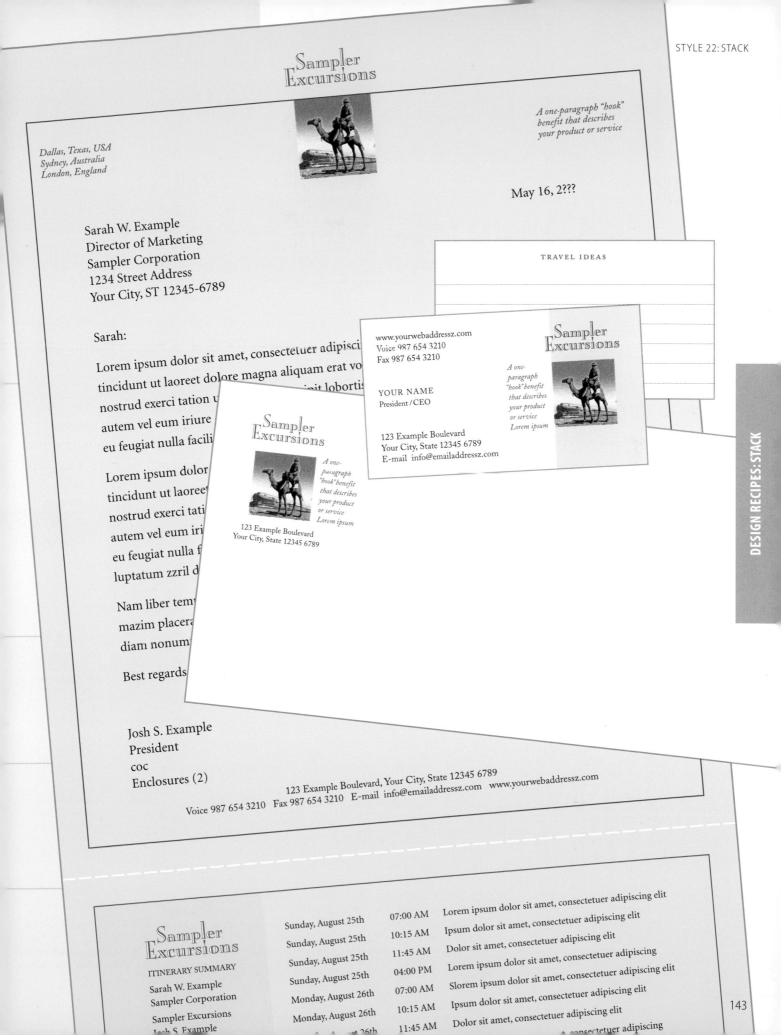

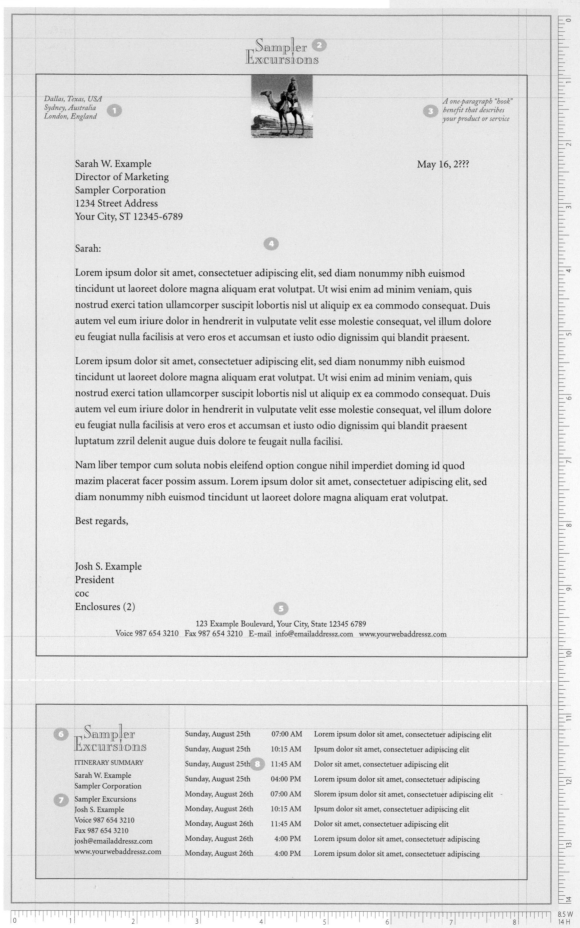

Sampler Excursions ②

Dallas, Texas, USA
Sydney, Australia
London, England ①

③ *A one-paragraph "hook"
benefit that describes
your product or service*

Sarah W. Example
Director of Marketing
Sampler Corporation
1234 Street Address
Your City, ST 12345-6789

May 16, 2???

Sarah: ④

Lorem ipsum dolor sit amet, consectetuer adipiscing elit, sed diam nonummy nibh euismod tincidunt ut laoreet dolore magna aliquam erat volutpat. Ut wisi enim ad minim veniam, quis nostrud exerci tation ullamcorper suscipit lobortis nisl ut aliquip ex ea commodo consequat. Duis autem vel eum iriure dolor in hendrerit in vulputate velit esse molestie consequat, vel illum dolore eu feugiat nulla facilisis at vero eros et accumsan et iusto odio dignissim qui blandit praesent.

Lorem ipsum dolor sit amet, consectetuer adipiscing elit, sed diam nonummy nibh euismod tincidunt ut laoreet dolore magna aliquam erat volutpat. Ut wisi enim ad minim veniam, quis nostrud exerci tation ullamcorper suscipit lobortis nisl ut aliquip ex ea commodo consequat. Duis autem vel eum iriure dolor in hendrerit in vulputate velit esse molestie consequat, vel illum dolore eu feugiat nulla facilisis at vero eros et accumsan et iusto odio dignissim qui blandit praesent luptatum zzril delenit augue duis dolore te feugait nulla facilisi.

Nam liber tempor cum soluta nobis eleifend option congue nihil imperdiet doming id quod mazim placerat facer possim assum. Lorem ipsum dolor sit amet, consectetuer adipiscing elit, sed diam nonummy nibh euismod tincidunt ut laoreet dolore magna aliquam erat volutpat.

Best regards,

Josh S. Example
President
coc
Enclosures (2)

⑤

123 Example Boulevard, Your City, State 12345 6789
Voice 987 654 3210 Fax 987 654 3210 E-mail info@emailaddressz.com www.yourwebaddressz.com

⑥ Sampler Excursions

ITINERARY SUMMARY

Sarah W. Example
Sampler Corporation

⑦ Sampler Excursions
Josh S. Example
Voice 987 654 3210
Fax 987 654 3210
josh@emailaddressz.com
www.yourwebaddressz.com

Sunday, August 25th	07:00 AM	Lorem ipsum dolor sit amet, consectetuer adipiscing elit	
Sunday, August 25th	10:15 AM	Ipsum dolor sit amet, consectetuer adipiscing elit	
Sunday, August 25th ⑧	11:45 AM	Dolor sit amet, consectetuer adipiscing elit	
Sunday, August 25th	04:00 PM	Lorem ipsum dolor sit amet, consectetuer adipiscing	
Monday, August 26th	07:00 AM	Slorem ipsum dolor sit amet, consectetuer adipiscing elit	
Monday, August 26th	10:15 AM	Ipsum dolor sit amet, consectetuer adipiscing elit	
Monday, August 26th	11:45 AM	Dolor sit amet, consectetuer adipiscing elit	
Monday, August 26th	4:00 PM	Lorem ipsum dolor sit amet, consectetuer adipiscing	
Monday, August 26th	4:00 PM	Lorem ipsum dolor sit amet, consectetuer adipiscing	

8.5 W
14 H

Business Card, Front 3.5 W by 2 H inches

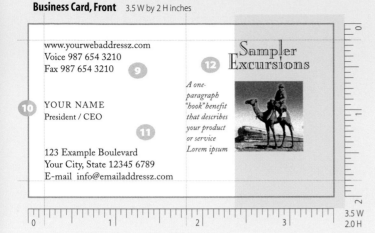

Business Card, Back 3.5 W by 2 H inches

Envelope, Commercial 9.5 W by 4.125 H inches

Letterhead

1 Lines 1pt; **"Dallas"** Caslon Regular Italic, 9/10pt, align left; **2 "Sampler"** Burlington, 22pt, align center; **"Excursions"** Burlington, 24pt, align center; **3 Defining phrase** Caslon Regular Italic, 9/10pt, align left; **4 Letter body** Minion, 12/18pt, align left; **5 Address** Caslon Regular, 9/11pt, align center; **6 "Sampler"** Burlington, 22pt, align center; **"Excursions"** Burlington, 24pt, align center; **"ITINERARY"** Caslon Regular, 7pt, align left; **7 "Sarah"** Minion, 9/12pt, align left; **8 Text** Minion, 9/17pt, align left

Business Card, Front

9 "www." Caslon Regular, 8/10pt, align left; **10 Name** Caslon Regular, 7/10pt, align left; **11 Address** Caslon Regular, 8/10pt, align left; **12 Defining phrase** Caslon Regular Italic, 7/9pt, align left; **"Sampler"** Burlington, 17pt, align center; **"Excursions"** Burlington, 19pt, align center

Business Card, Back

13 "TRAVEL" Caslon Regular, 9pt, align center; **Lines** 0.25pt

Envelope

14 "Sampler" Burlington, 17pt, align center; **"Excursions"** Burlington, 19pt, align center; **15 Defining phrase** Caslon Regular Italic, 7/9pt, align left; **16 Address** Caslon Regular, 7/9pt, align left

Color

Printed in four-color process (see Step 9.3) using values of cyan, magenta, yellow, and black (CMYK) as defined on the color palette below. Actual color will vary.

Process Colors

C5	M10	Y20	K0
C100	M45	Y0	K15
C15	M7.5	Y0	K0

STYLE 23

Transparency

This style requires some real finesse with your paint program, but the results can be stunning.

A program such as Adobe Photoshop allows you to layer one image on top of another. It is possible then to change the opacity of a layer enough to see through it to the layers below. That single feature allows seemingly endless possibilities.

The logo below includes four layers.

The orange plant and sliced orange are extracted from the same illustration.

The sliced orange is the top layer of the logo.

The layer below the orange includes the shadow of the orange.

The next layer holds a semitransparent version of the plant illustration.

The bottom layer is the background.

For the business card, a simple white rectangle is on the layer above the illustration. The opacity of the rectangle is adjusted to reveal the illustration below.

The parts and pieces of illustrations are combined to create a second version of the logo for the envelope.

The space between the letters in the word "ORCHARDS" is increased to allow for the descending loop of the "p"—one of the small details that make the difference between a design that works and one that doesn't.

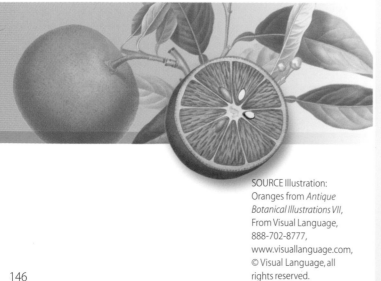

Samplerhaven
O R C H A R D S

SOURCE Type families: Bickham Script, Minion, Myriad, Adobe Systems, Inc., 800-682-3623, www.adobe.com/type.

? What you need

Editing the illustration requires a paint or digital imaging program such as Adobe Photoshop or Jasc Software's Paint Shop Pro. Simple text and shapes can be produced with a desktop publishing program such as Adobe InDesign, Adobe PageMaker, QuarkXPress, or Microsoft Publisher.

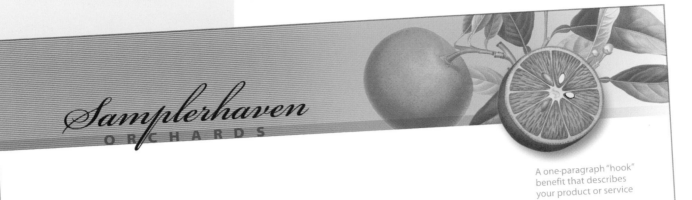

A one-paragraph "hook"
benefit that describes
your product or service

May 16, 2???

Sarah W. Example
Director of Marketing
Sampler Corporation
1234 Street Address
Your City, ST 12345-6789

Sarah:

Lorem ipsum dolor sit amet, consectetue
tincidunt ut laoreet dolore magna aliqua
nostrud exerci tation ullamcorper suscip
autem vel eum iriure dolor in hendrerit
eu feugiat nulla facilisis at vero eros et a

Lorem ipsum dolor sit amet, consectetu
tincidunt ut laoreet dolore magna aliqua
nostrud exerci tation ullamcorper susci
autem vel eum iriure dolor in hendrerit
eu feugiat nulla facilisis at vero eros et accumsan
luptatum zzril delenit aug

Nam liber tempor cum so
mazim placerat facer pos
diam nonummy nibh eu

Best regards,

Josh S. Example
President
coc
Enclosures (2)

A one-parag
describes

Samplerhaven
ORCHARDS

123 Example Boulevard
Your City, State 12345 6789

Samplerhaven
ORCHARDS
YOUR NAME
President/CEO
Voice 987 654 3210 Fax 987 654 3210
www.yourwebaddressz.com E-mail info@emailaddressz.com
123 Example Boulevard, Your City, State 12345 6789
A one-paragraph "hook" benefit that describes your product or service

ORANGES
Lorem ipsum dolor
sit amet,
consectetuer
adipiscing elit sed
diam nonummy
nibh euismod
tincidunt ut laoreet
dolore magna
aliquam erat
volutpat. Ut wisi
enim ad mi

APPLES
Exerci tation
ullamcorper
suscipit lobortis
nisl ut aliquip ex ea
com-modo
conseq
aut

KIWI
Lorem ipsum dolor
sit amet, consect-
etuer adipiscing
elit, sed diam
nonummy nibh
euismod tincidunt
ut laoreet dolore
magna aliquam erat
volutpat. Ut wisi
enim ad minim ven-
quis nostrud.

123 Example Boulevard
Your City, State 12345 6789
Voice 987 654 3210
Fax 987 654 3210
www.yourwebaddressz.com
E-mail info@emailaddressz.com

Samplerhaven
ORCHARDS

A one-paragraph "hook" benefit that describes your product or service

May 16, 2???

Sarah W. Example
Director of Marketing
Sampler Corporation
1234 Street Address
Your City, ST 12345-6789

Sarah:

Lorem ipsum dolor sit amet, consectetuer adipiscing elit, sed diam nonummy nibh euismod tincidunt ut laoreet dolore magna aliquam erat volutpat. Ut wisi enim ad minim veniam, quis nostrud exerci tation ullamcorper suscipit lobortis nisl ut aliquip ex ea commodo consequat. Duis autem vel eum iriure dolor in hendrerit in vulputate velit esse molestie consequat, vel illum dolore eu feugiat nulla facilisis at vero eros et accumsan et iusto odio dignissim qui blandit praesent.

Lorem ipsum dolor sit amet, consectetuer adipiscing elit, sed diam nonummy nibh euismod tincidunt ut laoreet dolore magna aliquam erat volutpat. Ut wisi enim ad minim veniam, quis nostrud exerci tation ullamcorper suscipit lobortis nisl ut aliquip ex ea commodo consequat. Duis autem vel eum iriure dolor in hendrerit in vulputate velit esse molestie consequat, vel illum dolore eu feugiat nulla facilisis at vero eros et accumsan et iusto odio dignissim qui blandit praesent luptatum zzril delenit augue duis dolore te feugait nulla facilisi.

Nam liber tempor cum soluta nobis eleifend option congue nihil imperdiet doming id quod mazim placerat facer possim assum. Lorem ipsum dolor sit amet, consectetuer adipiscing elit, sed diam nonummy nibh euismod tincidunt ut laoreet dolore magna aliquam erat volutpat.

Best regards,

Josh S. Example
President
coc
Enclosures (2)

123 Example Boulevard
Your City, State 12345 6789
Voice 987 654 3210
Fax 987 654 3210
www.yourwebaddressz.com
E-mail info@emailaddressz.com

Business Card, Front 3.5 W by 2 H inches

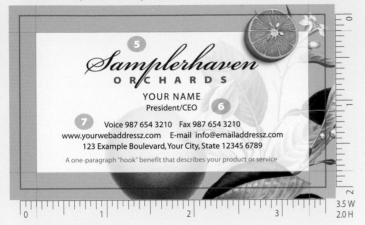

⑤ *Samplerhaven*
O R C H A R D S
YOUR NAME
President/CEO
⑦ Voice 987 654 3210 Fax 987 654 3210 **⑥**
www.yourwebaddressz.com E-mail info@emailaddressz.com
123 Example Boulevard, Your City, State 12345 6789
A one-paragraph "hook" benefit that describes your product or service

Business Card, Back 3.5 W by 2 H inches

⑧

O R A N G E S
Lorem ipsum dolor sit amet, onsectetuer adipiscing elit, sed diam nonummy nibh euismod tincidunt ut laoreet dolore magna aliquam erat volutpat. Ut wisi enim ad minim.

A P P L E S
Exerci tation ullamcorper suscipit lobortis nisl ut aliquip ex ea com-modo consequat. Duis autem vel eum iriure dolor in hendrerit in vulput-ate velit esse conseq-uat Ut wisi enim ad minim.

K I W I
Lorem ipsum dolor sit amet, consect-etuer adipiscing elit, sed diam nonummy nibh euismod tincidunt ut laoreet dolore magna aliquam erat volutpat. Ut wisi enim ad minim ven-iam, quis nostrud.

Letterhead

1 "Samplerhaven" Bickham Script, 60pt; "ORCHARDS" Myriad 800bl, 700se, 18pt; **2 Defining phrase** Myriad Regular, 9/10pt, align left; **3 Letter body** Minion, 12/18pt, align left; **4 Address** Myriad Regular, 7.5/10pt, align left

Business Card, Front

5 "Samplerhaven" Bickham Script, 38pt; "ORCHARDS" Myriad 800bl, 700se, 8pt; **6 Name** Myriad Regular, 8pt, align center; **Title** Myriad Regular, 7pt, align center; **7 Address** Myriad Regular, 7/9pt, align center; **Defining phrase** Myriad Regular, 6pt, align center

Business Card, Back

8 "ORANGES" Myriad 800bl, 700se, 6pt, align left; **Text** Myriad 800bl, 700se, Bold, 7/9pt, align left

Envelope

9 "Samplerhaven" Bickham Script, 34pt; "ORCHARDS" Myriad 800bl, 700se, 7pt; **Address** Myriad Regular, 7/8pt, align center; **10 Defining phrase** Myriad Regular, 6/7pt, align center

Color

Printed in four-color process (see Step 9.3) using values of cyan, magenta, yellow, and black (CMYK) as defined on the color palette below. Actual color will vary.

DESIGN RECIPES: TRANSPARENCY

Process Colors

C0	M45	Y80	K0

C20	M75	Y95	K10

Envelope, Commercial 9.5 W by 4.125 H inches

Samplerhaven
O R C H A R D S
123 Example Boulevard
Your City, State 12345 6789 **⑨**

⑩

A one-paragraph "hook" benefit that
describes your product or service

STYLE 24

Type

Who needs illustrations when you've got beautiful typefaces? And filters?

A filter is a feature within most draw and paint software that allows you to apply special effects to the images, lines, shapes, and text that you create and edit within the program.

In a paint program, you can, for example, change a photograph into something more reminiscent of a pastel drawing. In a drawing program, you can take a simple rank of horizontal lines, as shown here, and use a twirl filter to turn it into a wave.

SamplerCopyCenter

Color instead of space is used to divide the words in the name.

In a drawing program, a twirl filter is applied to a series of horizontal lines to create the backgrounds.

Graphic Design >

A list of products and services is added along the path above the bottom wave.

A map is used to pinpoint the organization's location.

SamplerCopyCenter

SOURCE Typeface: Franklin Gothic, Minion, Myriad, Adobe Systems, Inc., 800-682-3623, www.adobe.com/type.

? What you need

Creating wave lines, text along a path, and the map requires a draw program such as Adobe Illustrator, CorelDRAW, or Macromedia FreeHand. Simple text and shapes can be produced with a desktop publishing program such as Adobe InDesign, Adobe PageMaker, QuarkXPress, or Microsoft Publisher.

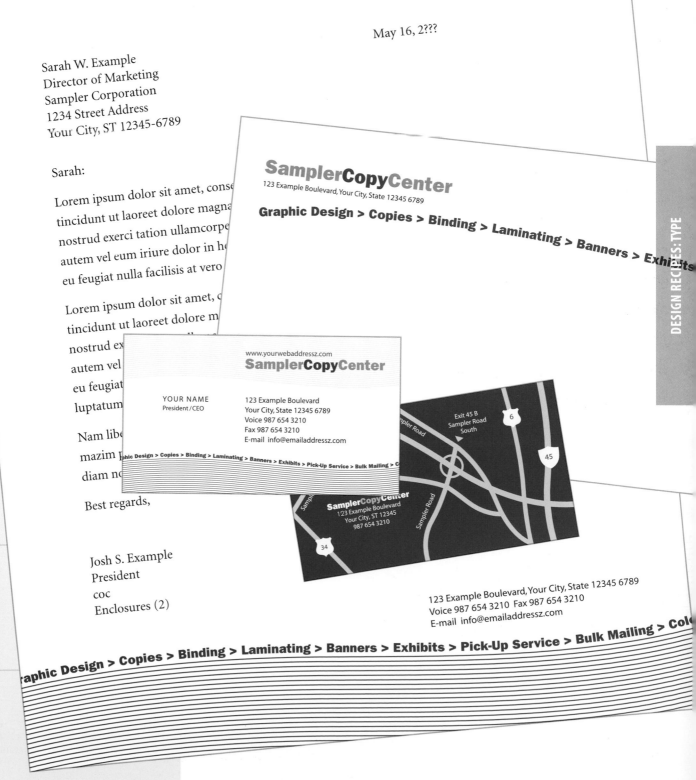

SamplerCopyCenter

Sarah W. Example
Director of Marketing
Sampler Corporation
1234 Street Address
Your City, ST 12345-6789

May 16, 2???

Sarah:

Lorem ipsum dolor sit amet, consectetuer adipiscing elit, sed diam nonummy nibh euismod tincidunt ut laoreet dolore magna aliquam erat volutpat. Ut wisi enim ad minim veniam, quis nostrud exerci tation ullamcorper suscipit lobortis nisl ut aliquip ex ea commodo consequat. Duis autem vel eum iriure dolor in hendrerit in vulputate velit esse molestie consequat, vel illum dolore eu feugiat nulla facilisis at vero eros et accumsan et iusto odio dignissim qui blandit praesent.

Lorem ipsum dolor sit amet, consectetuer adipiscing elit, sed diam nonummy nibh euismod tincidunt ut laoreet dolore magna aliquam erat volutpat. Ut wisi enim ad minim veniam, quis nostrud exerci tation ullamcorper suscipit lobortis nisl ut aliquip ex ea commodo consequat. Duis autem vel eum iriure dolor in hendrerit in vulputate velit esse molestie consequat, vel illum dolore eu feugiat nulla facilisis at vero eros et accumsan et iusto odio dignissim qui blandit praesent luptatum zzril delenit augue duis dolore te feugait nulla facilisi.

Nam liber tempor cum soluta nobis eleifend option congue nihil imperdiet doming id quod mazim placerat facer possim assum. Lorem ipsum dolor sit amet, consectetuer adipiscing elit, sed diam nonummy nibh euismod tincidunt ut laoreet dolore magna aliquam erat volutpat.

Best regards,

Josh S. Example
President
coc
Enclosures (2)

123 Example Boulevard, Your City, State 12345 6789
Voice 987 654 3210 Fax 987 654 3210
E-mail info@emailaddressz.com

Graphic Design > Copies > Binding > Laminating > Banners > Exhibits > Pick-Up Service > Bulk Mailing > Color

Business Card, Front 3.5 W by 2 H inches

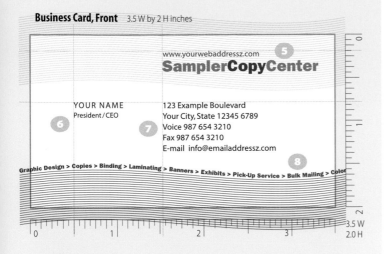

Business Card, Back 3.5 W by 2 H inches

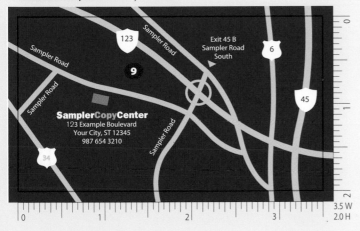

Envelope, Commercial 9.5 W by 4.125 H inches

SamplerCopyCenter
123 Example Boulevard, Your City, State 12345 6789

Graphic Design > Copies > Binding > Laminating > Banners > Exhibits > Pick-Up Service > Bulk Mailing > Color

Letterhead

1 **Web Address** Myriad Regular, 9pt, align left; **Organization** Franklin Gothic Heavy, 18pt, align left; **2** **Letter body** Minion, 12/18pt, align left; **3** **Address** Myriad Regular, 9/11pt, align left; **4** **Defining Phrase** Franklin Gothic Heavy, 18pt

Business Card, Front

5 **Web Address** Myriad Regular, 6.75pt, align left; **Organization** Franklin Gothic Heavy, 13.5pt, align left; **6** **Name** Myriad Regular, 7pt, align left; **Title** Myriad Regular, 6pt, align left; **7** **Address** Myriad Regular, 7/9pt, align left; **Title** Myriad Regular, 6pt, align left; **8** **Defining Phrase** Franklin Gothic Heavy, 5pt

Business Card, Back

9 **Organization** Franklin Gothic Heavy, 8pt, align center; **Text** Myriad Regular, 6/7pt, align center; **Route Numbers** Myriad Regular, 7pt

Envelope

10 **Organization** Franklin Gothic Heavy, 18pt, align left; **Address** Myriad Regular, 7pt, align left; **11** **Defining Phrase** Franklin Gothic Heavy, 12pt

Color

To be printed in black and a solid PANTONE Color Ink as defined on the palette below (see Step 9.3). (Because this book is printed in process colors (CMYK), the illustration is only a simulation of the actual solid PANTONE Color).

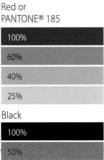

Red or
PANTONE® 185

100%
60%
40%
25%

Black

100%
50%
15%

STYLE 25

Vertical Bar

Bars of color—vertical or horizontal—serve the same purpose: They anchor the page.

It is important to note on this and on similar styles that placing the foundation graphics on the right of the page keeps the letter as the center of attention. Remember, the primary purpose of a letterhead, business card, and envelope is to communicate information. The style of your materials should complement, never overwhelm, that message.

SOURCE Illustration: figure by the author.

The figure is created from a series of simple lines and circles.

Copies of the figure are stacked in a flock formation.

The formation is slightly distorted and rotated into position, and color is added.

To create a shadow, a copy of the formation is pasted behind the original and colored with a tint of the solid blue.

Sampler
Employment

The name is made up of contrasting bold and light typefaces. The longest word is reduced to fit the same width as the other. Changing "Employment" to the bold face would reverse the emphasis.

SOURCE Type families: Franklin Gothic, Minion, Myriad, Adobe Systems, Inc., 800-682-3623, www.adobe.com/type.

? What you need
Creating the figure requires a draw program such as Adobe Illustrator, CorelDRAW, or Macromedia FreeHand. Simple text and shapes can be produced with a desktop publishing program such as Adobe InDesign, Adobe PageMaker, QuarkXPress, or Microsoft Publisher.

Sampler
Employment

A one-sentence "hook"
benefit that describes your
product or service lorem
ipsum dolor sit amet ipsum
dolor sit amet

May 16, 2???

Sarah W. Example
Director of Marketing
Sampler Corporation
1234 Street Address
Your City, ST 12345-6789

Sarah:

Lorem ipsum dolor sit amet, consectetuer adipiscing elit, sed diam nonummy nibh euismod
tincidunt ut laoreet dolore magna aliquam erat volutpat. Ut wisi enim ad minim veniam, quis
nostrud exerci tation ullamcorper suscipit lobortis nisl ut aliquip ex ea commodo consequat. Duis
autem vel eum iriure dolor in hendrerit in vulputate velit esse molestie consequat, vel illum dolore
eu feugiat nulla

Lorem ipsum d
tincidunt ut la
nostrud exerci
autem vel eum
eu feugiat nu
luptatum zzri

Nam liber te
mazim plac
diam nonu

Best regard

Josh S. E
Presiden
coc
Enclosures (2)

Sampler
Employment
123 Example Boulevard
Your City, State 12345 6789

A one
sentence
"hook"
benefit that
describes
your product
or service
lorem ipsum
dolor sit
amet,
ipsum dolor
sit amet

www.yourwebaddressz.com
Voice 987 654 3210
Fax 987 654 3210

YOUR NAME
President / CEO

123 Example Boulevard
Your City, State 12345 6789
info@emailaddressz.com

Sampler
Employment

JOBS	MISSION
1 Lorem ipsumo	Lorem ipsum dolor sit amet, consectetuer adipiscing elit,
2 Dolor sit ametpt	sed diam nonummy nibh euismod tincidunt ut laoreet
3 Sconsectetuer	dolore magna aliquam erat volutpat. Ut wisi enim ad
4 Jadipiscing elite	minim veniam, quis nostrud lorem ipsum dolor sit amet,
5 Lsed diammod	consectetuer adipiscing elit, sed
6 Dnonummy	diam nonummy nibh euismod
7 Snibh euismod	tincidunt ut laoreet dolore
8 Dtincidunt elite	magna aliquam erat
9 Slaoreet dolore ip	veniam, quis nostrud.

www.yo
info@emailaddressz.com

DESIGN RECIPES: VERTICAL BAR

Sampler
Employment

① A one-sentence "hook" benefit that describes your product or service lorem ipsum dolor sit amet ipsum dolor sit amet

May 16, 2???

Sarah W. Example
Director of Marketing
Sampler Corporation
1234 Street Address
Your City, ST 12345-6789

②

Sarah:

Lorem ipsum dolor sit amet, consectetuer adipiscing elit, sed diam nonummy nibh euismod tincidunt ut laoreet dolore magna aliquam erat volutpat. Ut wisi enim ad minim veniam, quis nostrud exerci tation ullamcorper suscipit lobortis nisl ut aliquip ex ea commodo consequat. Duis autem vel eum iriure dolor in hendrerit in vulputate velit esse molestie consequat, vel illum dolore eu feugiat nulla facilisis at vero eros et accumsan et iusto odio dignissim qui blandit praesent.

Lorem ipsum dolor sit amet, consectetuer adipiscing elit, sed diam nonummy nibh euismod tincidunt ut laoreet dolore magna aliquam erat volutpat. Ut wisi enim ad minim veniam, quis nostrud exerci tation ullamcorper suscipit lobortis nisl ut aliquip ex ea commodo consequat. Duis autem vel eum iriure dolor in hendrerit in vulputate velit esse molestie consequat, vel illum dolore eu feugiat nulla facilisis at vero eros et accumsan et iusto odio dignissim qui blandit praesent luptatum zzril delenit augue duis dolore te feugait nulla facilisi.

Nam liber tempor cum soluta nobis eleifend option congue nihil imperdiet doming id quod mazim placerat facer possim assum. Lorem ipsum dolor sit amet, consectetuer adipiscing elit, sed diam nonummy nibh euismod tincidunt ut laoreet dolore magna aliquam erat volutpat.

Best regards,

Josh S. Example
President
coc
Enclosures (2)

③ 123 Example Boulevard,
Your City, State 12345 6789
Voice 987 654 3210
Fax 987 654 3210
www.yourwebaddressz.com
info@emailaddressz.com

Business Card, Front 3.5 W by 2 H inches

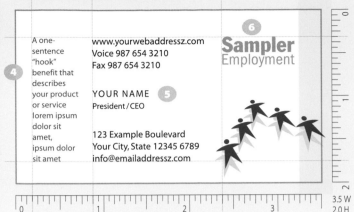

A one-sentence "hook" benefit that describes your product or service lorem ipsum dolor sit amet, ipsum dolor sit amet

www.yourwebaddressz.com
Voice 987 654 3210
Fax 987 654 3210

YOUR NAME
President / CEO

123 Example Boulevard
Your City, State 12345 6789
info@emailaddressz.com

Sampler
Employment

3.5 W
2.0 H

Business Card, Back 3.5 W by 2 H inches

JOBS
1 Lorem ipsumo
2 Dolor sit ametpt
3 Sconsectetuer
4 Jadipiscing elite
5 Lsed diammod
6 Dnonummy
7 Snibh euismod
8 Dtincidunt elite
9 Slaoreet dolore ip

MISSION
Lorem ipsum dolor sit amet, consectetuer adipiscing elit, sed diam nonummy nibh euismod tincidunt ut laoreet dolore magna aliquam erat volutpat. Ut wisi enim ad minim veniam, quis nostrud lorem ipsum dolor sit amet, consectetuer adipiscing elit, sed diam nonummy nibh euismod tincidunt ut laoreet dolore magna aliquam erat veniam, quis nostrud.

3.5 W
2.0 H

Envelope, Commercial 9.5 W by 4.125 H inches

Sampler
Employment
123 Example Boulevard
Your City, State 12345 6789

9.5 W
4.125 H

Letterhead

1 "Sampler" Franklin Gothic Bold Condensed, 25pt, align left; "Employment" Franklin Gothic Book Condensed, 18.5pt, align left; **Defining Phrase** Myriad Regular, 7/10pt, align left; **2** **Letter body** Minion, 12/18pt, align left; **3** **Address** Myriad Regular, 7/10pt, align left

Business Card, Front

4 **Defining Phrase** Myriad Regular, 7/9pt, align left; **5** **Address** Myriad Regular, 8/10pt, align left; **Title** Myriad Regular, 7pt, align left; **6** "Sampler" Franklin Gothic Bold Condensed, 18pt, align left; "Employment" Franklin Gothic Book Condensed, 13pt, align left

Business Card, Back

7 "JOBS" Myriad Multiple Master (MM), 700bd, 300cn, 8/12.5pt, align left; **8** "MISSION" Myriad MM, 700bd, 300cn, 8/12pt, align left

Envelope

9 "Sampler" Franklin Gothic Bold Condensed, 22pt, align left; "Employment" Franklin Gothic Book Condensed, 15.5pt, align left; **Address** Myriad Regular, 7/9pt, align left

Color

To be printed in black and a solid PANTONE Color Ink as defined on the palette below (see Step 9.3). (Because this book is printed in process colors (CMYK), the illustration is only a simulation of the actual solid PANTONE Color).

Deep Blue or
PANTONE® 286

| 100% |
| 50% |
| 20% |
| 10% |

Glossary

Bit-mapped graphics *See* Paint graphics.

Bleed The layout image area that extends beyond the trim edge.

CMYK *See* Four-color process.

Defining phrase A five- to fifteen-word phrase that defines your market and expresses the most important benefits of using your product or service.

Design grid The invisible framework on which a page is designed.

Draw graphics Graphics created using objects such as lines, ovals, rectangles, and curves in a program such as Adobe Illustrator, CorelDRAW, or Macromedia FreeHand. Common draw file formats include: Encapsulated PostScript (EPS) and Windows Metafiles (WMF). Also referred to as "vector" or "object-oriented" graphics. *See* Paint graphics.

Fill The area within the stroke or outline of a shape or typeface character. In a drawing software program, strokes and fills can be assigned different colors. *See* Stroke.

Font There is disagreement over the current definition of this term. For the purposes of this book, a font is a typeface in digital form. *See* Typeface *and* Type family.

Four-color process A printing process that primarily uses cyan, magenta, yellow, and black (referred to as CMYK) to reproduce color photographs and other materials that contain a range of colors that cannot economically be reproduced using individual solid ink colors. *See* Solid color.

Ghosting A doubled or blurred image on the printed sheet typically caused by a misapplication of ink on the rollers.

Hickey A spot or other inperfection on the printed sheet caused by dirt or paper particles that adhere to the plate or rollers during printing.

Hook The combination of product or service benefits that establishes the important difference between an organization and its competition.

Icon An image that suggests its meaning—for example, an opened padlock represents the state of being unlocked.

Kerning The space between typeface characters.

Leading The amount of verticle space between the baselines of a typeface. Expressed as 12/18pt, which means the size of the specified type is 12pt and the spacing between lines is 18pt.

Logo The combination of a name, a symbol, and a short tag line. At a glance, identifies the nature of your product or service, transmits the benefit of using it, and defines your attitude about it.

Lorem ipsum Scrambled Latin text used by designer's to demonstrate the approximate number of words it will take to fill an area of the layout before the actual text is specified.

Mottle Uneven, spotty areas of ink coverage on a printed sheet.

Object-oriented graphics *See* Draw graphics.

Paint graphics Graphics created on a grid of tiny rectangles called pixels. Each pixel can be a different color or shade of gray. Created in a program such as Adobe Photoshop or Jasc Software's Paint Shop Pro. Common paint file formats include Joint Photographic Experts Group (JPEG or JPG) and Tagged-Image File Format (TIFF or TIF). Also referred to as "raster" or "bit-mapped" graphics. *See* Draw graphics.

Picture font Collection of images that are installed like a font and produced by typing on the computer keyboard.

Pinhole A speck on a printed sheet caused by a hole in the printing plate negative.

Preflight The process of gathering together and reviewing all the elements necessary for translating the designer's information to a commercial printer's computer software and printing presses.

Press check The process of reviewing a job on the printing press at the beginning of the press run. Provides an opportunity for slight color adjustments of process colors.

Proof A mock page or series of pages produced prior to printing by a commercial printer to demonstrate how a finished printed job will look.

Raster graphics *See* Paint graphics.

Registration The process by which multiple printing images are aligned.

Royalty-free In most cases, grants the buyer unlimited (within the vendor's license agreement) use of a photograph or illustration. *See* Stock.

Sans serif A type character that does not have an end stroke or "foot." *See* Serif.

Serif The end stroke, or "foot," of a type character.

Service mark The United States Patent and Trademark Office defines a service mark as "the same as a trademark except that it identifies and distinguishes the source of a service rather than a product." *See* Trademark.

Sign A shorthand device that stands for something else—for example, the @ sign which stands for "at."

Skew A crooked image in a printed sheet caused by a misaligned plate or careless trimming.

Solid color A specific ink color produced by a specific manufacturer. Typically matched using a printed source book such as a PANTONE formula guide.

Stock (1) In most cases, grants the buyer one-time use of a photograph or illustration for a specific project. *See* Royalty-free. (2) The substraight on which printing is applied—in most cases, paper.

Stroke The line that surrounds the solid area of a shape or typeface character. In a drawing software program, strokes can be widened or eliminated, and strokes and fills can be assigned different colors. *See* Fill.

Style The visual and emotional mood of your organization. It is the combination of the message, how it is presented, the images used to illustrate it, the stance of the layout, and the choices of typefaces and color.

Symbol A visible image of something that is invisible—for example, an hourglass represents the idea of time.

Tint A tone of a solid color expressed as a percentage.

Trap The hairline overlap between colors necessary to eliminate gaps between colors.

Trim The page dimension on which a final printed sheet is cut.

Type family Two or more typefaces with a common design, including weights, widths, and slopes. *See* Typeface and Font.

Typeface One variation of a type family with a specific weight (i.e., light, regular, bold), width (i.e., condensed, narrow, extended), or slope (i.e., roman, italic). *See* Type family *and* Font.

Trademark The United States Patent and Trademark Office defines a trademark as "a word, phrase, symbol, or design, or combination of words, phrases, symbols, or designs, which identifies and distinguishes the source of the goods or services of one party from those of others." *See* Service mark.

Vector graphics *See* Draw graphics.

Index

8623